Louisiana Wild

Louisiana Wild

Louisiana State University Press | Baton Rouge

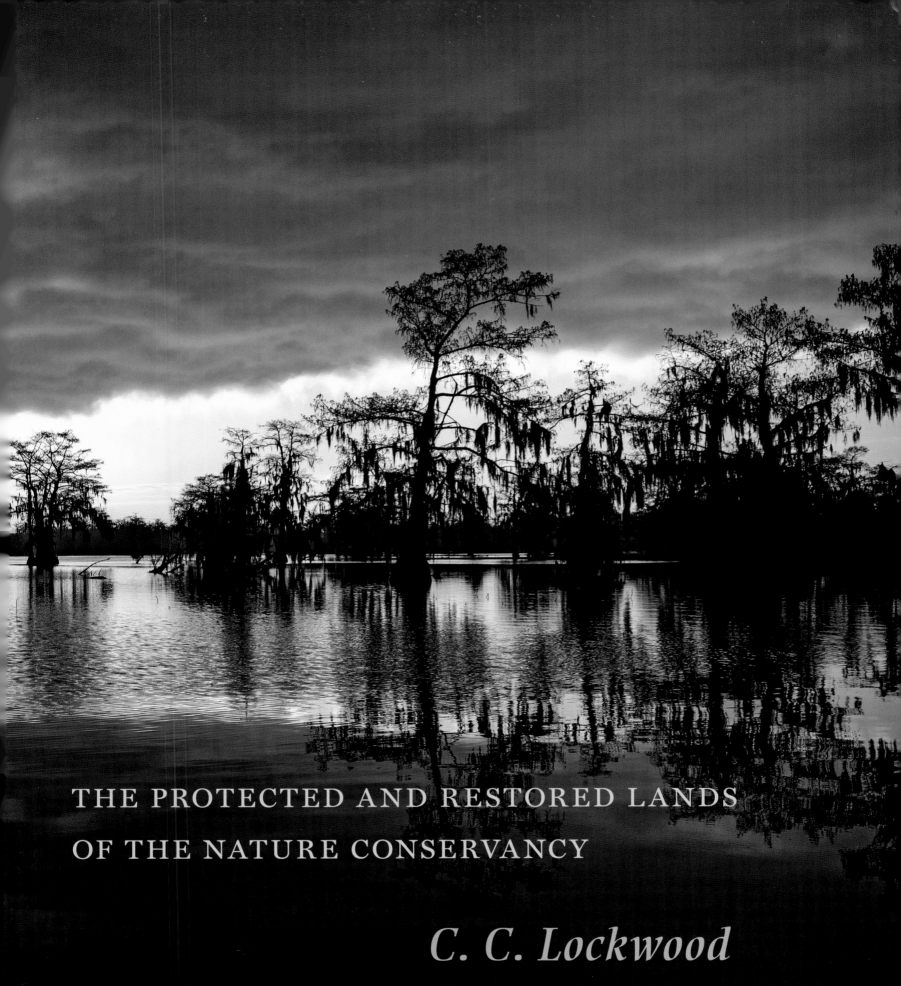

THE PROTECTED AND RESTORED LANDS
OF THE NATURE CONSERVANCY

C. C. Lockwood

With a Foreword by *Keith Ouchley*

OTHER BOOKS BY C. C. LOCKWOOD

The Gulf Coast: Where Land Meets Sea

Discovering Louisiana

The Yucatán Peninsula

C. C. Lockwood's Louisiana Nature Guide

Beneath the Rim: A Photographic Journey through the Grand Canyon

Around the Bend: A Mississippi River Adventure

Still Waters: Images, 1971–1999

The Alligator Book

Marsh Mission: Capturing the Vanishing Wetlands

C. C. Lockwood's Atchafalaya

Published with the assistance of
the Borne Fund

Published by
Louisiana State University Press
Manufactured in China
First printing

Designer: Laura Roubique Gleason
Typeface: MillerText Pro
Printer and binder: Everbest Printing
 Co. through Four Colour Imports, Ltd.,
 Louisville, Kentucky

Library of Congress
Cataloging-in-Publication Data are available at
the Library of Congress.

ISBN 978-0-8071-6123-4 (cloth: alk. paper)

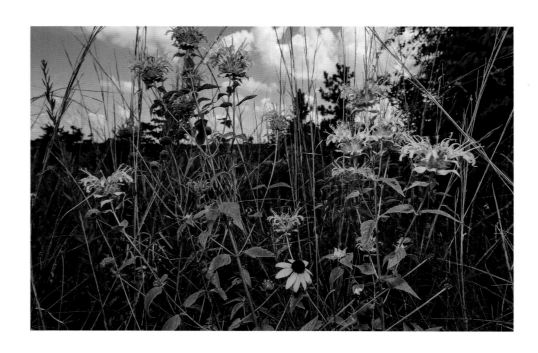

The mission of The Nature Conservancy is to conserve
the lands and waters on which all life depends.

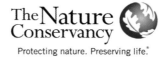

The Nature Conservancy
Protecting nature. Preserving life.

To my dad, Frank Lockwood,
Who guided me with his built-in compass to this wonderful world of nature,
and to my father-in-law, Boney Richardson,
Whose wit and character always inspire.

All America lies at the end of the wilderness road, and our past is not a
dead past, but still lives in us. Our forefathers had civilization inside them-
selves, the wild outside. We live in the civilization they created, but within
us the wilderness still lingers. What they dreamed, we live, and what they
lived, we dream.

 —T. K. Whipple

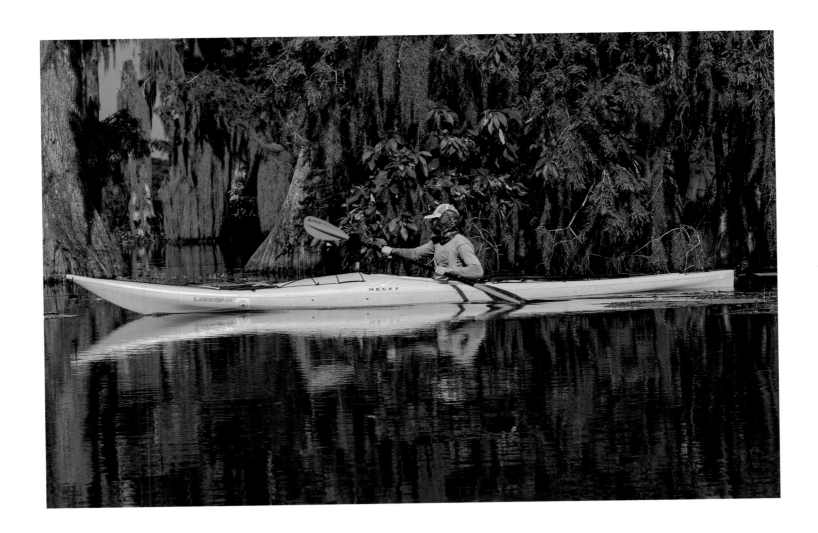

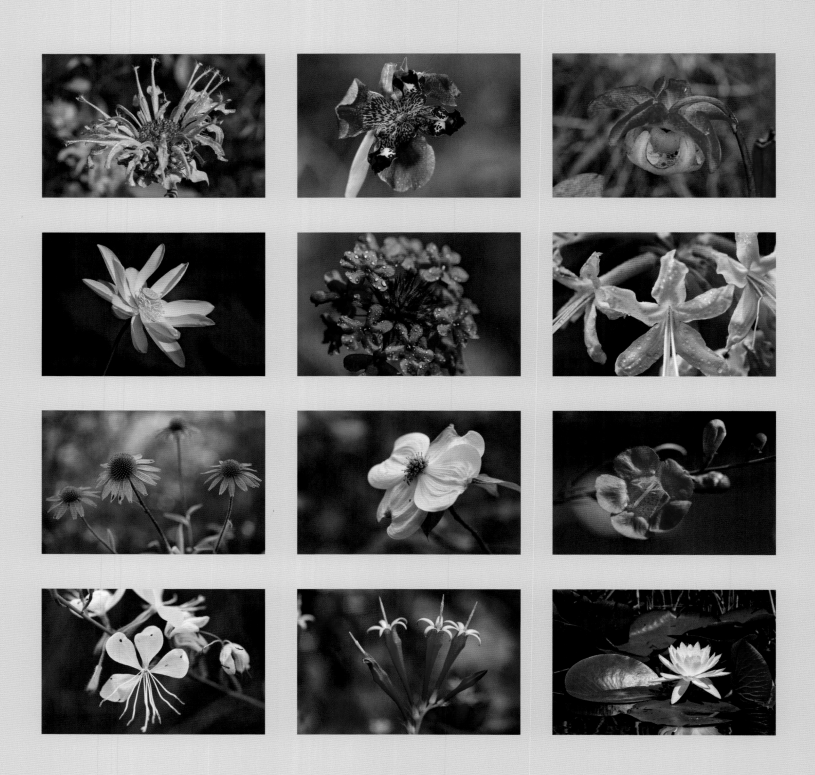

Contents

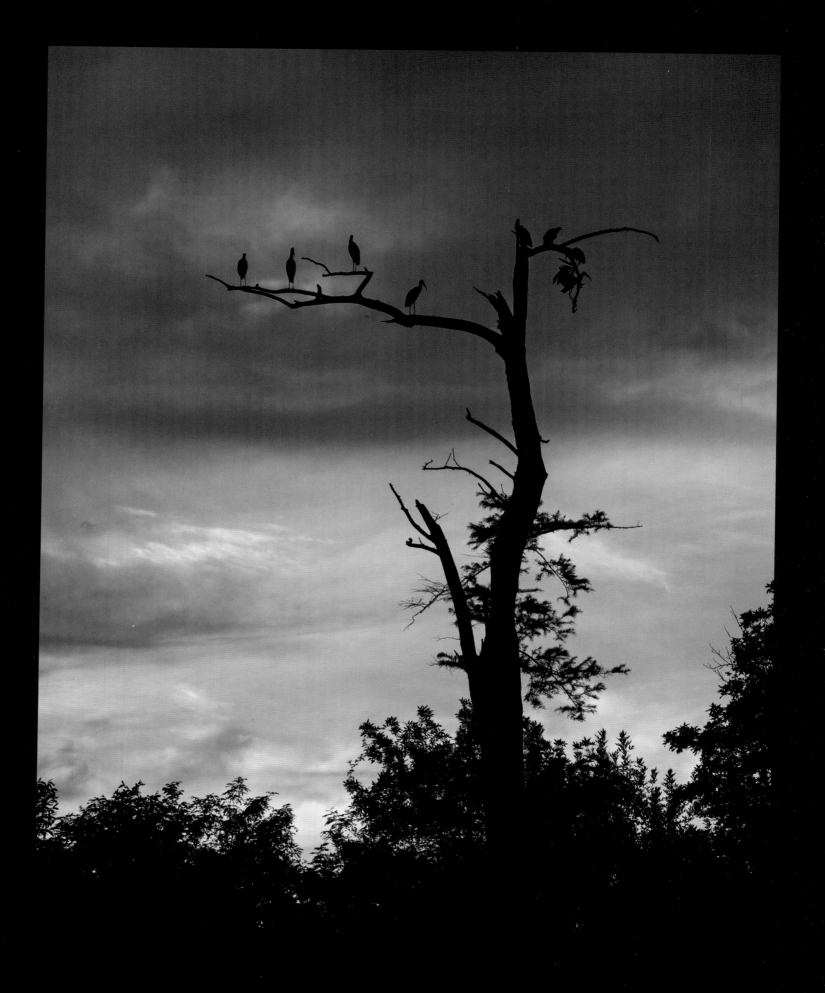

Foreword

The showy, rare flame flower blooms in early fall at Abita Creek.

Left: Roosting wood storks appear as sentinels on an ancient bald cypress snag. Cat Island NWR.

Few words capture it better—it's called "a sense of place." Few places represent it more strongly than Louisiana. It is triggered by different connections to the natural world that we all have. For some it's that comforting feeling you get when you watch the sun rise across the rolling hills of north Louisiana, or when you hear the sounds of the birds in our coastal marshes. It could come from the cypress-lined bayou where you first fished with your grandparents, or it may be at the cold-water spring that flows by the beech trees and wild azaleas near the old homeplace. An old slough at sunset in the delta, or the site of towering longleaf pines accompanied by the whistling of a bobwhite may elicit the response in others. It varies by our life experiences, but most of us have this connection to places in the natural world that are special to us. And here in Louisiana we are blessed with a wonderful array of possibilities.

It's our natural world that has shaped our history and culture and helped give us that sense of place. Who we are and what we have become has largely been influenced by the bounty of natural resources in Louisiana. Don't think this current generation is the first in Louisiana to be influenced by our ecology. There's a reason some of the most ancient cultures in North America, like Poverty Point, first emerged here. The natural bounty of one of the richest and most productive ecosystems on this continent fueled the birth of that society thousands of years ago, and it has continued to shape who we are through modern times. Vast timber resources, rich coastal systems, and majestic rivers coupled with a warm climate have produced one of the most ecologically diverse and productive places in our country. The abundance and variety of plants and animals in Louisiana is truly legendary. Our natural world shaped where our communities grew and how our economy performed, and gave us that connection to our landscapes that instilled in most of us a true sense of place. We identify with elements of the environment like few other places in the country. Spanish moss, crawfish, cypress trees, ducks, alligators, and an endless list of other cultural trademarks are emblems of the Louisiana environment. We are who we are, in large part, because of our natural environment here in Louisiana.

Because the environment is so closely tied to our collective sense of society in Louisiana, it is only right that we would want to be good stewards of our natural resources. After all, the environment does sustain us culturally and economically, and many would say, spiritually. But as with many places around the world, the advance of our society has come at the expense of the environment here in Louisiana. Most people know about, or at least have heard of, the issues facing the country's largest deltaic system—coastal Louisiana. The measuring stick so often cited is that we lose a football field of the coast every hour or so. But just as important is the loss of other major habitat types around the state—in some places, still occur-

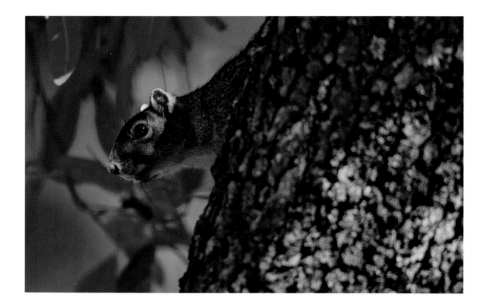

Bachman's fox squirrel.

Pine lily.

ring today. Louisiana once had over two million acres of tall grass prairie similar to that of the southern Great Plains. It was an incredibly diverse habitat with hundreds of species of prairie plants such as wildflowers and prairie grasses, and animals such as prairie chickens and bison. Today, less than a thousand acres remain. While the prairies are an extreme example, other habitats have been severely diminished as well. In north Louisiana, millions of acres were once dominated by a mixed forest of shortleaf or loblolly pine and an array of upland hardwoods. Finding patches of this forest in a relatively natural condition is becoming increasingly harder. Longleaf pine forests dominated much of the Florida Parishes and central Louisiana, continuing westward into Texas. Essentially open, savanna-like stands of forest with tall straight pines, they too harbored hundreds of species of plants and animals, most occurring in the understory. Many species in Louisiana are now found nowhere else but in these forests dominated by longleaf pine. It is a system sustained by fire that clears the underbrush and actually allows the rich understory, and the fire-tolerant longleaf, to regenerate. Today, less than 5 percent of the original 5 to 7 million acres of longleaf pine forests in Louisiana remain in a relatively natural condition. The bottomland hardwood forest in the parishes along the Mississippi River from the Arkansas line southward was once nearly one vast unbroken swath of trees spanning millions of acres. Now it stands as isolated patches in a sea of open land. With the felling of the last true old-growth timber in the Singer Tract in the 1940s, no original forest as the first explorers saw it is known to exist. Outside of a few old, mostly hollow sentinels that are left standing today, we may never have a truly good idea of what the majesty of those bottomland hardwood forests really looked like. Gone too are some of the species that inhabited these forests, like the ivory-billed woodpecker, Bachman's warbler, and others. Our rivers and streams are perhaps our most overlooked natural resource in Louisiana and have been altered to the point most don't even realize. Dams, channelization, dredging, levees, increased sedimentation, altered water chemistry, and, in many cases, complete reconfiguration are all issues that have affected our waterways. These changes have often altered the composition of the rich aquatic communities that inhabit them. Water always has been and will continue to be a vital lifeline in Louisiana. The Bayou State has not always been kind to this important resource.

It's a situation that nearly every society faces. We will always need farmlands and places to live and work, and we need the food, fiber, and other products of the natural world to sustain us. We also need the services that our natural habitats provide. We need floodplain forests to capture the storm water and recharge the aquifers. We need healthy forests, grasslands, and marshes that clean the air. We need the resources that fishing and timbering provide. We need clean water to live. These and many other "ecosystem service" values are critical to our existence. Even though we have lost or altered parts of our natural heritage in Louisiana, we are more fortunate than many other places in several regards. We have retained portions of our different habitat types that serve as areas where nature can still function and the plants and animals that depend on them can still survive. In many cases these areas occur as public lands, but they also exist on many acres of private land. How we

choose to manage and steward these lands into the future is important. Pressures on the natural world increase daily, and we are constantly faced with choices about how we should manage and conserve these resources. Secondly, there is that sense of place that is strong in many Louisianans. Thanks to the forethought of people who came before us, we have these areas of habitat on public and private lands across our state. We are going to need that connection to our natural heritage to help us steward those resources into the future and to gain through conservation and restoration some critical aspects that have been lost to the detriment of us all.

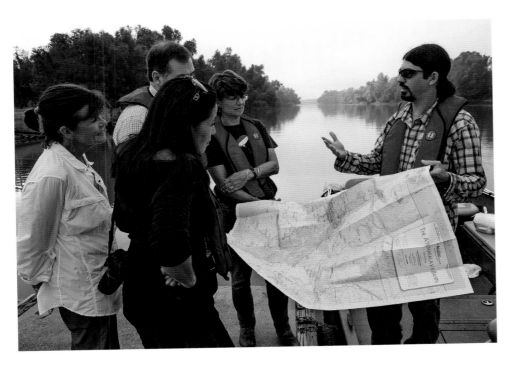

Brian Piazza points out the route of a Nature Conservancy field trip into the Atchafalaya Basin.

The Nature Conservancy has been working in Louisiana for nearly thirty years to help make sure that sense of place continues for the citizens of this state, and for those who visit here, by helping conserve the lands and waters on which all life depends. TNC is a nonprofit organization that was established over sixty years ago and works in all 50 states and in 35 countries around the world with a track record of conserving over 100 million acres. In Louisiana, TNC has helped conserve and restore nearly 350,000 acres of our great natural heritage. From coastal marshes to longleaf pine forests, from bottomland hardwoods to mixed-pine uplands, The Nature Conservancy has worked all across the state to conserve habitats for people and nature. Science based and staffed by an outstanding group of natural resource professionals, TNC uses a nonconfrontational, cooperative approach with landowners, public agencies, corporations, and like-minded citizens to help achieve conservation success.

One of the nation's premier nature photographers, C. C. Lockwood has called Louisiana his home for over fifty years. It seemed only fitting for The Nature Conservancy to partner with C.C. to highlight some of our outstanding projects in Louisiana that have led to the conservation of many of the state's iconic natural areas. Nearly two years in the making, this book is the culmination of C.C.'s full-time efforts traveling the state to capture these images. His dedication, professionalism, and obvious passion for wild places in Louisiana have made this experience a true joy for all of us who have had the privilege and honor to work with him. C.C. and his charming wife Sue visited nearly every single project we have worked on, shadowed our staff through prescribed fires, waded across swamps, hiked across all manner of terrain, traveled by boat and ATV, and flew across the landscapes as they traversed the state to help tell this story, all the while loving every minute and endearing themselves to our staff. No one works harder and few can capture the story of Louisiana's great outdoors like C.C. It is our hope that these images remind everyone how important it is to continue to conserve and restore our state's natural heritage so that generations to come can still experience that truly unique sense of place that is Louisiana.

Keith Ouchley
State Director, The Nature Conservancy of Louisiana

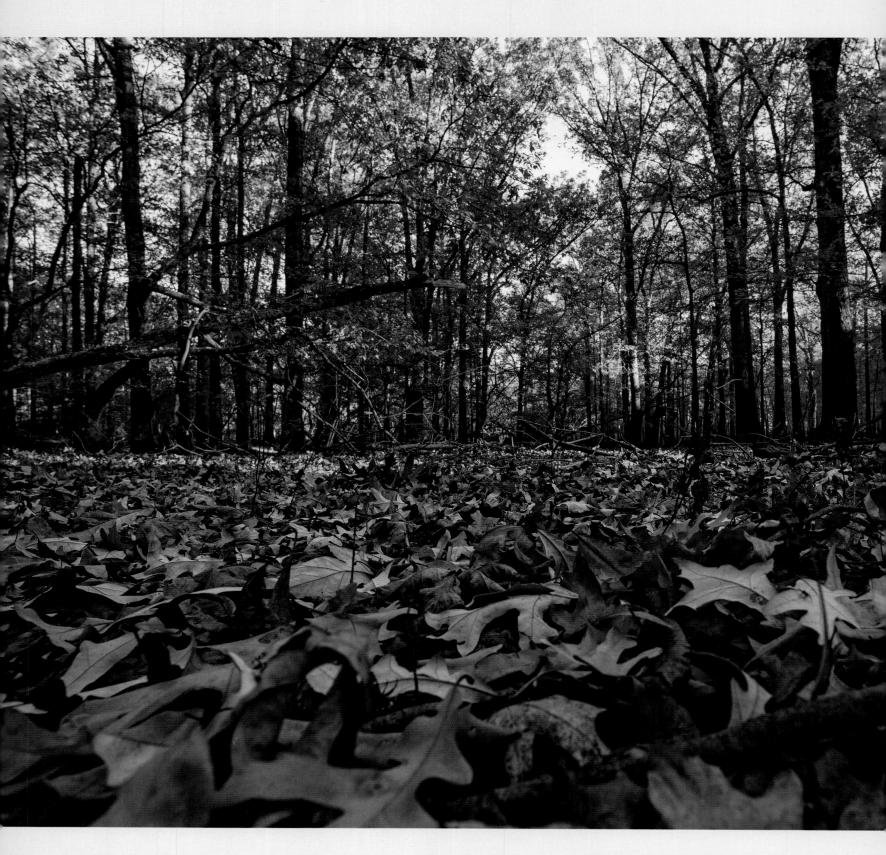

A carpet of leaves so soft, so stunning, at Bayou Dorcheat.

Acknowledgments

I have been lucky enough to visit all of Louisiana's diverse habitats, from the islands on the coast to the piney woods in the north and everything in-between, over the past forty-three years. For this book I got to experience all those habitats again, most in new locations. To find, explore, and learn about these wonderful properties required a lot of help, and I thank every single person I met along the way. I want to particularly thank the staff of the Louisiana offices of The Nature Conservancy, currently twenty-nine strong. Each of these dedicated and highly professional people was inspiring to me. A few have moved on since I started, and I thank them too. I am especially grateful to the state director, Keith Ouchley. I wish I could be as good a leader of conservation efforts as he is. Others at TNC that especially helped me in the field or with logistics are Jim Bergan, Seth Blitch, Jennifer Browning, Lisa Creasman, Laura Lanier, Richard Martin, Tracie Martin, Bryan Piazza, Kacy King, Matt Pardue, Jean Landry, Latimore Smith, Ronnie Ulmer, Chris Rice, Dan Weber, Rick Jacob, Alex Entrup, Tom Lydon, Newlyn McInnis, and Bill Rivers. David Harlan and Jill Andrew did a wonderful job of supplying me with maps as well as making the maps for this book. Behind the scene in the TNC office were Joe Baustian, Karen Gautreaux, Nicole Love, Richelle Richardson, Emmy Wright, and Amy Kyle Smith. And Don McDowell, now retired, worked hard with me on the inspiration for this book. Other folks with a TNC badge are Nancy Jo Craig and Skipper Dickson, who first brought to Louisiana the concept of the Nature Conservancy. TNC board members Harris Brown and Cris Kinsey supplied me the use of their planes for aerials in this book.

In my office, Kelly Tate, Hilary Scheinuk, and Haley Rowe-Kadow kept me organized. Friends Al McDuff, Jimbo Roland, and Marty Stouffer offered many suggestions along the way. Robert Barham, head of the Louisiana Department of Wildlife and Fisheries, helped with logistics. Others that assisted in the field or in research are Johnny Armstrong, Chris Carlton, Eddie Lowe, Eddy Sherman, Kelly Purkey, Taylor Simoneaux, Betsy Conney, Becky Shuman, Michael Biggerstaff, Charles Simon, Jim Caldwell, Ray Aycock, Brett Wehrle, Dan O'Malley, Michel Seymour, Steve Uffman, and Donata Henry. Many more that helped make this book possible are listed at www.cclockwood.com/acknowledgements.

In putting this book together the staff of LSU Press has done their usual excellent job, especially Director MaryKatherine Callaway, editor Catherine Kadair, and designer Laura Gleason. Finally, Sue Lockwood, wife and sidekick Ms. Wonderful, walked most every step of the woods and waters of TNC Louisiana properties with me.

Following page: Ruth, a canal old enough to mimic a bayou, flows on the north side of Lake Martin at sunrise.

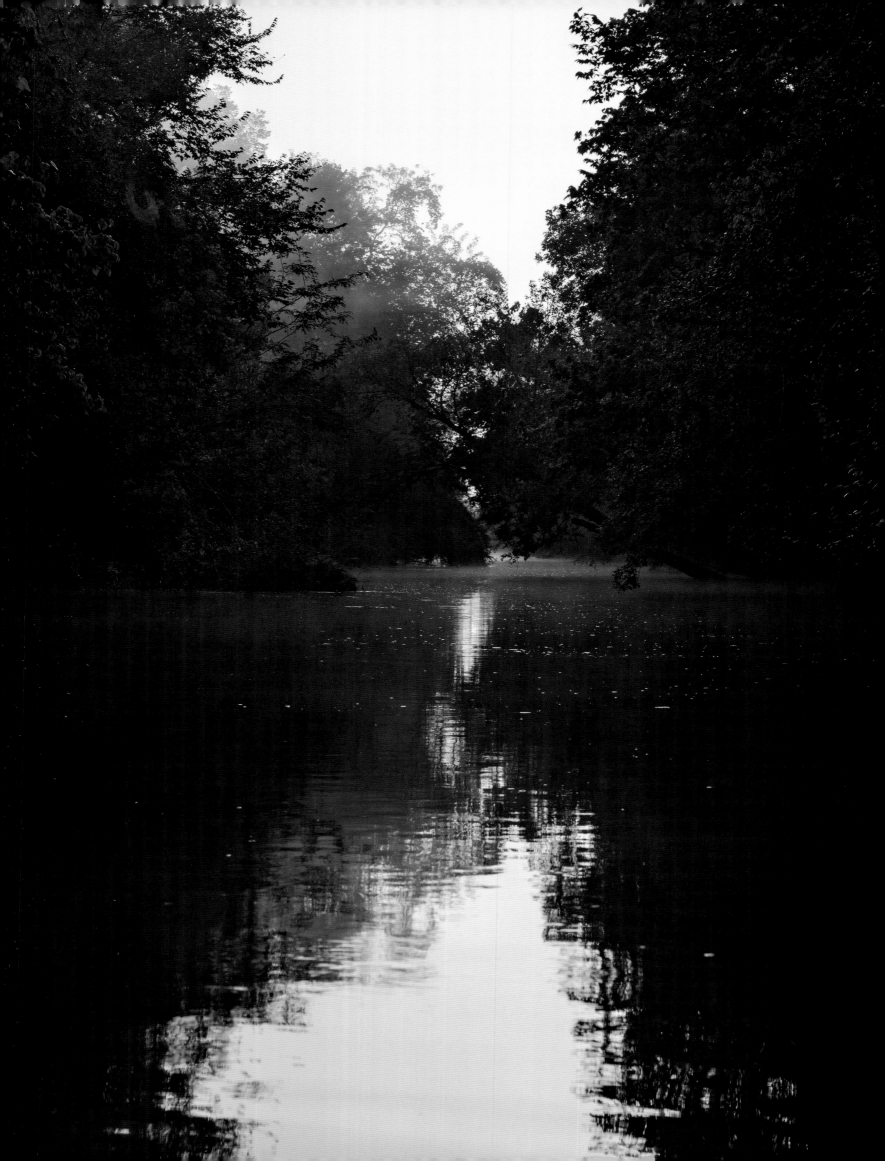

Louisiana Wild

Projects of The Nature Conservancy in Louisiana

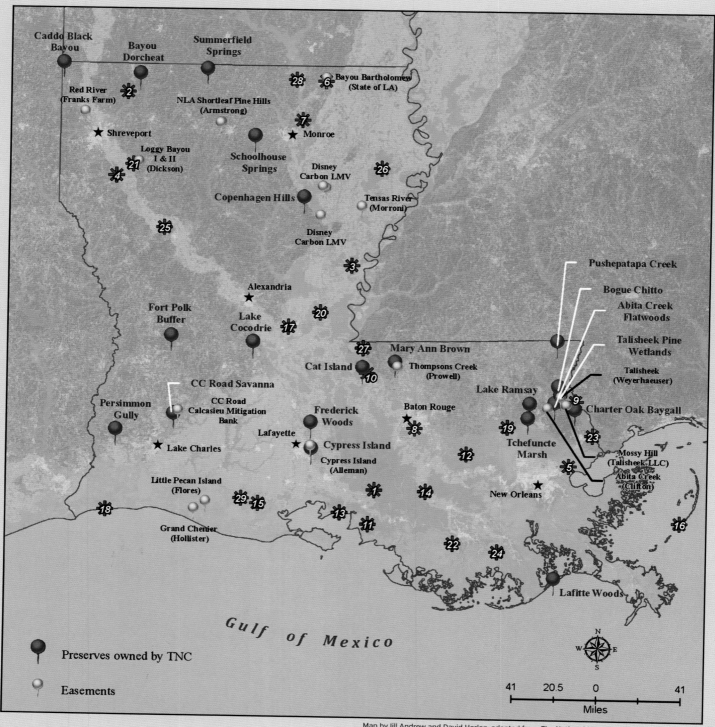

Preserves owned by TNC

Easements

Gulf of Mexico

41 20.5 0 41
Miles

Map by Jill Andrew and David Harlan, adapted from *The National Map* of the U.S. Geological Survey

COOPERATIVE PROJECTS

1. Attakapas Island WMA (LDWF)
2. Bayou Bodcau WMA (COE)
3. Bayou Cocodrie NRW (FWS)
4. Bayou Pierre WMA (LDWF)
5. Bayou Sauvage NWR (LDWF)
6. Ben Lilly Conservation Area (LDWF)
7. Black Bayou Lake NWR (FWS)
8. Bluebonnet Swamp (BREC)
9. Bogue Chitto NWR (FWS)
10. Cat Island NWR (FWS)

11. CIAP Bayou Sale (CPRA)
12. CIAP Blind River (CPRA)
13. CIAP Cote Blanche Island (CPRA)
14. CIAP Hard Times Plantation (CPRA)
15. CIAP Outside Island (CPRA)
16. Curlew Island (LDWF/State Lands)
17. Grand Cote NWR (FWS)
18. Holleyman-Sheely (BR Audubon)
19. Joyce WMA (LDWF)
20. Lake Ophelia NWR (FWS)

21. Loggy Bayou WMA (LDWF)
22. Mandalay NWR (FWS)
23. Pearl River WMA (LDWF; White Kitchen)
24. Pointe Aux Chenes WMA (LDWF)
25. Red River NWR (FWS)
26. Tensas NWR (FWS)
27. Tunica Hills WMA (LDWF)
28. Upper Ouachita NWR (FWS)
29. White Lake Conservation Area (LDWF)

ABBREVIATIONS:

BR Audubon: Baton Rouge Audubon Society
BREC: Recreation and Park Commission for the Parish of East Baton Rouge

CIAP: Coastal Impact Assistance Program
COE: U.S. Army Corps of Engineers
CPRA: Coastal Protection and Restoration Authority
FWS: U.S. Fish and Wildlife Service

LDWF: Louisiana Department of Wildlife and Fisheries
NWR: National Wildlife Refuge
TPL: Trust for Public Land
WMA: Wildlife Management Area

Introduction

A praying mantis poses on a prairie blazing star.

When I was younger, I thought you could only love a person, while a thing, an animal, or a concept you could simply like. Now I see the misjudgment in those thoughts. Today, among other things, I love my dog and I love nature. Nature. It's in my bones, my brain, and throughout my soul. Nature has remained with me and been my joy for all my intelligent life.

Sue—my wife, Sherpa, researcher, equipment planner, and sidekick extraordinaire on this book project—has always enjoyed walks in the woods or paddles on a river. But now after a year in the field she genuinely notices nature. Take, for instance, a pair of bluebird parents we heard squawking loudly above their nest. It was not just noise in the woods but something happening. It turns out a Texas rat snake was lurking nearby doing what he does best, looking for eggs and mice. Hunger drives the snake to the nest. The ability to climb, camouflage, and move with stealth helps that snake satiate his hunger. Four eggs, many nests, and renesting help the bluebird continue its existence. All parts of nature. Some violent, all wonderful.

Nature is enjoyed deeply by some people, it's totally ignored by others, and the majority of human beings probably lie in between. You do not have to know why a bird chirps in an excited way or whether a cherrybark oak tree has simple leaves or leaflets, but we should all know how close our good and productive life is tied to our natural world.

The same is as true of our love for our planet and our natural environment as it is for our love of other people. When we come to understand the tremendous value of our emotional connection to everything else on this earth, we can begin to make this a better place for all living things. In the process, we help ourselves.

When Keith Ouchley, Don McDowell, and I sat down and conceived this project, I felt like a dog in a butcher shop. To crisscross the state visiting more than 60 properties The Nature Conservancy (TNC) owns or has helped other organizations obtain is about the best assignment a natural history photographer could ask for. There is no Katrina or oil spill involved in this, only positive projects and purchases by TNC to protect and restore native habitats to Louisiana—the same mission it has worldwide.

The goals in these properties vary. They are located in 33 different parishes. Less than a mile from Arkansas and Texas lies Caddo Bayou Black Preserve, purchased as the only refuge for rare plants that grow in xeric sandy soil. Lafitte Woods on Grand Isle is the smallest in size of TNC properties but one of the biggest in importance—to the birds, the coast, and us alike. Spring bird migration in Grand Isle and knee-knocking fall colors at Caddo Bayou Black are two vivid reminders of TNC's value in Louisiana. These two refuges are about as far apart in looks and distance as you can get in Louisiana. The crow would fly 348 miles and a car would cover 424 miles between the two. In between are 60-plus properties that TNC owns or helped

with in some way, covering nearly 350,000 acres. These are diverse habitats, in size, in soil, in weather conditions, in vegetation, in wildlife, and in reason to be set aside. TNC covers the state. Protecting nature . . . preserving life.

Restored oyster reefs follow the Louisiana coast in Vermilion, St. Bernard, and Jefferson Parishes. Leaving the coast, there are marshes, hardwood bottomlands, prairies, piney woods, and longleaf pine wetlands with carnivorous plants. All different, all important. Some are near pristine, and many others are a work in progress to restore them as much as possible to the way they were. Living as we do in the man-altered conglomeration of apartments, condos, houses, and subdivisions among shopping centers, highways, and buildings, it is so important to have these natural places. We need a little bit of both natural and manmade to keep this planet, our home, in shape for all of us to live better, happier, and healthier lives.

The Nature Conservancy protects lands in many ways. I hope you can see in these pages how important its work is.

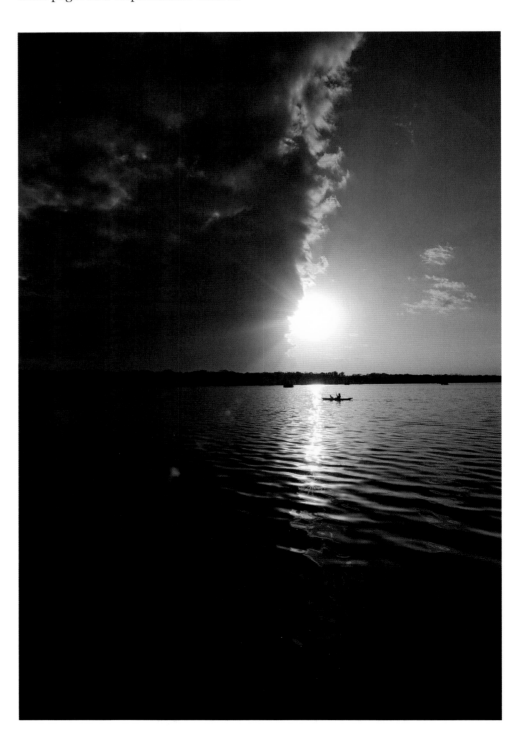

A lone kayak skirts storm clouds at sunset on Lake Martin.

Facing page: Sue Lockwood and Chris Rice inspect huge bald cypress and tupelo trees that house two species of bats in the summer months. Upper Ouachita NWR.

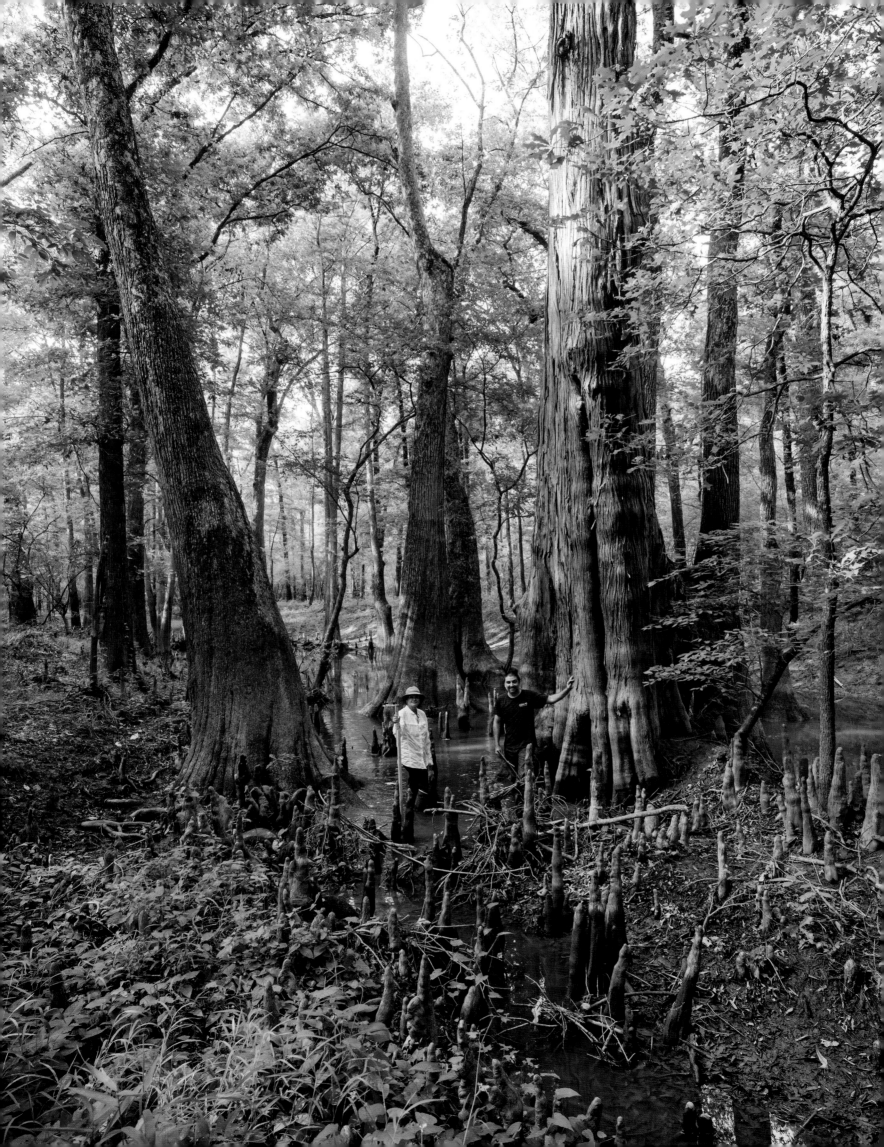

Copenhagen Hills

997 acres, Caldwell Parish

West Gulf Coastal Plain

Keith Ouchley, director of the Louisiana and Mississippi chapters of The Nature Conservancy, had been telling me about the plant varieties at Copenhagen Hills for years and inviting me to visit. The Hills, in fact, has the largest diversity of woody plants in Louisiana, highlighted in the late summer by a spectacular show of purple coneflowers. Don McDowell, past director of development for TNC, told me to be ready for something very different when I visited. He said excitedly, "The first time I saw Copenhagen Hills was on an early fall morning, and when shafts of sunlight hit the prairie grass, I was totally surprised. It was like something you would see in the West or Midwest." I can't figure out why I didn't get here until this project, but decided it should definitely be the place to get my first photograph for this book.

Sue and I met Ronnie Ulmer at a convenience store in Columbia, Louisiana, to be let in the gate for a quick tour of these hilly 997 acres overlooking the Ouachita River. Ronnie is with the Northeast Louisiana Office of TNC, and I was warned by Don to watch out for his Ronnie-isms. Sure enough, I heard one right off the bat when he said, "You can see more kinds of nature here with the fewest steps than anywhere else in Louisiana."

Louisiana's forty-ninth governor, John McKeithen, whose family sold this unique property to TNC in 2001, once enjoyed using the hunting camp here. Ronnie told us that when he had a tough political problem to solve, the governor would sit on the porch looking 200 feet down to the river. Sue and I agreed that you could do some serious contemplating on this porch. We got directions to the various special spots and headed off to see the purple coneflower, *Echinacea purpurea,* by hiking down a four-wheeler trail to Big John's Prairie. The flower stood out as the best hue

Purple coneflowers bloom by the dozens in the waist-high savanna grasses at Copenhagen Hills, a midsummer occurrence.

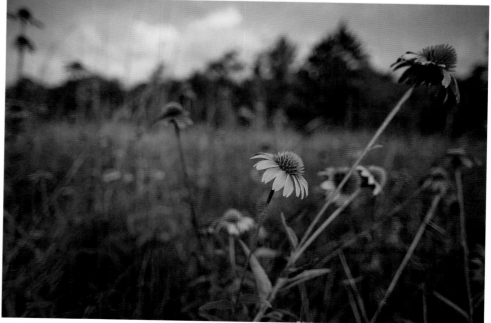

The xeric soils of Copenhagen Hills are sometimes worn bare by erosion. Here, a yellow puff flower hangs on for dear life.

Overleaf: The little bluestem waves in the winter winds long after the wildflowers have died.

of the prairie. The attractive bloom has a cone-shaped central disk flower that is an orangish-yellow, and the backward reflex petals are more lavender than purple. This set-up makes it an inviting feeding stop for wildlife. Butterflies can sip nectar unencumbered by complex outward-facing petals, and the seeds when ripe are easy pickings for birds. In addition, the roots and other plant parts of flowers in this genus are ground to make echinacea, an herbal remedy for the immune system.

Framing up a small group of the sturdy stalked wildflower, I made my first image and then we turned our attention to the rest of the bluestem-covered prairie. Among the first things we noticed were a few bare spots revealing the cracked, calcareous limey and clay soils interspersed with fragments of oyster shells and a few other sea-going Mollusca. We later found out that in some of the drainage off this hilltop meadow, many more fossil remains of sea creatures have been found, including shark teeth, coral, clamshells, and even bones of an ancient whale. All this was deposited by an ancient sea that covered Louisiana 22 million years ago. Richard Martin, TNC director of forest programs for Louisiana and Mississippi, explained to me that this formation is covered by layers of alluvial and loess soils, but here at Copenhagen Hills a combination of uplift, erosion, and cutting by the Ouachita River has exposed these sediments.

At the edge of the field, similar to the camp porch, there is a steep drop to the river. The Nature Conservancy's web site describes the view as "a most 'un-Louisiana-like' vista—precipitous tree-covered slopes, interspersed with gullies, and dotted with pleasant open prairies." Dogwoods, sugar maples, black gum, white ash, the rare Oglethorpe, and other oaks root into the steep hillside bluff. Throughout the next three seasons I watched this botanical array change to reds and yellows, then a carpet of brown beneath the bare branches, and finally spring bursting out green again, all the while a different set of wildflowers in bloom. On our last visit we joined Rick Jacob, TNC director of conservation forestry, leading Louisiana

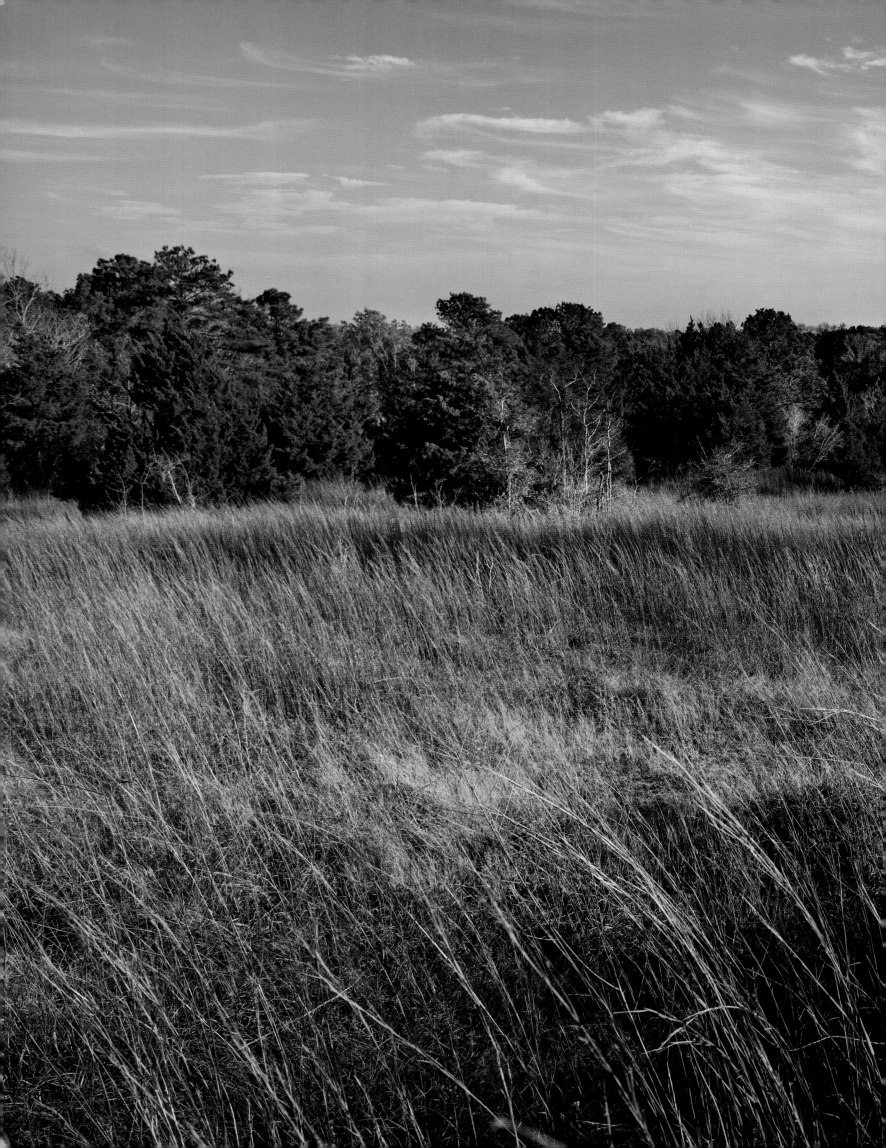

Tech professor Gordon Holly and ten students on a grad-student field trip. The students had good questions, and I was a little surprised to realize how much change for the good has happened for our environment since my college days. To have a place like Copenhagen Hills, to preserve it, to use it for education, and to do some restoration are so important to my home, your home, our home, planet earth.

Above: The yellow of fall comes from sugar maples; these beauties dress the edges of the Copenhagen Hills prairie.

Left: A katydid camouflages itself in green leaves.

Above: A rattan vine twists its way among the sugar maples.

Left: One of the many summer blooms in Copenhagen Hills is the wild bergamot.

9

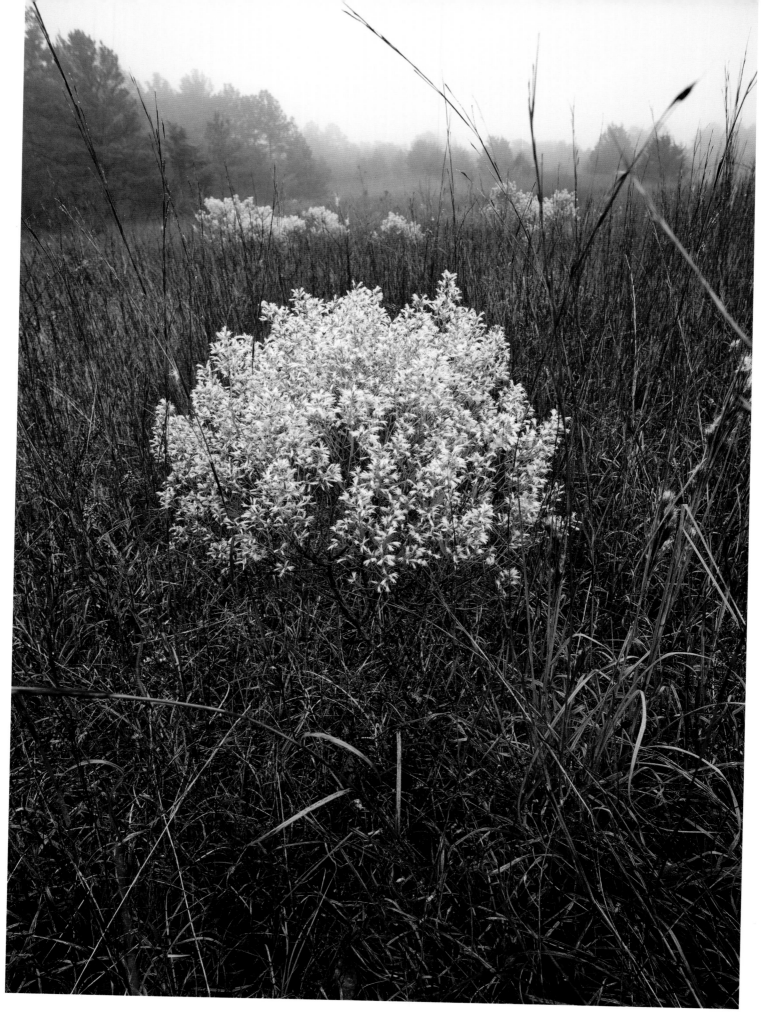

The browns of early winter on the prairie
are brightened by the showy white flowers
of Baccharis.

Cypress Island

9,000 acres, St. Martin Parish

Mississippi River Alluvial Valley

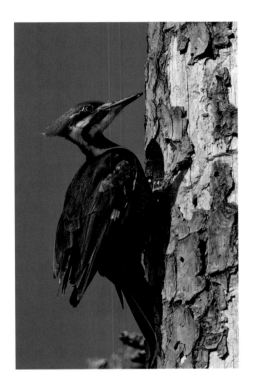

A pileated woodpecker inspects its nest at Cypress Island Preserve.

Most know it as Lake Martin, recently made famous for housing a wading bird rookery of grand proportions. The lake, along with surrounding swamp and hardwood bottomland, has probably done as much as the Atchafalaya Basin and our subsiding coastal marsh to bring wildlife and the environment to the forefront of our minds. Thirteen species of nesting water birds, estimated at 4,225 pairs in 2012, have attracted and educated people from all over the world. Resident bird-watcher Danny Dobbs has a total of 240 birds on his Lake Martin checklist. This swampland lake is a wildlife bonanza. The birds brought the tourists, and the alligators keep them coming.

Since 1994, TNC has been acquiring land around this lake, the amount now totaling over 9,000 acres. Texaco donated the first two parcels, the bulk of the preserve. Texaco named it Cypress Island Field after a nearby town of the same name. The town's name came from the surrounding geology, which created something of an island in the prairie wetlands. Since it is just a bit higher and dryer, the land was habitable to settlers. The area is one of the premier properties that TNC calls "platform preserves"—properties ideally suited as demonstration projects for habitat protection and restoration. Samuel H. Lockett, in his 1869 topographical survey of Louisiana, referred to the region and the lake by the names we use today. He wrote, "Lake Martin is quite a pretty sheet of water, whose firm banks are fringed with tall cypress and gum trees. It abounds with the usual variety of southern fishes." The bald cypress and tupelo still grow around and in the lake. One of my favorite stands surrounds the rookery zone, where the giant trees are stately, inspiring, and photogenic.

My first visit to this wonderful wildlife preserve was in the early '90s, when I came to see the nesting birds. I was told that they were easy to see and boy, howdy, that they were. My rookery experiences in the Atchafalaya Basin were epic adventures, all by boat, usually a canoe, and through tangles of flooded forest and over copious amounts of navigational nightmares, one being the jams of water hyacinth. I wanted to see this place with nesting spoonbills and egrets that were so close to a good gravel road. At dawn one April morning, I stopped 35 yards from both of these iconic species as they were building nests and courting. Just ahead of me was a dusty, black Mercedes sedan. At its open door was a middle-aged man in a full business suit peering into a Nikon attached to a 600 mm lens on a sturdy tripod. My guess is that he was a Lafayette lawyer out for a few shots before heading back to his office, a 20-minute trip to a downtown job.

So much for my thought that only the adventurous should be able to see something this special. I quickly realized this was a way to broadcast how important the remaining wild places on planet earth are, especially those with abundant life like this one. That is exactly what TNC is doing with Cypress Island Preserve.

Sunrises and sunsets can be good or great, and who would turn down a good

one? On a muggy August morning, Sue and I put our boat in Lake Martin before dawn and headed for a spot in the northwest corner to find the longest expanse of lake to reflect the sunrise as much as possible. We selected a location with some bald cypress, American lotus in bloom, and a fallen tree. The scene had a decent foreground with a good sunrise. The next morning we launched my bateau to try to improve on the shot, and we journeyed near yesterday's location. We set up for what appeared to be a great sunrise. A lone bald cypress covered with dangling Spanish moss and a few lotuses scattered about created a very special scene. The increasing light slowly peeled back the darkness. Night creatures gradually disappeared as the darkness turned to daylight. The amphibians and insects hushed while the waking birds brought an opera to the air with the squawks of the little blue herons, the sweet song of the prothonotary warbler, the loud raucous call of the pileated woodpecker, and the whoosh and flap of cormorants, herons, and other big birds landing in the treetops. It was a still morning, a flat calm lake, ripples coming only from our slight movements in the bateau.

My lens first captured silhouettes of the tree, looking almost black and white in tone. The light bloomed into yellows, oranges, and peachy pinks as the sun started its daily climb. Then the red ball of fire topped the bald cypress across the lake, and the colors exploded into sunrise. I never get tired of this wonderful early morning experience as a new day dawns. Every sunrise is different. I have always preferred sunrises to sunsets, as they push aside the darkness to reveal the ever-changing cinema of life and the beginning of the new day. Most folks know what to expect with a sunset. Of course they go from full broad daylight, which is quite harsh in the summer, to nicer subdued light, to the darkening glow of pre-sunset, to the set itself. You have a better knowledge of what's coming, whereas a sunrise is more often a surprise, and surprises are good.

The day was bright. Everything green. Not quite the fresh green of spring, but green enough to be beautiful. Even the water with its shimmering reflections looked to be a shade of green. Accents here and there were the creamy white of the lotus flowers with their golden yellow inner parts, the red of a cardinal, the orange of the trumpet creeper, the iridescent blue of the dragonflies, the flashy yellow of the prothonotary, the brown of the osprey's back, and the black of thousands of newly hatched midges. So many of the tiny insects were on the lotus flowers that it looked like they had freckles.

The big picture at this preserve is brilliant, just as the little habitats are fascinating. One microhabitat I find spellbinding is a water droplet on the top of a lotus leaf. Can lotus leaves shed water? Yes they can, and it's amazing. Droplets slide across this largest of North American aquatic leaves like hot grease on a skillet. Some droplets linger by gravity on a depression of the massive leaf. In that droplet with a close-up lens you can see life, a tiny global world. With a microscope you can see even more. These floating orbs are tough, making me wonder if Native Americans used them for building materials. We watched the variety of miniature life forms on these leaves for hours.

I spot a leaf with a minnow trapped and flopping around in a bigger droplet of water. It's perfect prey for the little blue herons, which are feeding as they walk so easily atop this microhabitat. Midges, insect larvae, and minnows attract birds above and fish below. The picture gets larger and grander as that drop of water expands into bigger and bigger habitats up to planet earth and all of us.

A month later, exploring the Ruth Canal and connecting sloughs on the northern edge of Lake Martin, we drift away from the rising sun. We pass soldier spiders high-webbed in the trees. The spiders, so acrobatic and with wind-driven maneu-

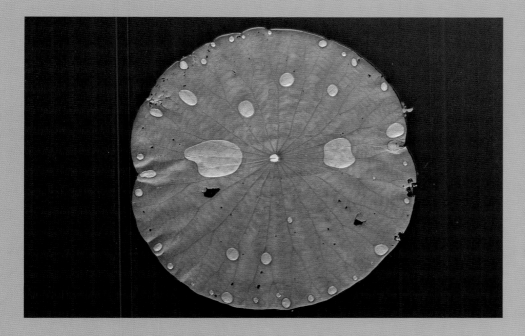

Life is small but plentiful on the American lotus plant at Lake Martin. A drop of water (*bottom*) teems with life in miniature. Midges cover the showerhead-shaped seedpod of this plant (*middle*). Native Americans ate the seeds, about twenty per pod.

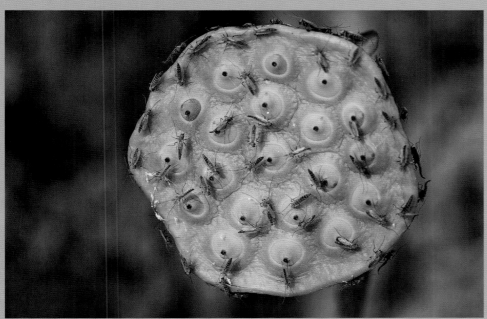

Lovely American lotus covers about 10 percent of Lake Martin's open water. Its creamy white petals frame the golden orange seedpod, brightening the summer landscape.

The vibrant red samaras (winged seeds) of the swamp red maple announce spring, the first color to emerge from the winter gray.

vers, make webs from tree to tree across the canal, 25 feet above the water. These are the same spiders that make webs about face high in the late summer and fall. Yes, the ones with strong, sticky webs that you hate to get on your face but love to see filled with the mosquitoes they catch. How can the spider fly on a line of silk 40 feet across the water to make a web so high? Well, that's nature, amazing nature. I see the waning gibbous moon above one of the spiders, a hard shot to capture with my camera because of so much contrast. I imagine that spider with Neil Armstrong heading for the moon. Back to earth, I see a wasp nest dangling from a tree limb on the high spoil bank. I navigate carefully to keep Sue from being stung.

Everything is still green. It is too harsh to call it a sadder green, maybe a paler shade. The leaves have withstood wind and rain and the heat of the long days of summer. They look tougher, rougher, worn, and pale because they are middle-aged in human terms. On each side they are still dense, hiding the distant forest and the creatures within from our view.

Persimmon, box elder, hackberry, honey locust, bald cypress, water tupelo, cottonwood, sycamore, mulberry, and the exotic tallow tree dress the tall banks. Below it is dark and reflective, and above we see a slight bit of haze or morning fog in the quickly brightening skies. The persimmon is loaded with its tart fruit and the box elder crowded with its helicopter-winged seeds. It's quiet except for the chatter of squirrels and the occasional bird singing. Then *boom, boom, boom!* The teal hunters in Lake Martin fire away. Hunting is one of the numerous ways to experience Cypress Island. Add to that fishing, boating, hiking, bird-watching, nature photography, swamp tours, and education. Then you can begin to understand what an unbelievable planet ours is.

It's a cloudless morning, and the haze disappears quickly. I see the prothonotary warbler and hear the multifaceted call of the barred owl. A water snake falls into the bayou, but not close to our drifting bateau, giving support to my theory that snakes falling into boats fishing the bayou banks are old wives' tales.

On a cold and windy February day, with clouds coming and going, I was driving on the gravel road around the lake, hoping to see a great egret with feathery plumes displayed in a fan, enticing a mate to help build a nest. But none are there, which I say is logical. This winter has been extremely harsh, with numerous freezes and two snows, which could be holding back the breeding urge by a few weeks. My mind worries, "What if they don't come back like in 2006?" Charles Bush, nature photog-

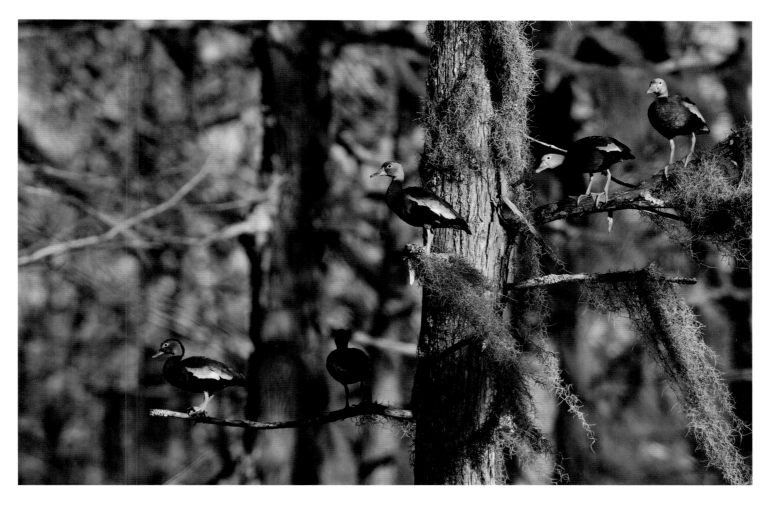

Black-bellied whistling ducks are one of two duck species that hang out in trees.

rapher, told me about March 24, 2006, when he visited the lake and saw the birds nesting in numbers equal to or better than his previous four years of frequent visits. Two days later he got an email from a friend saying the birds were gone. Completely gone. The roseate spoonbills and great egrets that had their nests near the road left overnight.

Speculation brought theories; blame was tossed around and worries deepened. Richard Martin, who before TNC was with the Natural Heritage Program of the Louisiana Department of Wildlife and Fisheries (LDWF), coauthored with Gary Lester a survey of wading birds across the state. They collected information from many sources and came up with eleven possibilities of why the birds left. Richard pared his list to three: disturbance by raccoons, nighttime disturbance by boats, and a landscape-scale decline in habitat quality.

Many blamed the pressure from a constant stream of bird enthusiasts. It is hard to believe that overnight this could make the birds abandon nests with eggs. There could have been some deliberate human disturbances. Some say spotlights and Roman candles were involved. We may never know for sure. Since estimates were first made in 1989, there have been as many as 30,000 pairs to as few as 500 some years, according to data compiled by LDWF ornithologist Michael Seymour and others.

Not all the birds left in 2006. Many in the interior of the rookery completed their nesting. Since then, the rookery has built back up to a number hovering around 4,000 pairs of nesting birds. The good news is that most of the wading and water birds that use the rookery are in good shape and increasing in numbers throughout their range. The bird that most wildlife enthusiasts come to see at Cypress Island is the roseate spoonbill—a beautiful creature, colored reddish pink and white with a spatulated bill. The spoonbill was nesting again last year. This cherished bird can

now be seen in crawfish ponds near Shreveport, in the marshes around Lake Maurepas, and in the other two corners of Louisiana. In the early 1970s you had to go to a few remote sites in Cameron Parish to see the pink bird. It is here to stay, thanks to preserves like this one.

Colonial water birds move, and as Richard Martin indicated, they can ruin their own habitat temporarily with large numbers of droppings. As long as we have enough wetlands with trees and shrubs as nesting platforms with alligators below, there will be birds. And yes, the rookeries have and need alligators. I guess you can call it a symbiotic relationship. The alligators get a few eggs that drop or weakling baby chicks that fall from the nest or surrounding limbs. In return for this modest sacrifice, the birds get 24-hour alligator security service, which keeps raccoons and other swimming predators away from the nests.

Between 1,200 and 1,800 American alligators are estimated to inhabit this 9,000-acre preserve. You can see a gator here about any time of the year except on the coldest days. Spring is one of the best times to spot them. Take a kayak and go boating, join a swamp tour, or just walk or drive along the edge of the lake, and you will see the Louisiana state reptile. Sue and I were out one day in the bateau, seeing an alligator on every floating log in the lake. The sun was shining hot; the water was cold. and the water lizards were out to catch rays. Soon I could not think of any other way to photograph one on a log, so I switched to movie mode. In the digital world, you can do so much with your cameras. Sue was at the helm, and she cut the motor about 25 yards from a nice-sized gator sunning itself. The boat's momentum would carry us a few feet, but the wind was brisk and we continued to drift toward the big gator. Getting too close, Sue was about to fire up the outboard while I was wondering if I ought to get off the bow, but I kept the camera running. The alligator was thinking something similar and did a 180-degree turn, hit the water with a big splash, and added a tail slap to make sure my GoPro and I got wet. Luckily the camera is waterproof.

As a platform preserve, Cypress Island has a visitor center, built in 2006 to mimic an old plantation-style structure. It houses exhibits and a changing photo gallery, which is sometimes set up as a contest sponsored by refuge manager Kacy King. Kacy tells me that she has 125 volunteers on her list. Of those, 20 are trained in the local natural history and 10 are regular helpers. I met Suzie Smith after a summer-time kayak adventure with 19 hardy paddlers. Suzie is a weekend volunteer, and when asked what she likes about her job, she said, "Meeting the people. You know we have had visitors from 50 countries." That's a lot for a little place off the beaten track, but in fact it is a huge 9,000 acres of value to our natural world.

On that paddle day, we had a rainbow of boat colors and only two were the same shape. Since it was alligator nesting season we did not see many of the reptiles, but good birds were everywhere. A green-backed heron with three fledgling chicks was on one of the duck blinds. Barred owls and osprey were bird-watcher treats. Osprey are ever present. Once in the early spring, I was watching a nest hole in a bald cypress that a pileated woodpecker had entered when Sue said, "Look up there." It was an osprey perched on the top of the tree with a sac-au-lait in its talons. As you may or may not know, that French term, *sac-au-lait,* meaning "sack of milk," is actually a local name for the fish that many people in other parts of America know as a crappie or white perch. Back lit and near sunset, the bird was only a silhouette in my lens until I slowly moved the boat to the other side for the golden light.

Another morning at Cypress Island we sat quietly in a buttonbush thicket watching a flock of black-bellied whistling ducks, *Dendrocygna autumnalis,* standing on their long legs in a bald cypress tree. This is not a typical waterfowl scene, for it's

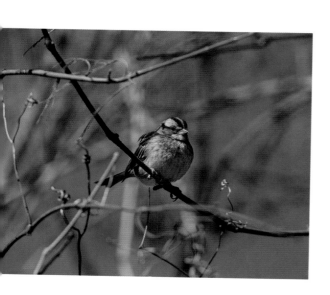

White-throated sparrow.

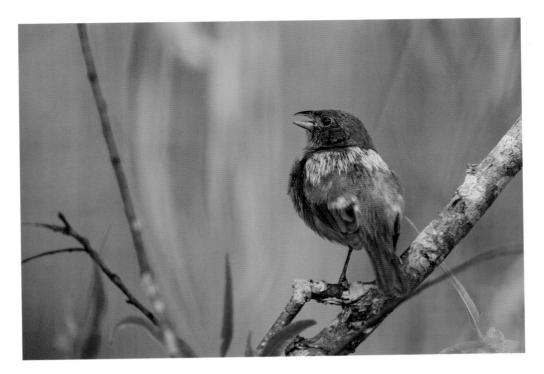

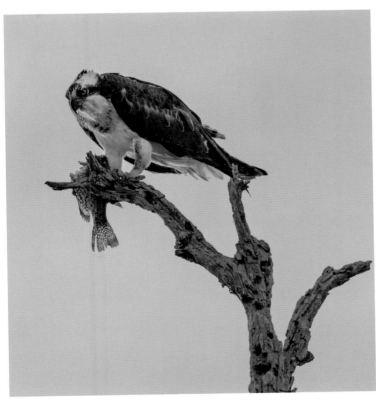

Clockwise from top: The painted bunting (the "Oh my god bird"); a red-shouldered hawk; the red-bellied woodpecker; an osprey eating a sac-au-lait.

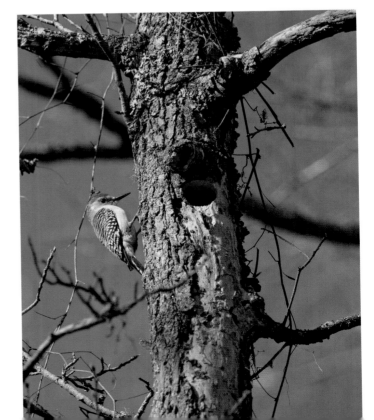

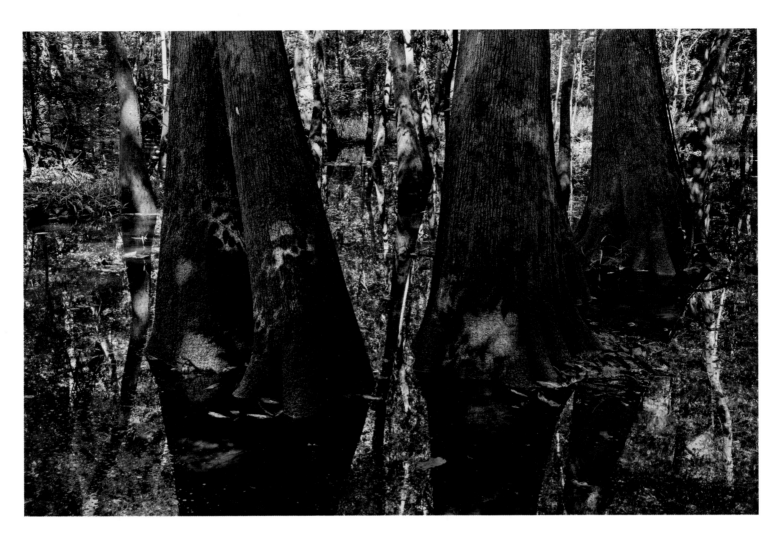

"Shadowshine" is the shimmering light reflected off water onto the bark of a tree. Video shows it better.

Facing page: Early morning in the swamp, the favorite hour of photographers and fishermen.

one of the few ducks that rests and nests in trees. Formerly, it was called the black-bellied tree duck because of its affinity for trees. Its gray face, with a distinct white eye ring next to its red bill, complements its brown and black body with a bright white wing patch, creating an appearance that is almost comical. They nest here in the preserve, both in tree cavities and on the floating marsh plants. They will surprise you with their high-pitched whistle when they wing by. In addition to all the regular wintering ducks, we observed a lone female white-winged scoter, *Melanitta fusca,* who hung out by a set of 75 duck decoys for a couple of weeks. She must have been real lonely. If you are working on a so-called "big year" in birding, then Cypress Island is a good place to come. For the plant lover, the wetlands surrounding the lake have a hybrid of the Louisiana iris that blooms in three colors in one area. You can see the typical purple, the deep reddish purple, and the coppery colored flowers blooming next to each other.

My favorite day at Cypress Island was one time in the month of March. With a cold front coming, sunrise was good, but it clouded up quickly with those steel blue-gray tones, my favorite natural color. I had my big lens out, hoping to get close to some migrating songbirds. A few myrtle warblers were trying to be helpful when I glanced toward the nearby bald cypress, covered heavily in Spanish moss. A hole had opened to the east, letting a shaft of dazzling rays decorate the trees. Light was bouncing crazily off the mostly cloudy skies and the dark, reflective water. Awesome golds, silver gray, steel blue, and shiny brown shimmered in the sky over the rippling blue and touch of green below. It was only for a moment, but that image is captured in my mind forever and fortunately on one of my Nikons. When you come to visit this special place, come early or stay late. You will be incredibly moved when you soak in the scene in the breathtaking moments of morning or evening low light.

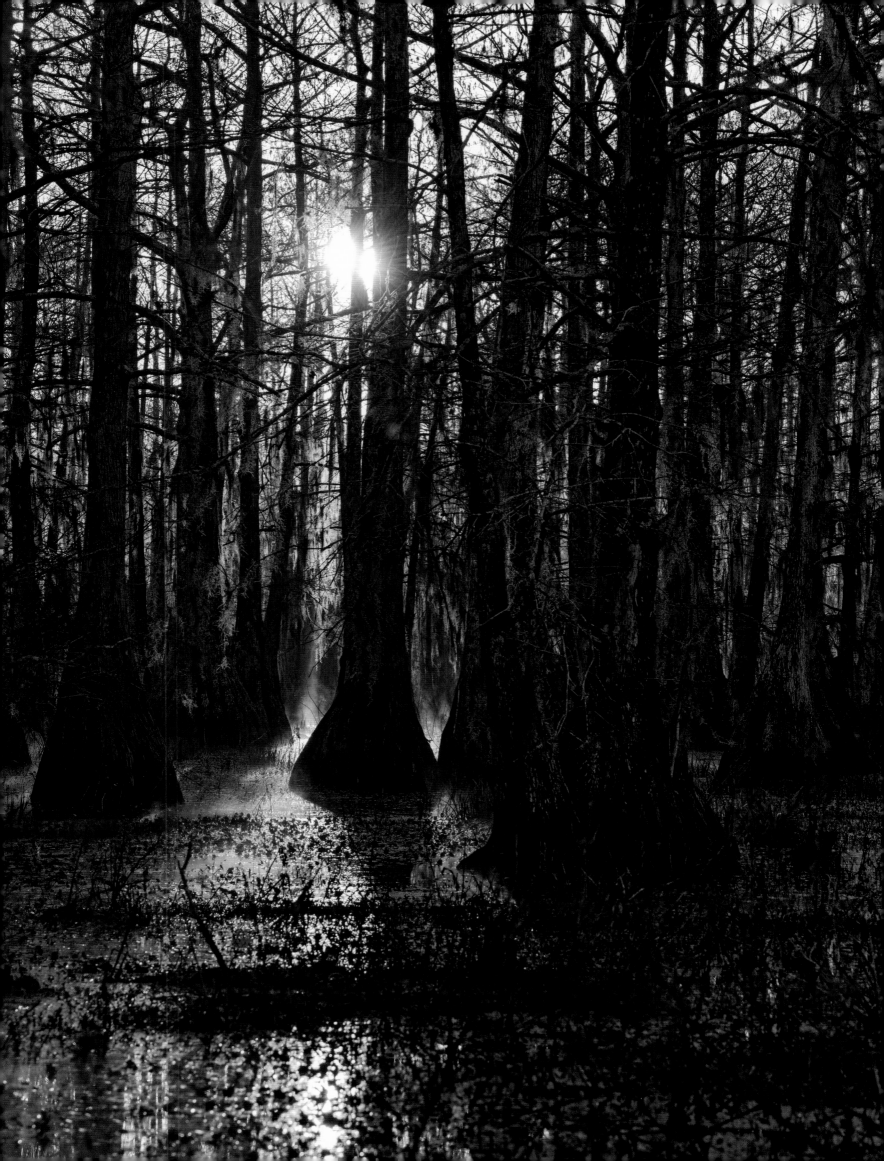

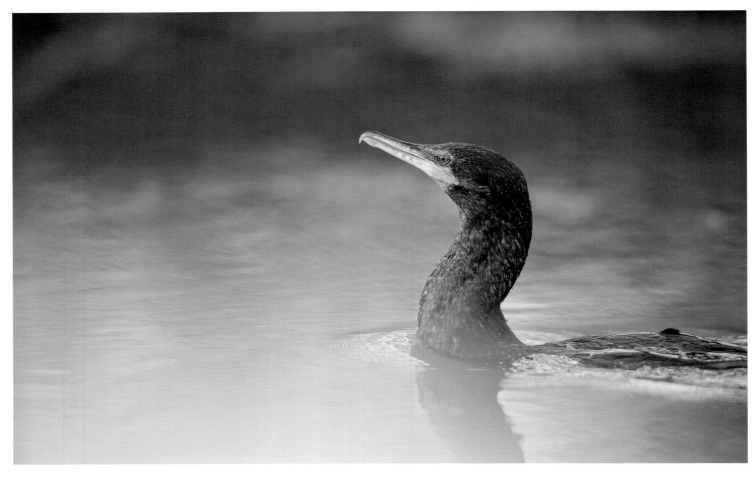

Neotropic cormorant.

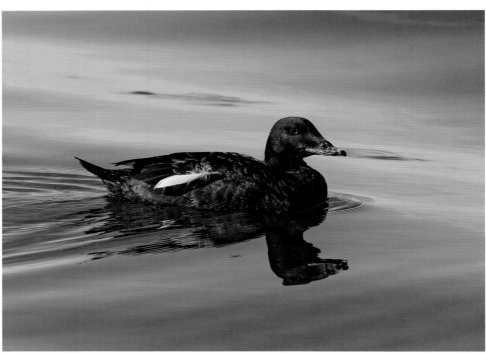

White-winged scoter.

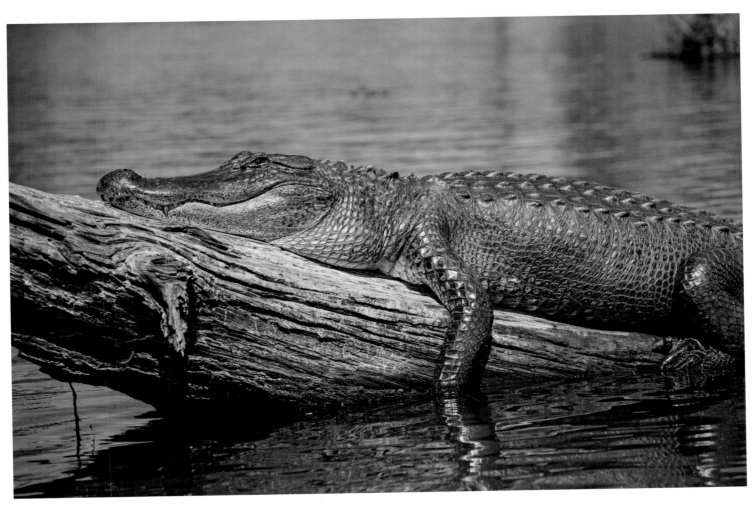

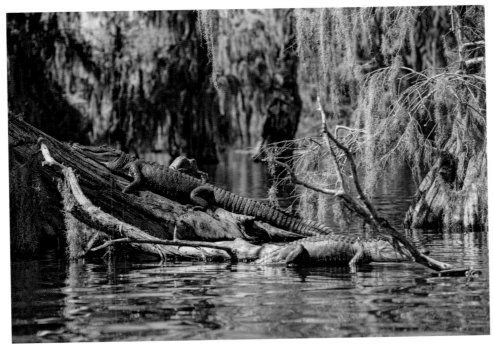

On sunny days in March, when the water is cold, the American alligator and other reptiles of Lake Martin use every log.

Overleaf: An Henri Cartier-Bresson moment. The sun shaft that lit these bald cypress trees lasted only a minute.

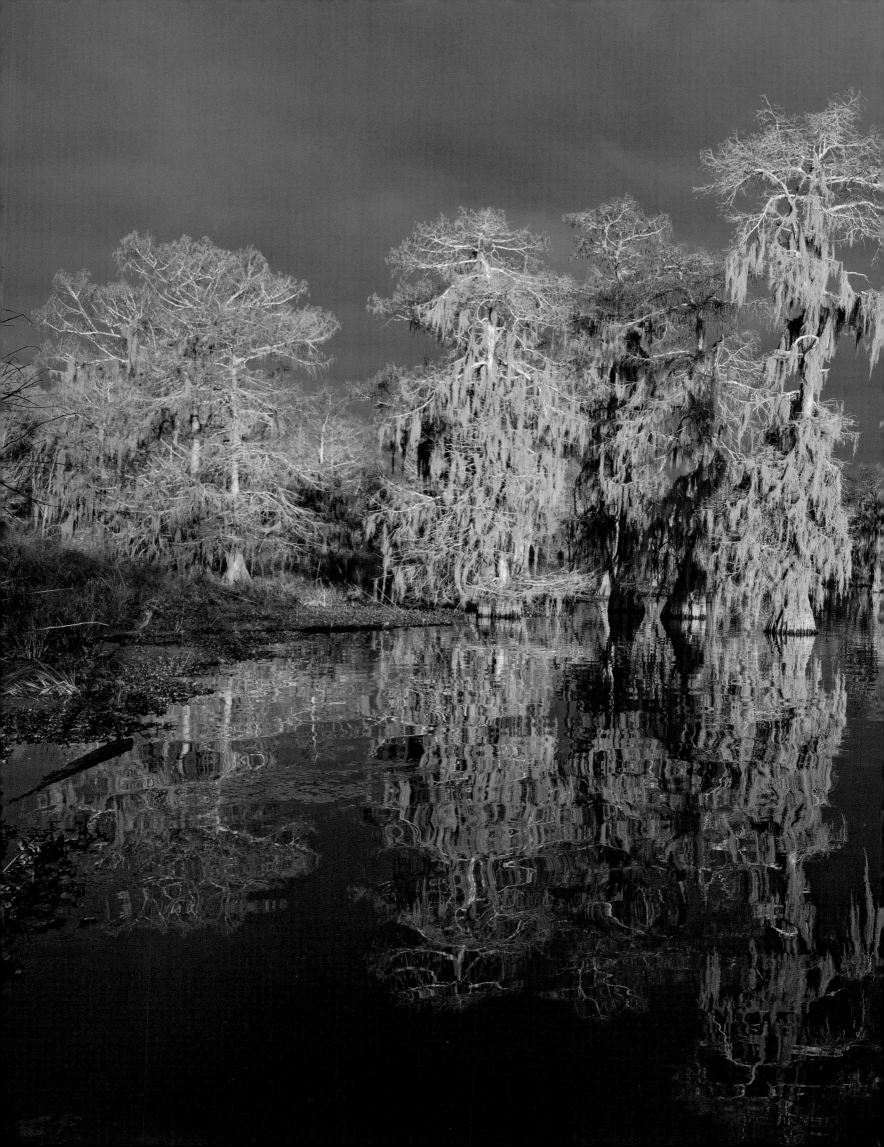

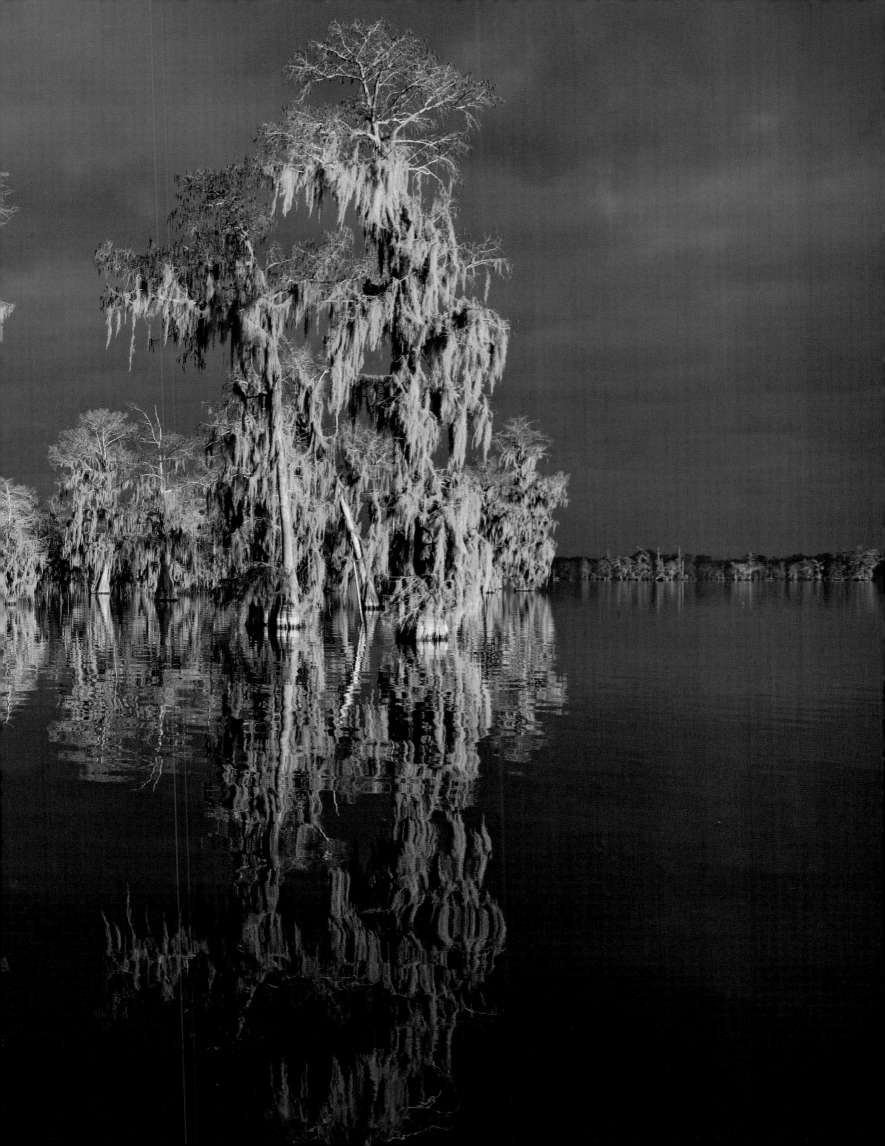

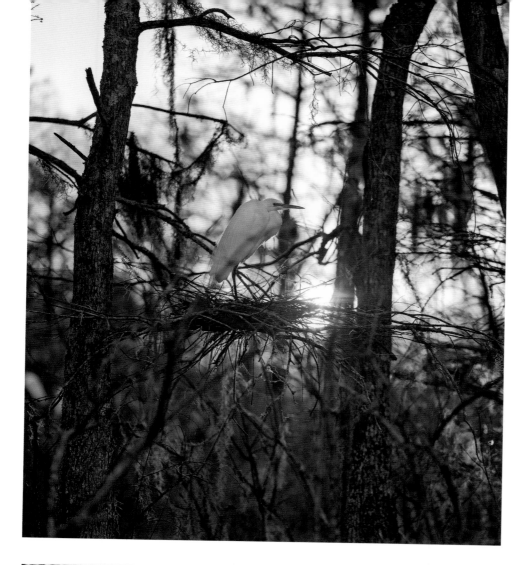

Left: One of the thousands of nesting birds at Lake Martin, a great egret stands tall at its flimsy nest at sunup.

Below: Joseph Scallan paddles his kayak among the bald cypress of the Cypress Island swamp, the new trend to experience wildlife and waterways.

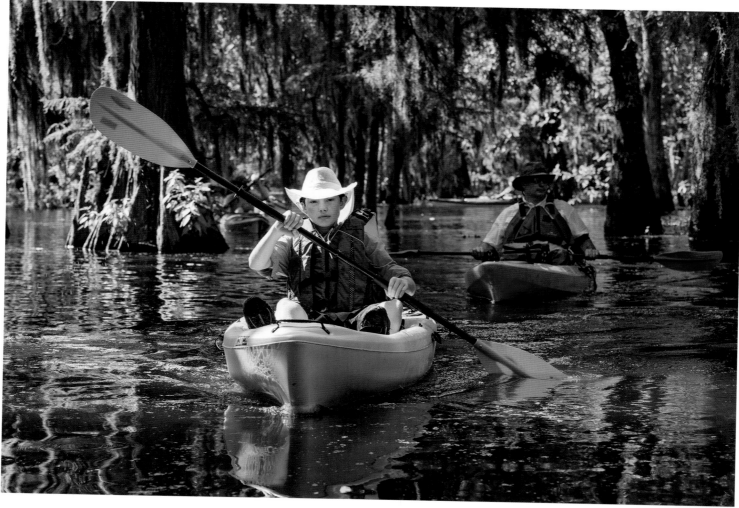

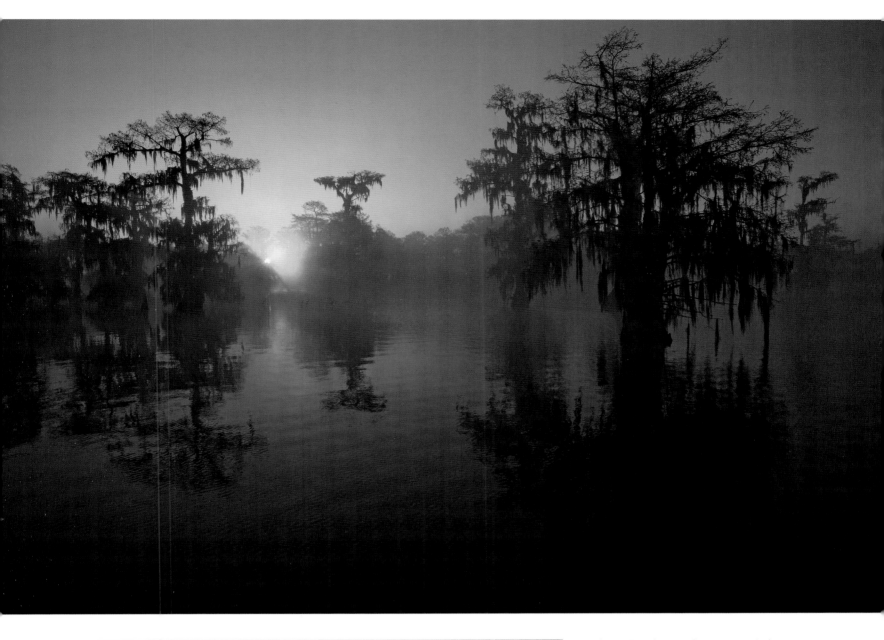

Above: Sunrises and sunsets at Lake Martin are as good as or better than anywhere else.

Left: Maybe rare, surely beautiful, is a patch of Louisiana iris blooming in three colors at Cypress Island platform preserve.

25

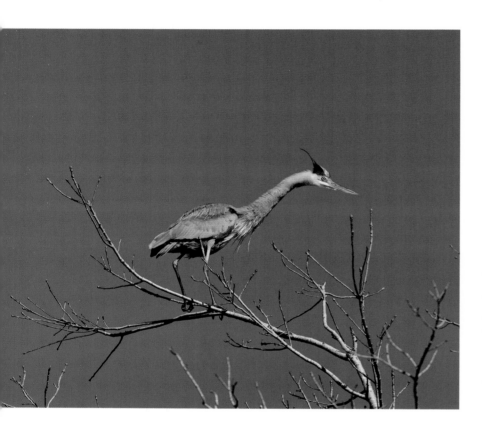

High above the rookery, this great blue heron is perhaps contemplating which limb to use to make its nest. This four-foot bird is the first to start nesting at Lake Martin.

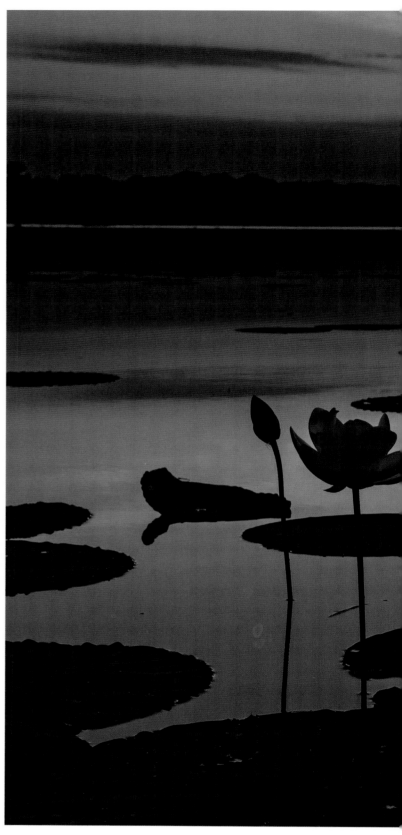

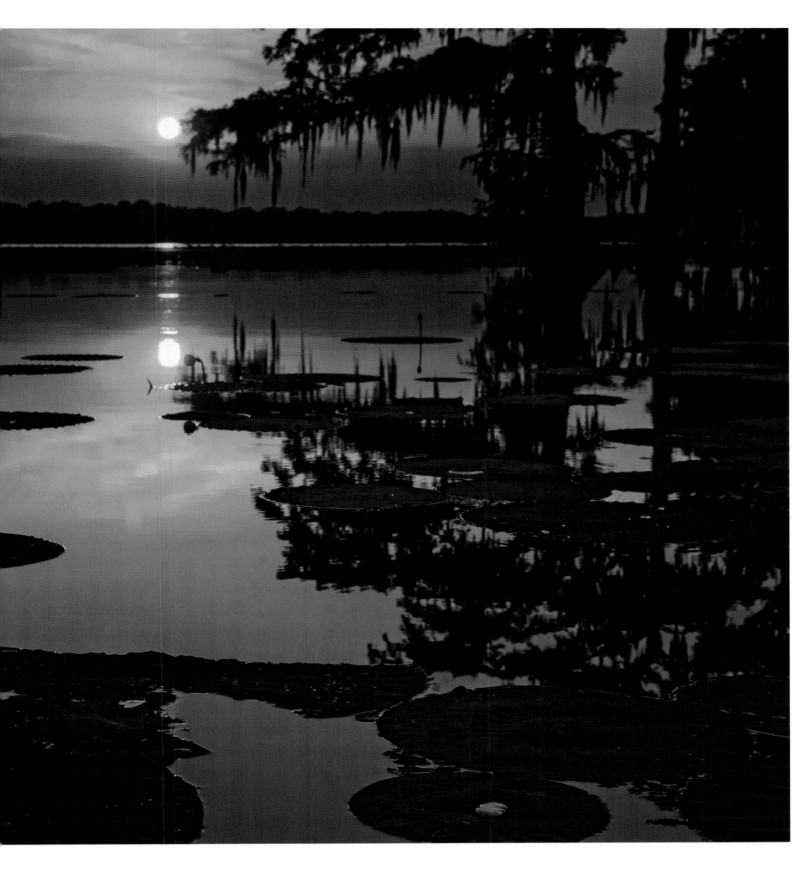

American lotus and bald cypress dress up
one more Lake Martin sunset.

Longleaf Pine

East Gulf Coastal Plain, West Gulf Coastal Plain

Subdued for years by the Smokey the Bear mentality, fire is now one of TNC's most important tools to restore longleaf pine habitat to its former glory. The yellow pitcher plant that burns here (its charred remains, far right) bounces back quickly as seen on page 48.

"Let's get fire on the ground," yells burn boss Bill Rivers, sounding serious but with an elfin grin, as he addresses his crew of five studying their burn maps. All are dressed in fire-resistant Nomex clothing: Bill's shirt is red, while most of the others wear standard yellow jumpsuits. Hard hats and radios, along with backpacks of safety gear, add to their bulk. Alex Entrup, TNC stewardship technician, starts down the firebreak at a rapid walk with drip torch in hand. This device is a gallon-and-a-half canister containing three parts diesel fuel and one part gasoline. It's lighted, pointed nozzle down, and flames flow as a trigger releases the incendiary liquid in a line along the firebreak. The crew wants the burn to go in a planned direction. Weather knowledge helps to accomplish this goal. Wind, temperature, dew point, and humidity are all checked, and if not perfect, the burn is aborted.

The orchestrated fire at Abita Creek Flatwoods Preserve moves across the savanna, usually staying low, with flames that are only about two to four feet high. It runs over the little bluestem grass, a desired species that will grow back quickly. It fries the leaves and burns the stalks of unwanted shrubs such as gallberry and titi. Occasionally, with a gust of wind and some good underbrush, flames jump up the sides of the fire-resistant longleaf pine ten feet or more. That's when a blast of very hot air slaps you in the face. Smoke is dangerous, and the unaccustomed can become disoriented. Obviously, getting lost in a fire is potentially deadly. The map Bill and crew went over shows safe exit routes, firebreaks, and regrouping points. Safety is foremost.

A firebreak can be a road, a bayou, or a newly plowed strip. Sometimes a wind gust or switch blows some hot ash back across the break, starting a wildfire. Sentries on four-wheelers drive this line; they carry a tank of water and portable bags of water with hoselike ends. One culprit of floating sparks is the Japanese climbing fern. This exotic species catches fire, and then a burning top piece breaks off and floats into the surrounding area. The sentries spot it and, like a city fire department, rush to put it out. My cameras saw this close up when I climbed into a deer stand to get a better view and noticed how light and flightworthy ash is. The day's half-done and already my camera needs a good cleaning.

Brush burning is not a man-made idea that arrived with the influx of modern civilization. Nature did it first. In any given area historically, lightning strikes started fires on an average of every one to four years. Longleaf pine and the associated rare flowering plants adapted well to this natural cycle of burning and regrowth. Since ancient times, Native Americans started fires for various reasons, including wanting the succulent young plants to grow.

Bill's hard-working crew starts burning in February and goes on until the combined heat of summer and the flames is too much. TNC restoration ecologist Latimore Smith heads up the planning committee, which has the job of deciding what needs to be burned and when. Manpower and finances are restrictive, but it is remarkable what a bit of fire in the hands of professionals can do. Bill did 33 burns in

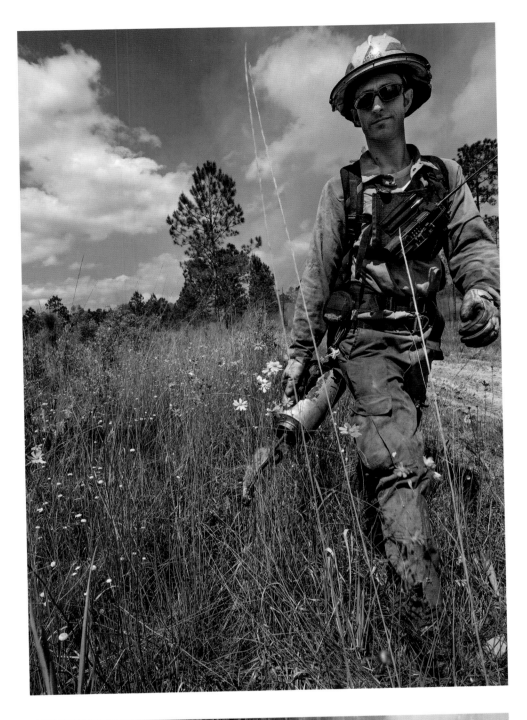

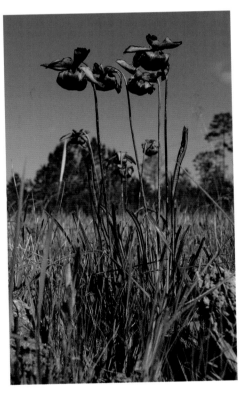

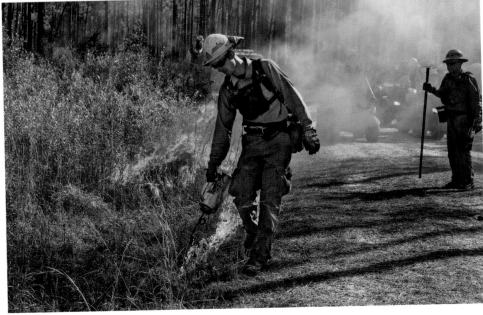

Alex Entrup, with drip torch, starts a controlled burn at Abita Creek (*upper left*) and at Talisheek (*left*). With fireproof clothing and a multitude of safety plans, the dangerous job goes smoothly.

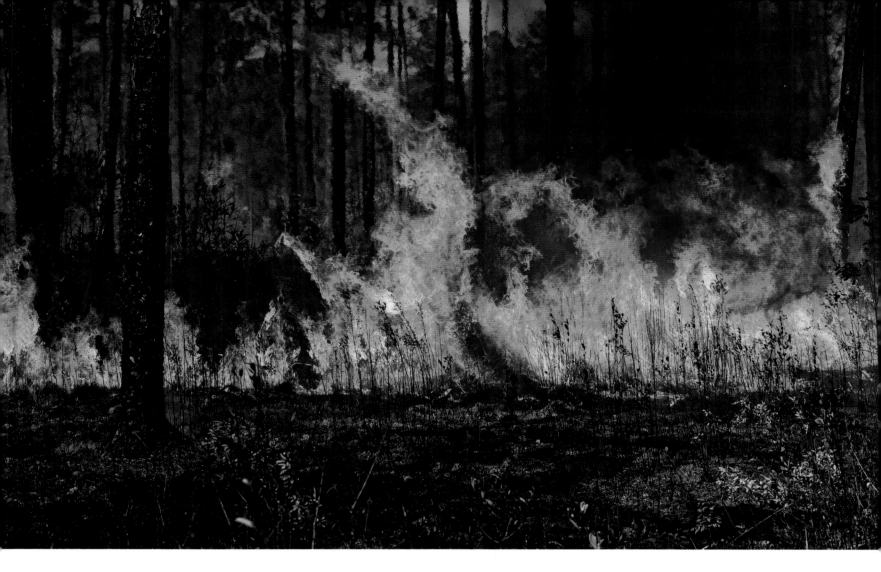

Gusts of wind can briefly turn the flames into a towering inferno through the long-leaf pine (*above*) or next to a firebreak (*right*).

2014, giving a needed bit of "medicine" to 4,300 acres. Fire is nature's medicine in the extreme; longleaf pine habitat needs the prescription of fire.

"The savanna hums with life after a burn," Latimore comments as we walk through stands of pitcher plants, white-topped sedges, and grass pink orchids as thick as waving wheat. The grass pink is in the genus *Calopogon,* a lovely group of terrestrial orchids. The generic name is from the Greek and means "beautiful beard." Like many other orchids, the plant prefers a wet site. Wet is the word in these eastern Louisiana longleaf savannas, as opposed to the dry sandy soil in central Louisiana longleaf habitat.

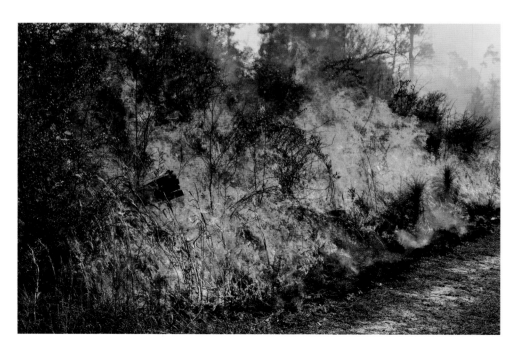

It is just five weeks after the burn at Abita Creek Flatwoods Preserve. Amazing what a prescribed burn can do. Longleaf pines adapted to and thrive on fire. Historically, the longleaf pine ecoregion stretched from eastern Texas to Virginia, covering 90 million acres. Today, barely 3 million acres are left of what's been called "the wood that built America." In their book *Longleaf, Far as the Eye Can See*, Bill Finch, Beth Maynor Young, Rhett Johnson, and John C. Hall wrote, "The malt houses and the almshouses, the churches and the synagogues, the mansions and the warehouses of Dickens's London all proudly specified longleaf 'pitch pine' for the bones and fittings, for the floors, doors, paneling, cabinetry, benches, and wardrobes. The walls and floors of Balmoral, Prince Albert and Queen Victoria's royal castle in Scotland, were built with longleaf pitch pine." The 1892 edition of Great Britain's *Journal of the Society of the Chemical Industry* describes "pitch pine," as it is known in England, as "the most valuable wood of the country for mercantile purposes," later adding, "the longleaf pine is known to be superior to all other species in strength and durability. In tensile strength it is said to approach, and perhaps surpass, cast iron."

In those days, I guess man thought it reasonable to plow through this commodity like a swashbuckling pirate. But in hindsight we went too fast and cleared too much. I hope we have learned that the 5 percent of remaining redwoods on the Pacific Coast, the bald cypress that butt up to the coastal marsh of Louisiana, and the remaining longleaf pine are more valuable than just a saw log or a bag of garden mulch. Longleaf can be harvested sustainably and in some cases, such as in the sandy soils of Bienville Parish, to a value equal to that of a loblolly pine plantation. Our goal now should be maintaining a reasonable amount of all habitats, thus keeping the biodiversity so needed and important to all lives.

The underbrush burns rapidly and the fire quickly calms down to smoldering pine needles and branches. The savanna will soon bloom profusely.

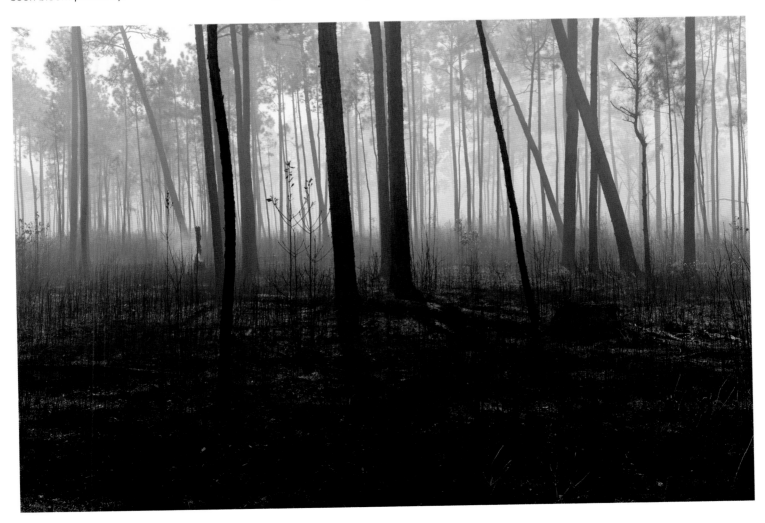

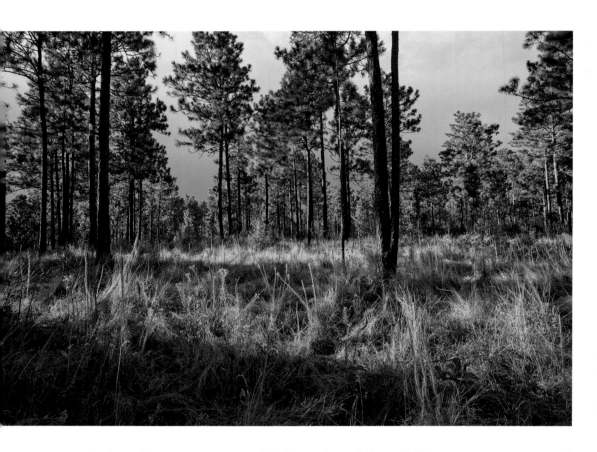

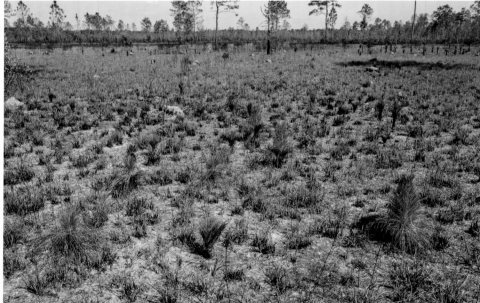

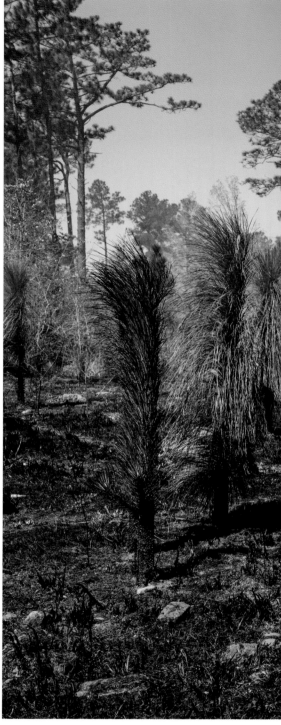

Top left: A properly managed longleaf pine forest looks like this one at CC Road, a clean understory with waist-high savanna grasses. *Left:* Lake Ramsay Preserve a few weeks after a controlled burn. *Above:* Young longleaf pine trees have an amazing ability not only to live through fire, but to thrive over other tree species.

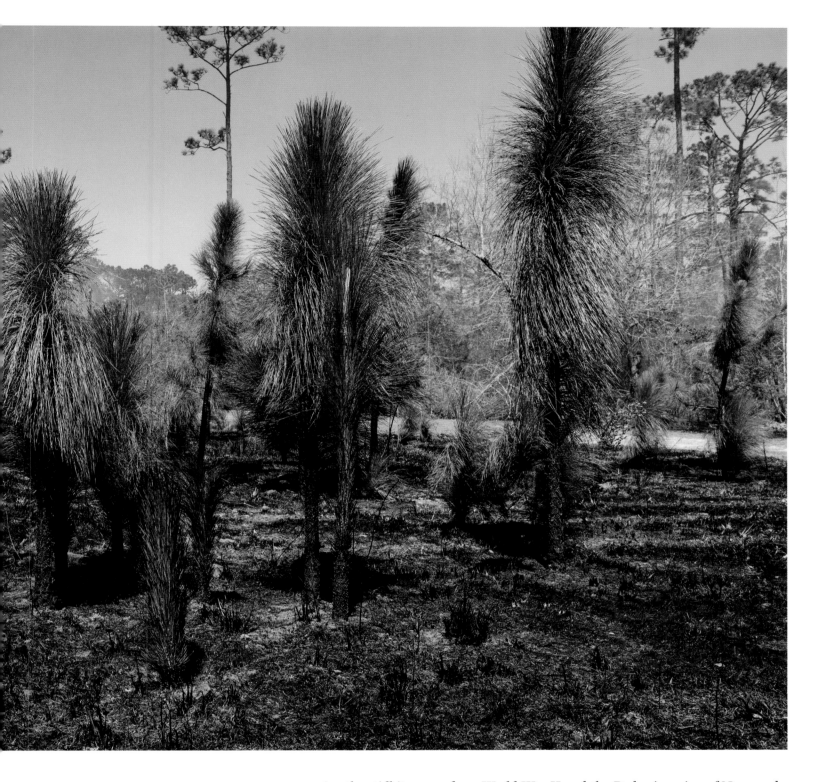

Another tidbit comes from World War II and the D-day invasion of Normandy. Referring to Higgins boats, Melanie Torbett writes on the Antique and Classic Boat Society web page, "Interestingly, trees from Louisiana forests—specifically old-growth, long leaf yellow pine—were an important ingredient in these boats that made successful amphibious military operations possible. Prized for its strength and durability, yellow pine was coupled with oak, mahogany and steel to build the boxy, unlovely boats that were churned out by the thousands in Higgins Industries' New Orleans plants during the war years."

Caroline Dormon, known as the "spiritual founder" of Kisatchie National Forest, was a longleaf lover who did her best to save a few of the remaining virgin stands of this iconic tree. Due to the cut-and-run mentality of the 1920s, she failed. But when Kisatchie was dedicated by an act of Congress, and when it became a national

33

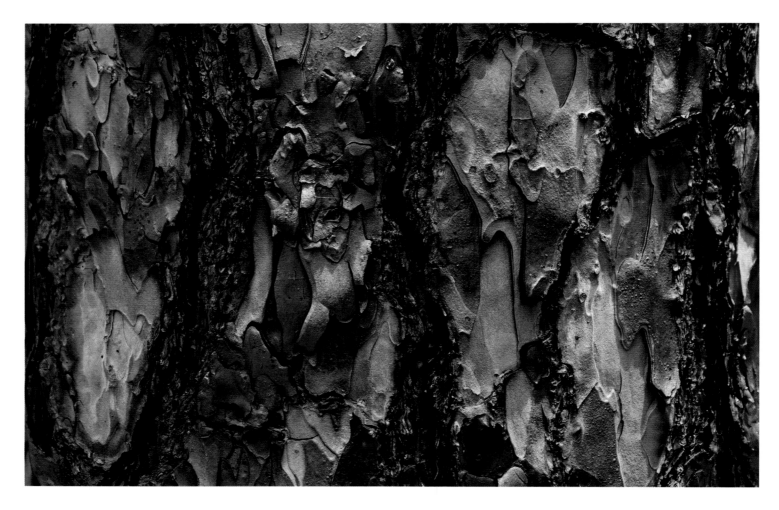

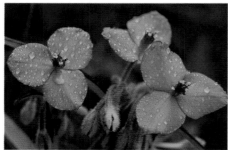

Top: The thick bark of longleaf pine can withstand fire.

Above: A hairy spiderwort blooms at the Fort Polk Buffer Tracts.

forest on June 30, 1930, it was partly because of her efforts. Civilian Conservation Corps workers planted longleaf in the 1930s. Then in the 1950s and 1960s, the mentality epitomized by Smokey the Bear of "no fires at all" turned to controlled burns and managing this habitat the way it historically evolved. Today, the best-managed longleaf pine tracts are in the Vernon Unit of Kisatchie National Forest, near Fort Polk. Since 2011, TNC has acquired 1,041 acres in six tracts of inholdings and land near the Vernon Unit. Much of the area purchased is disturbed earth with some loblolly pine plantations. TNC is hard at work restoring the area to native longleaf pine habitat.

The holdings are called the Fort Polk Buffer Tracts. We walked an area of 40 acres named the Scenic Tract; it is not quite scenic yet. It's a loblolly pine plantation, recently thinned by TNC. It looks ugly at first, with piles of limbs and branches lying on bare earth. Walking farther in, I sat down and listened. I imagined the future while a skink, a fascinating chubby member of the lizard family, ambled slowly by a small toad. The pink of a rose gentian bloom caught my eye, and I pictured this forest in the future when the restoration succeeds. And it will.

This tract is a buffer on the west side of a pristine longleaf forest that is a red-cockaded woodpecker nesting area on Kisatchie National Forest land. In the 1920s, this now full-grown forest was trimmed to the nub—just like the short haircuts of the men stationed on the adjoining army base. For the birds, some of the mature longleaf pine trees are marked with blue paint, indicating a nest tree. A nest tree usually has red heart disease, which makes the wood on the inside of the tough layer of bark soft enough to let the endangered woodpecker chip out its home. Once a hole is made, sap from the layer of cambium between the surface of the tree and the inner wood drips down the outside of the bark, making it unappealing for a rat snake or raccoon to raid the nest.

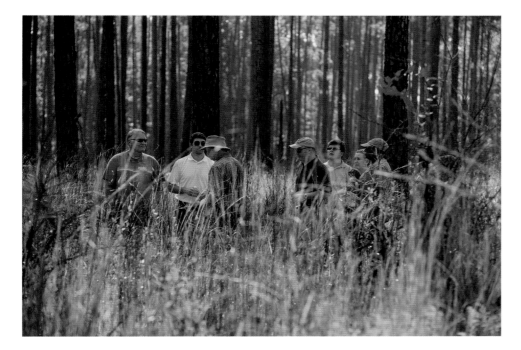

Latimore Smith, third from left, explains the ecology of a longleaf forest at Abita Creek (*left*). The trees sometimes remain in the grass stage for years (*below*) before they pop up into real trees. TNC uses field trips to educate members, donors, and the public about the value of these rare habitats they protect and restore.

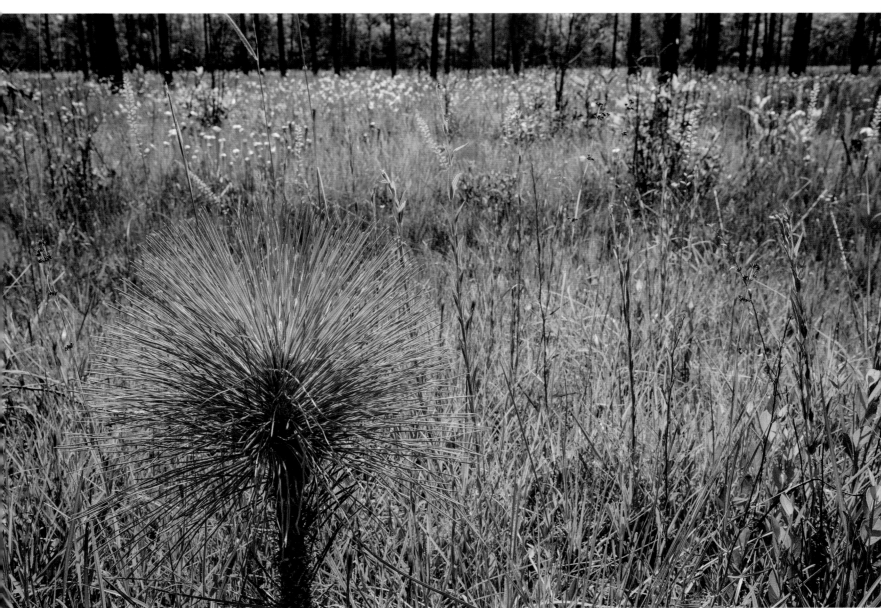

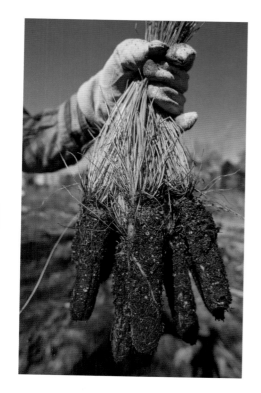

Top: A handful of longleaf seedlings ready to be planted by volunteers at Abita Creek. *Above:* Brownie scouts help plant.

The Scenic Tract is on a slow road to restoration. It will take a while, but someday this and the other buffer tracts will have orchids and ferns under maturing longleaf pines. It may even provide some housing for a woodpecker that we hope will not be rare anymore.

Lake Ramsay Preserve is a TNC platform preserve, bordered on the west by the Little Tchefuncte River, with its clear water and sandy banks. It touches a thick stand of bottomlands before reaching a pristine savanna. Relic longleaf pines over-look this wet prairie—an area that has never been plowed. Latimore Smith has a fa-vorite spot to stand and enjoy this rare prairie with a 200-year-old relic tree in the foreground. He is delighted that this spot still exists. Newly planted longleaf pine will grow here and in time turn this area back into a native habitat.

Managing habitat restoration, especially with fire, is controversial in our crowded world. To the north of this preserve is the lake, surrounded by a subdivision with 330 homes. When TNC first burned the prairie right up to the neighborhood prop-erty line, some residents were fearful. TNC educated them on how frequent con-trolled burns would make their homes safer. If the vegetative matter built up too thick over the years, a lightning-started fire could be devastating to the neighbor-hood.

The Shoshone call the full moon in December the winter moon. I hiked into Lake Ramsay Preserve at dusk to watch that moon rise. It's not easy walking in the day-time, and at night it is much tougher. This prairie looks flat from a distance, but the ground is uneven and the tufts of waist-high grasses impede your way. Slight varia-tions in topography are important to a wet savanna. Hydrology is one of the reasons a savanna has such a diverse community of plant life. I walked to the center so I could get a good broad view of the rising moon. Here were newly planted longleaf trees; some were in the grass stage and others shooting up to a few feet, known as the rocket stage. In the silver glow the prairie was more beautiful than eerie. First I saw the "pumpkin" moon. When it is just above the horizon, it appears orange be-cause you are looking at it through more of the earth's atmosphere, which has mois-ture, dust, and pollutants to color it. The moon also appears larger because you have earth-size references such as the trees to compare it with. I played around shoot-ing the moon through the bottlebrush tufts of long pine needles. The silvery glow is comforting.

Lake Ramsay has a trail with interpretive signs and just twenty miles to the east is Abita Creek, the showiest of the longleaf platform preserves. Sue and I met Lati-more there a few times to find attractive and rare flowers. I really like to work alone; that way I am never worrying about someone waiting on me to finish a shot. In this case, though, it was good to keep focused on what was blooming at the time. If I walked in by myself to find the grass pink orchid, I might stop at the first pretty site and spend all morning on it. Latimore can keep me on track to see the entire savanna rather than one showy flower. On this tour we saw a bunch, including the white flowers of the death camas, *Zigadenus leimanthoides.* As the name suggests, it is toxic. In contrast to that "devil in disguise" are three plants used in pioneer medicine. The colic root, *Aletris aurea,* with brilliant yellow florets around an erect stem, was used for colic. For a painful tooth you could chew on toothache grass, *Ctenium aromaticum;* its curved seed head looks like some kind of cutting tool. One of the brightest was the fewflower milkweed, *Asclepias lanceolata,* its round red bloom opening into orange petals. It was used to cure warts; then and now it hosts monarch and a few other species of butterflies. *Rhynchospora colorata,* or white-topped sedge, could be called "star flower" or "star grass" as the bright white

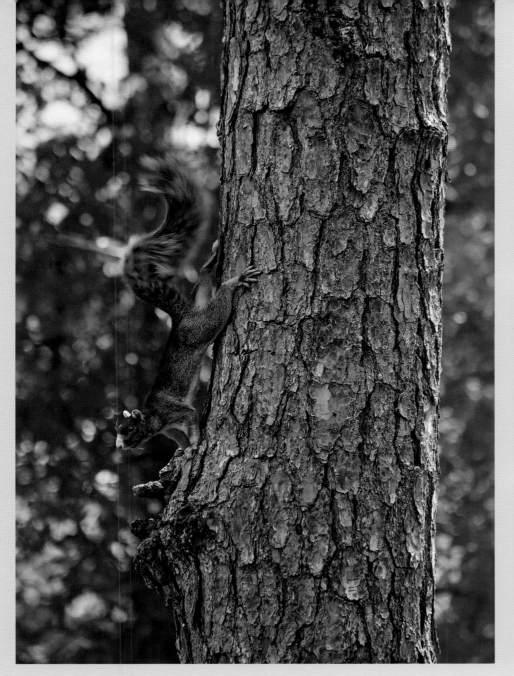

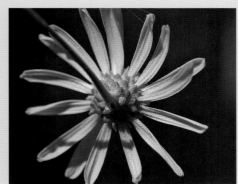

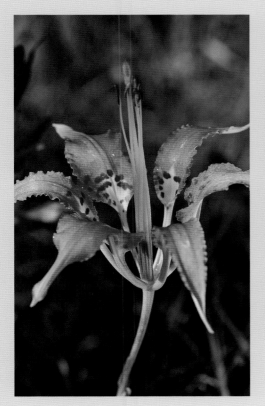

Flora and fauna of the longleaf piney woods include, *clockwise from left,* Bachman's fox squirrel, the pale purple coneflower, the wildly purple Stokes aster, the oneflower honeycombhead, a southern cricket frog, and the rare pine lily.

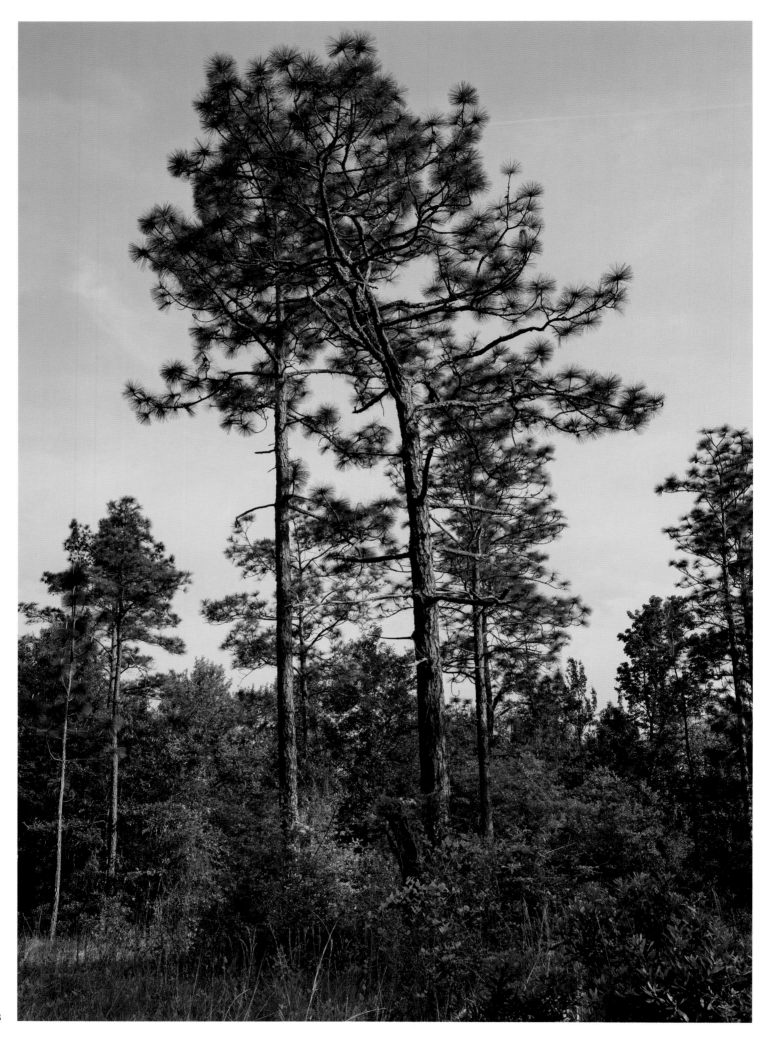

leaves peel back in a star shape. Large clusters of this sedge make for picturesque landscapes, which were easy to find on this day.

Abita Creek has the most extensive boardwalk of all the platform preserves. You can ramble through a pitcher plant wetland observing both species native to this area—the winged or yellow pitcher, *Sarracenia alata*, and the parrot pitcher, *S. psittacina*. Sue and I have heard some botanists refer to the latter as the Jimmy Buffett pitcher, relating it to the Parrot Heads. These are two of Louisiana's carnivorous plants and get some of their nutrients from insects that crawl in their hat-cover mouth to find it both sticky and with downward-pointing hairs. This traps them, and the enzymes more or less digest the bug. On a field trip with the Baton Rouge Area Foundation, Latimore split one of the tubular-shaped plants to show this trap. While opening his knife, he said, "We might see a digested insect inside." As soon as he split the plant, out flew a moth to freedom. I wonder if that moth will be smart enough to avoid pitcher plants from now on.

The boardwalk continues through a baygall, which is a low area usually associated with a marshy area or a stream. Here sweet bay, titi, pond cypress, and other wetland-tolerant trees and shrubs make a dense thicket—totally different than the surrounding longleaf savanna. Leaving this thicket on the safety of a boardwalk, you see an open savanna with its bluestem grasses and a few pitcher plants. The walk then recrosses the baygall and into a maturing longleaf forest. Here pines of 20-inch diameter 70 to 80 years old are closing in on what a mature forest looked like before the logging heyday. It was here I got one of my magic shots. It was a typical winter morning with a little dampness in the air. Shafts of sunlight picked up the moisture to make rays of misty light, and enough bounced back to show some of the charred blackness on the thick bark from the last burn. Below, the little bluestem grass was tan, brown with a little bit of reddish color. The grass was tangled and soft looking. It's a scene you can watch evolve into the full-on day. I just wanted to keep looking.

The boardwalk finally quits and turns into a wide trail that leads you right up to a tar pit. Here longleaf stumps were burned under the cover of dirt to extract pitch, a valuable commodity in the late 1880s. All along you can learn from large and well-done interpretive signs. These tell both the history and the ecology of a longleaf forest. In this area I found another interesting creature, the redheaded pine sawfly, *Neodiprion lecontei*, eating at the tip of a longleaf pine needle. Latimore said that this caterpillar is one of the few animals that can eat pine needles and this is its sole diet.

Longleaf pines (*left*) tower above the wet savanna of Persimmon Gully, where the Kansas gayfeather blossoms (*above*), looking like a bad hair day. On the other side of the state, the waxy flower of the yellow pitcher plant (*top*) blooms at Abita Creek.

To the east is Talisheek Pine Wetlands, similar to Abita Creek. At 3,014 acres, it is the second-largest piece of property that TNC owns. One of the fires I photographed occurred here, and I came back six weeks later to see the regrowth on a misting, cloudy spring day. The weather effect makes the green, as in Ireland, just a lot greener. Meadow beauties were colorful scattered among the toothache grass, pitcher plants, white-topped sedge, and smaller numbers of many other plants. Botanists have counted a greater variety and a larger number of plant species in a square meter of prairie than in any other habitat in the United States. Old-timers say that when virgin prairie was first plowed, it sounded like thunder as that massive root ball of all those plant species tore apart.

North of Lake Charles are two more longleaf pine savannas owned by TNC: CC Road Savanna, at 477 acres; and Persimmon Gully, covering 656 acres. I choose CC Road to visit first on a hot September day just because it had my initials in its name. *Liatris pycnostachya*, or Kansas gayfeather, was in prime bloom. That was what I was after, and kneeling down I zoomed in on a purple plume that kind of looks like a giant paintbrush from a distance. Up close it changes into a bunch of small flo-

rets circling the stalk, each with numerous tiny purple petals and stigmas that look like someone with a bad hair day. Before I could snap the shutter, an odd, strikingly green spider with long legs caught my eye. On the purple, it sure was not blending in. Turned out to be a green lynx spider, *Peucetia viridans,* and I had never seen one. This arachnid is a predator, a long, strong great leaper. I soon saw this happen as it jumped and caught a honeybee in its agile legs. For the next two months, at every savanna we visited we watched this spider eat insects of all shapes and forms, many larger and heavier than itself.

Persimmon Gully has some beautiful groups of older longleaf pines on pimple mounds. I write in my *Discovering Louisiana* book, "Pimple mounds are an unexplained feature of Louisiana's landscape. The miniature hills, up to six feet tall, are rounded or sometimes elliptical. They occur only west of the Mississippi River, mainly on the terraces, and have been attributed to Indians, ants, wallowing bison, and burrowing animals." They could also be caused by wind-deposited soil during droughts. Whatever their origin, they supply a little higher ground for the longleaf to thrive. This preserve is divided into three sections; the prettiest by far is the one with Persimmon Bayou on it. Sue and I hiked to the small waterway after studying the pines and the savanna wildflowers and sat down to eat our lunch. We had just about finished our sandwiches when we heard a splash, followed by a flash of mammalian fur. Beaver was my first thought; then over one log and under another came a raft of otter. One stopped on the log to crunch the tail of a fish it was eating, and then all four swam upstream and right toward us. What a treat! The otter is my favorite mammal. I love the fact that they are such efficient fishermen they have time to play.

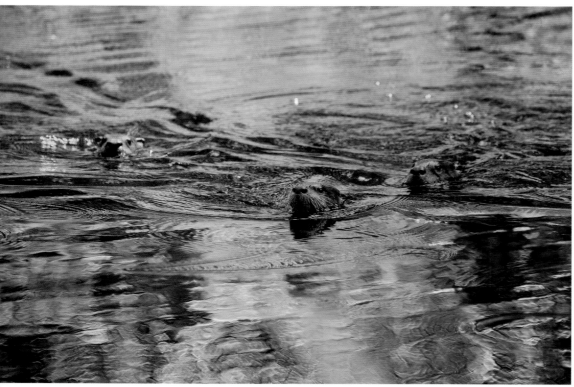

Above: A raft of young river otters. *Right:* The Lockwoods' tent at Persimmon Gully.

40

The savanna in most TNC longleaf pine areas is home to carnivorous plants such as the yellow pitcher plant (*facing page, top*), shown here with a green lynx spider poised waiting on a meal; and the tiny red sundew (*below*), which captures insect prey with its sticky droplets.

On April 30 we camped in the savanna to get some night shots. Looking north from Persimmon Gully is about as dark as you can get in Louisiana. I had fun shooting the North Star and the Big Dipper over the tent lit up with a flashlight. Once I finished and had time to notice what was happening, I said to Sue, "Uh-oh! I think we messed up." It was getting cold, and that is not supposed to happen in south Louisiana when tomorrow is May. At least we had a tent, plus a pad to sleep on and two sheets. We put on our spare t-shirts and shivered all night to find frost on the tent in the morning, and learned the temperature was 28 degrees. With hot tea on the camp stove and the day warming up quickly with sunrise, we made it.

Later that morning, while exploring a baygall next to a pimple mound, we found the ripe red fruit of the jelly tree—I mean mayhaw, *Crataegus opaca*—covering the ground. I am sure the raccoons, opossums, and probably a fox or two were eating these over the last few nights.

I do love the longleaf habitat. The subtleties from preserve to preserve make it tremendously interesting.

Overleaf: A maturing longleaf pine forest beams enchantment as the gleam of silhouetted trees stands in stark contrast to the shafts of early morning haze. Abita Creek.

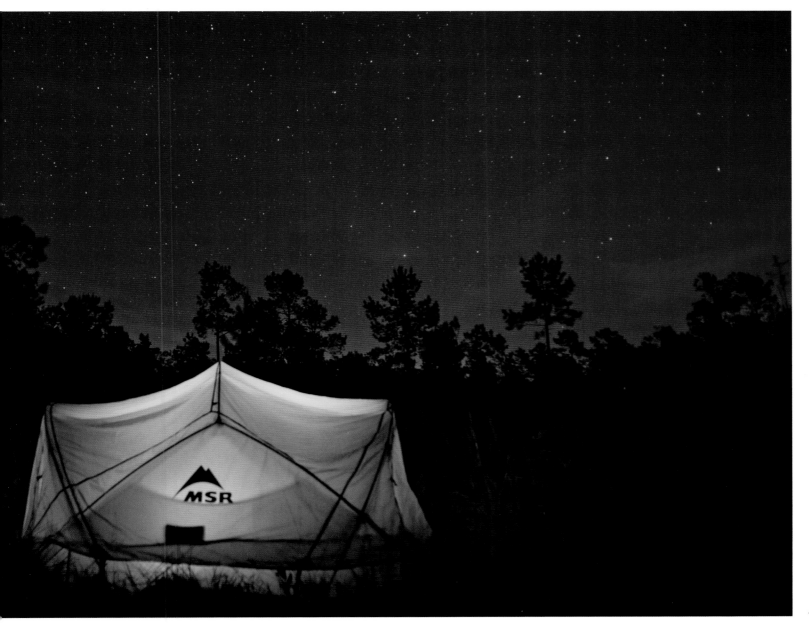

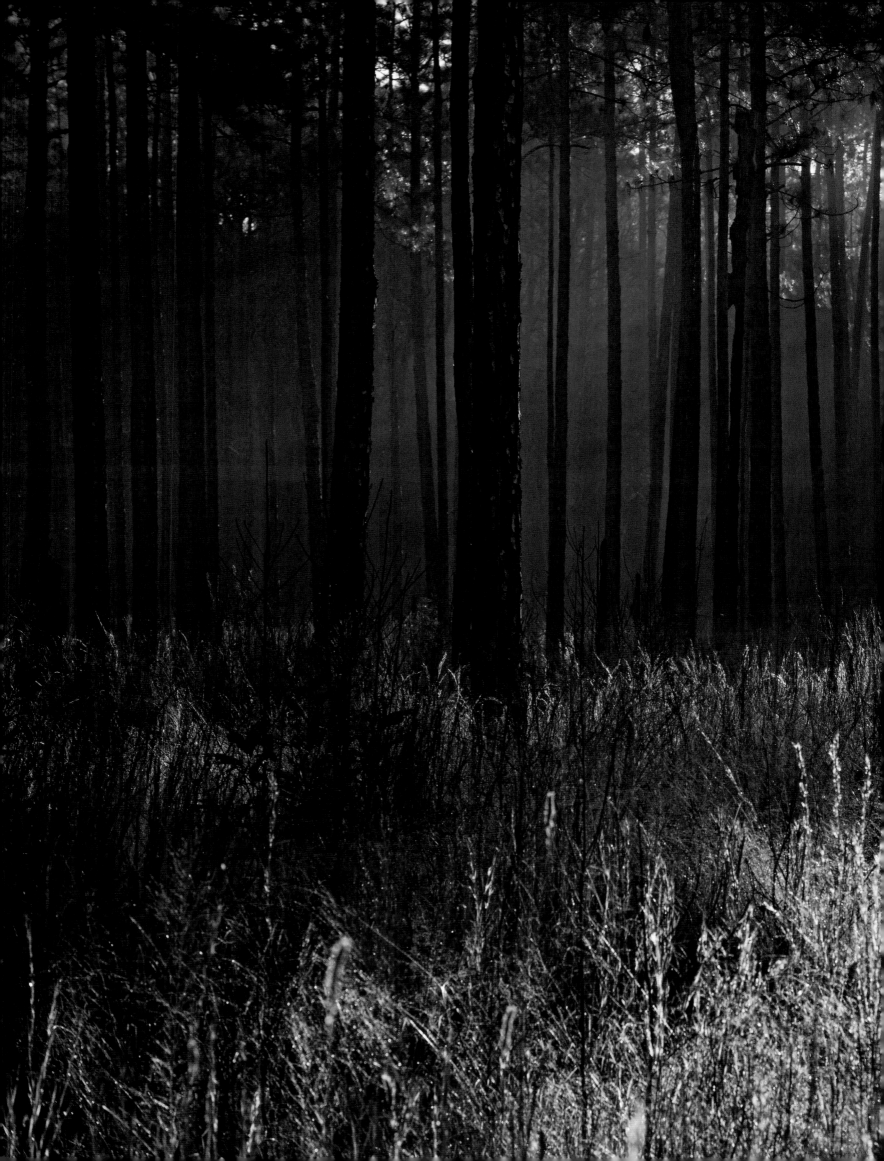

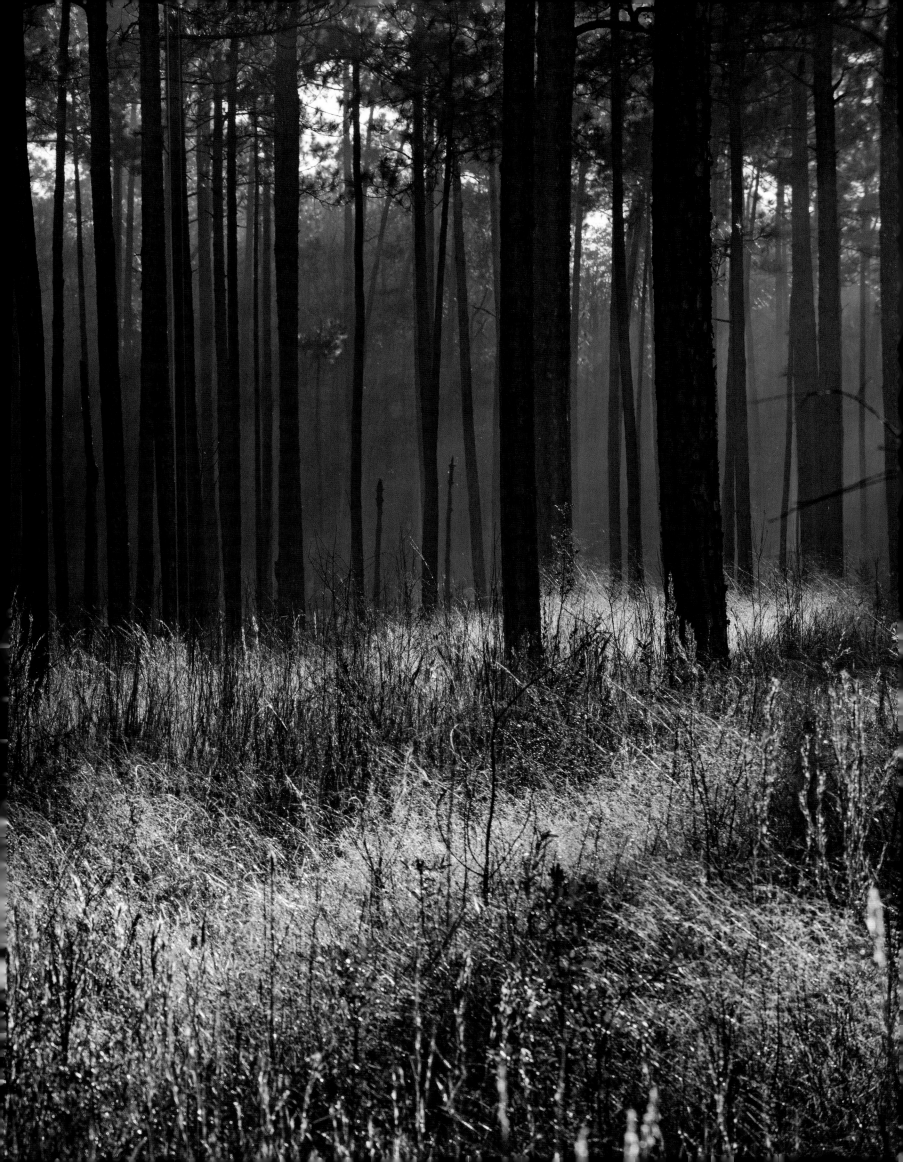

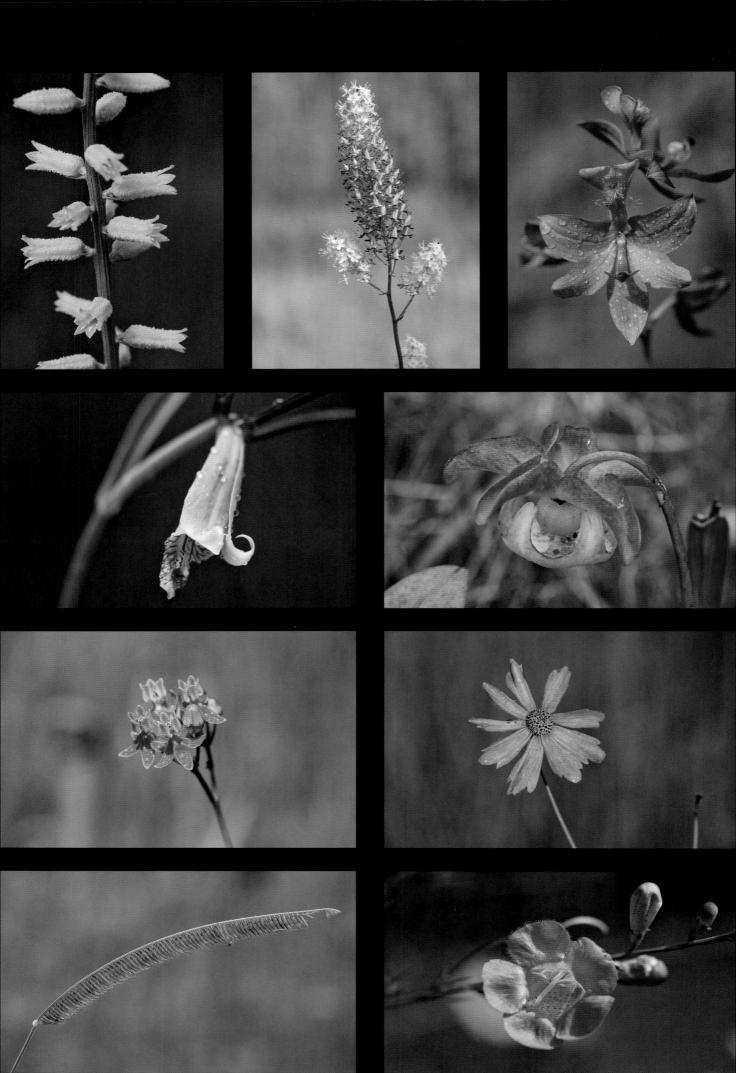

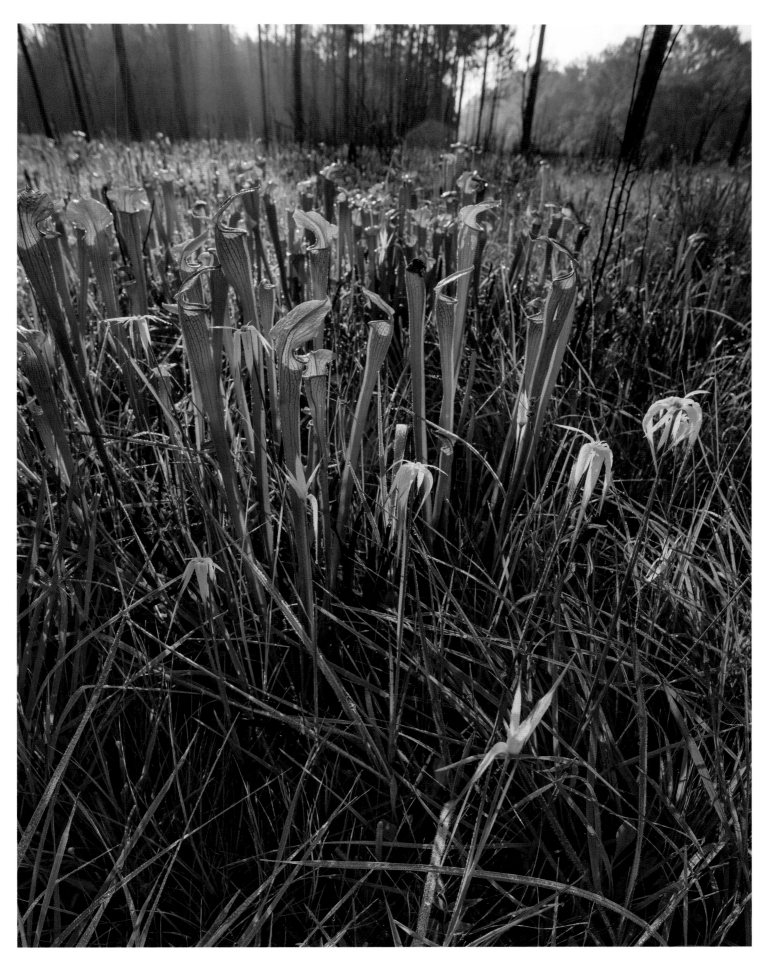

Facing page: Flowers and grasses of the savannas and prairies of TNC longleaf properties include (*clockwise from left*) colic root, pine barren deathcamas, grass pink orchid, yellow pitcher plant, Georgia tickseed, beach false foxglove, toothache grass, fewflower milkweed, and small spreading pogonia orchid.

Above: Yellow pitcher plants stand tall and trumpetlike, with white-topped sedge blooming among them.

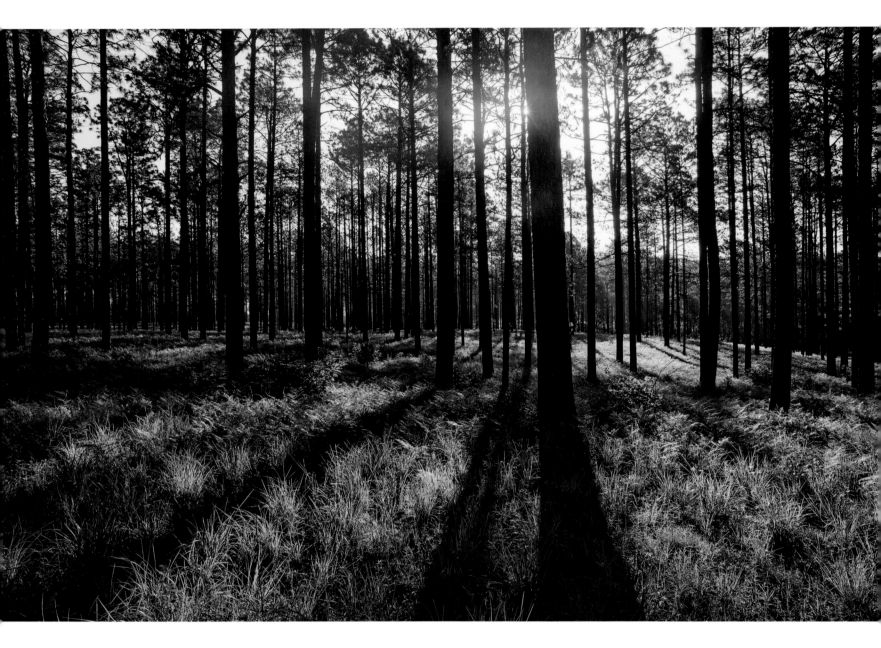

A stand of maturing longleaf pines shows
optimum spacing and undergrowth in a
fire-managed forest.

Above: Bee blossom.

Right: The lovely grass pink orchid stands out in an army of yellow pitcher plants.

Below: Slender bluestem grass grows under longleaf pines at CC Road Savanna.

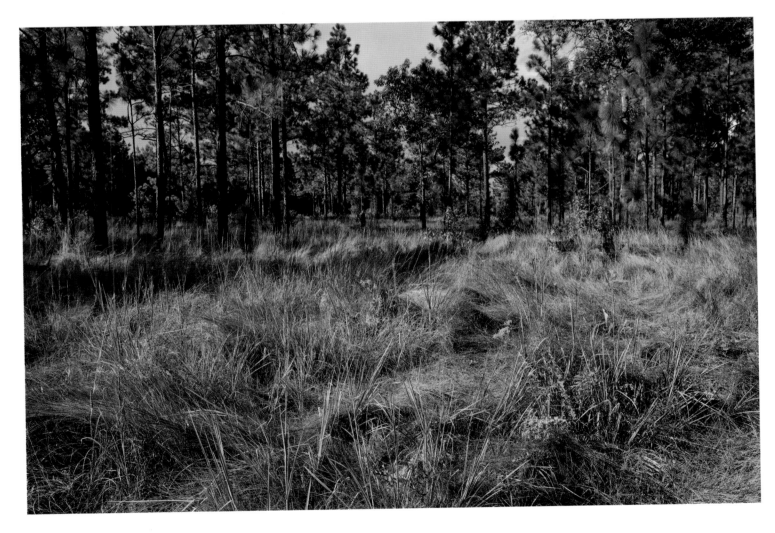

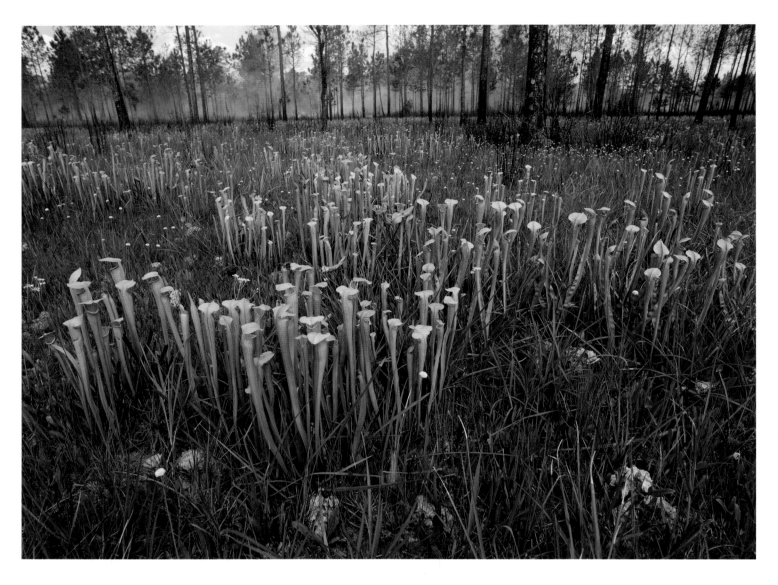

Above: Yellow pitcher plants shoot their tubular stalks up three weeks after a fire burned this area down to the soil. Smoke from a current burn can be seen in the background.

Left: In the grass stage, a longleaf pine can lie at ground level for years before it springs to life in the rocket stage of growth.

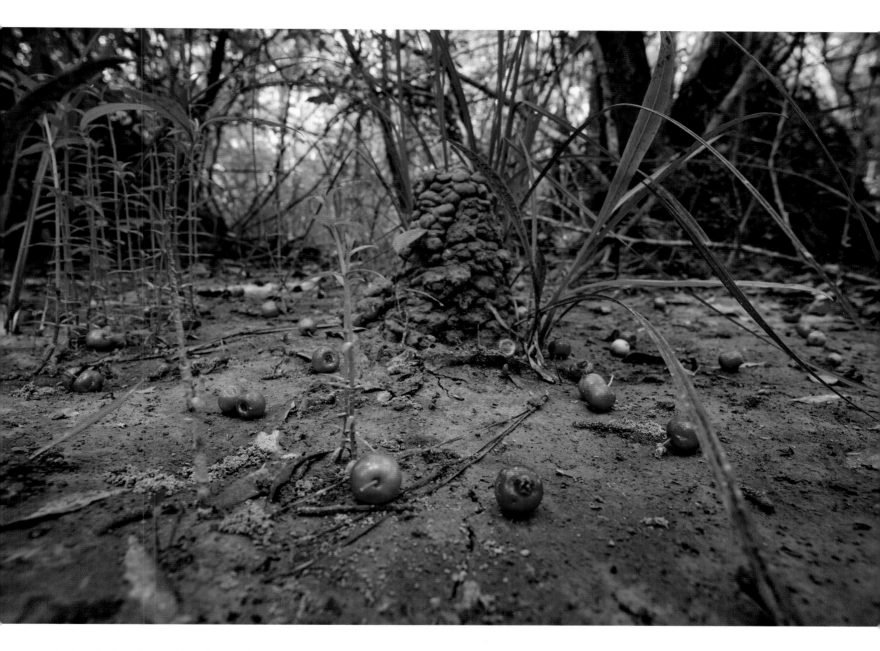

Mayhaw fruit and crawfish make good gro-
ceries for raccoons, foxes, opossum, and
many birds in this baygall, a wet area in a
longleaf pine savanna.

Schoolhouse Springs

30 acres, Jackson Parish

Upper West Gulf Coastal Plain

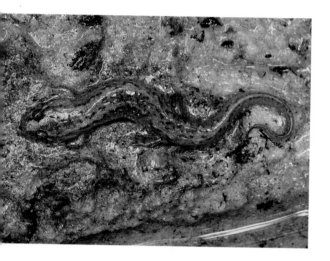

Above and facing page: Two color phases of the spotted dusky salamander live secretively under logs and other debris in the crystal clear waters of Schoolhouse Springs.

A fence-line thicket compounded with hurricane-tossed trees discourages entrance to this hidden gem located in the hills of Jackson Parish. The site is smallish at only 30 acres. The barrier of French mulberry, blackberry, and smilax tangled among the fallen limbs made our entry challenging. Once through, the forest opened to a clean understory. Majestic trees—oaks, shortleaf, loblolly pines, and magnolia— shade out shrubs and vines. Combat hiking becomes easy walking. Effort almost always brings reward. Sometimes I like something more challenging than maybe it is worth because of that fact. That is not the case here. We were instantly smitten while navigating hills and gullies as we searched for the namesake springs of this property. These woods quickly became one of our favorite preserves.

As we explored, we found a small dry drainage that had two tiny pools. One had a couple of frogs barely visible in the black water. Since the drainage to the pool was dry, I thought the springs had dried up. Still exploring, we cruised on to find a sandy, clear stream making a little wetland. I turned a log over and found a salamander; it was the spotted dusky salamander, *Desmognathus conanti.*

Continuing upstream, we were thinking the springs must be ahead. It was a scenic and sometimes tangled walk. Being such a swamp stomper, I find it exciting to see white sand and clear water. Up the stream we trekked, finally finding the source. The waters trickled out with a slow, gurgling sound from the bottom of steep hills in five places. One spot had bubbling sand where the water was coming straight up from below; elsewhere, the water emerged between the sand and the steeply sloping hill. It was a peaceful and quiet place except for that wonderful sound of water. The clear water was delicious, an added bonus to our exploration and discovery.

In November, with fall colors and leaf drop in progress, we visited the springs' source again. Sue was taking notes and I was in deep concentration with a close-up lens shined upon a mushroom when the adjacent landowner, Todd Hibbard, walked down the hill. He farms chickens, runs marathons, and is delighted to have this precious preserve next door. Sue asked, "How did this place get its name?" Todd replied, "Old-timers tell me about the small school that was up the hill. The schoolmarm would send a student down to the springs to fetch water for the class. That schoolhouse is long gone." Later we found out the school was called Springhill Academy.

TNC classifies this as hardwood slope forest with a bayhead swamp stringer. Leuctra stonefly—scientifically known as *Leuctra szczytkoi*—is the main reason this place was acquired by TNC. This insect is known to occur in Louisiana in only three parishes. A paper by John C. Morse and Cheryl B. Barr states that at least 43 species of caddisflies live here. Matt Pardue, TNC land steward, told me that these and the rare stonefly are small and not photogenic. He suggested looking for the showy ebony jewelwing damselfly, *Calopteryx maculata,* in the spring and summer.

In May, we hiked directly to the springs and sat still watching the water bubble

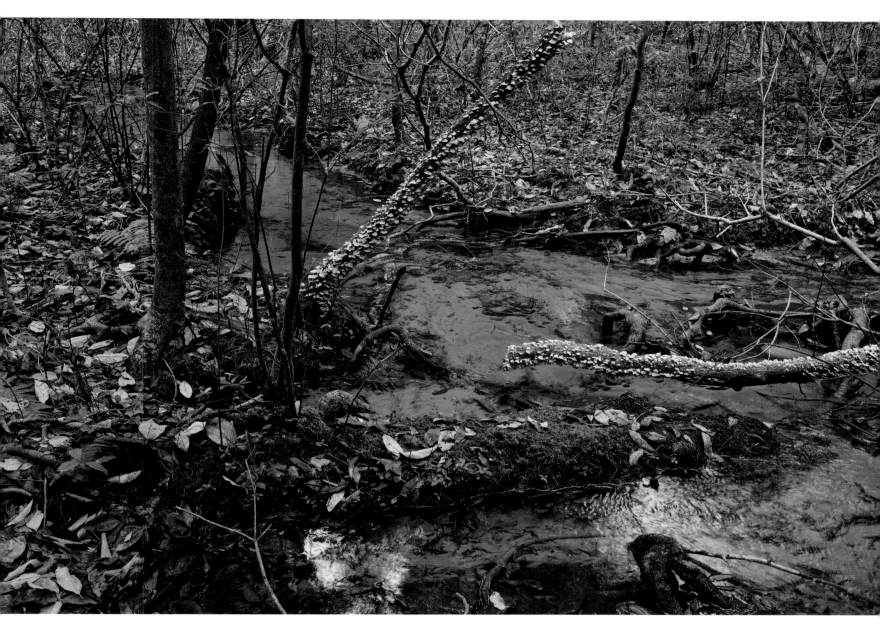

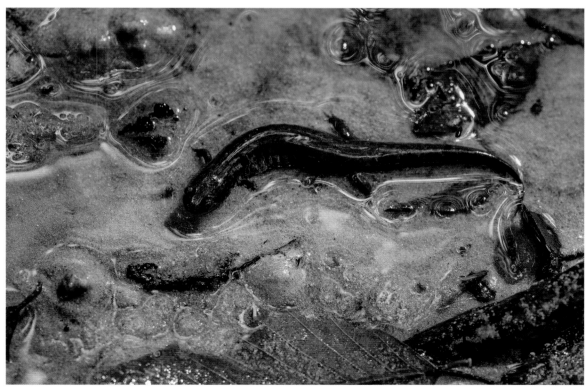

out of the white sand. A closer look revealed two baby salamanders in the stream and, up above, an ebony jewelwing damselfly sparkling on a deciduous holly branch. I wanted that shot. I crept to close the 15-foot gap, taking safety shots along the way. The dark insect was a whole different exposure than the rest of the brightly lit background, so I knew it was not a real winner. I decided that by seeing only one jewelwing, it must be rare. I continued shooting the bubbling fountain.

Captivated by the dusty white sand under the pure clear waters of the spring-fed creek, I was surprised to hear Sue hoot like a barred owl. A hoot is our signal of a find worth photographing. I found Sue down the creek standing over a large and very timeworn common snapping turtle. The snapper was like a two-year-old boy on the couch with his granddad, covering his eyes saying, "Papaw, you can't see me." It had its eyes closed and head down in two inches of water, thinking it was invisible. No muddy water here, no deep pools, no place to hide from a creature so much bigger than itself. Its shell plates were cut, cracked, and peeling off. Its legs were fleshy and soft. It was on its way to the turtle graveyard. When it finally decided to recognize us, it rose up painfully and snapped its jaws. True to its name in its final days.

Suddenly I noticed the damselflies were everywhere and realized that midmorning warmth brought a surge of these blue-and-black iridescent beauties. I followed and photographed them for the next hour, the project culminating in getting a pair mating. When they hooked up with their long abdomens, they formed a heart. A real love tryst.

Parts of the springs are open and easy to enjoy, and parts are covered up in low-hanging shrubs, creating a maze to climb through. At one point the springs run through some type of mineral, and the sand turns red. We assume that it was iron, but I am not certain about that. The woods on the hill on both sides are open because the big trees have a high and dense canopy that is blocking light, thus making the walking below just wonderful with a carpet of leaves broken in places by a field of ferns. Loud songs of nesting birds kept our ears open and listening. No other sounds, just nature. Peace and quiet. This place needs no effort to enjoy. The beauty abounds.

Leuctra szczytkoi? What if that crazily named stonefly can cure cancer? I would save this place for the beauty alone. The effort by TNC to protect a few rare species does that and opens other possibilities too.

Patterns of nature are revealed in leaf art (*above*) and in the heart-shaped form of two ebony jewelwing damselflies mating (*bottom right*).

Facing page, top: The source of Schoolhouse Springs appears like magic in the hill beyond the stream. *Bottom:* An aging common snapping turtle tries to hide in the spring's shallow, clear waters.

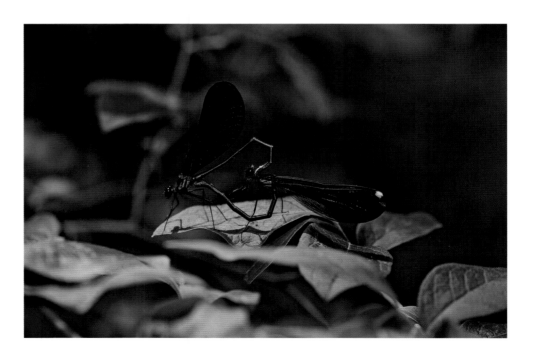

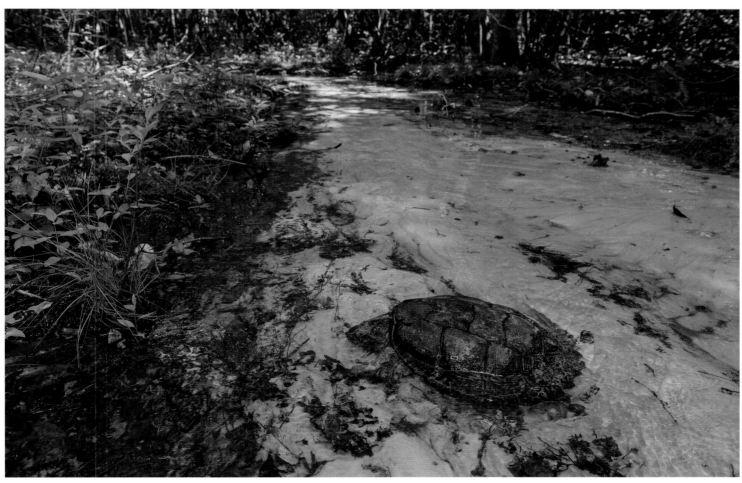

Bayou Dorcheat

1,140 acres, Webster Parish

Upper West Gulf Coastal Plain

The purple of French mulberry contrasts with the golden leaves of fall, much like the wardrobe of LSU Tiger fans.

Facing page: The similarly dressed banks of Bayou Dorcheat.

Have you seen the iconic white church in Stowe, Vermont, surrounded by fall colors? There is no church on these 1,000-plus acres in Webster Parish, but on a November morning on this delightful bayou, the fall colors glowing in the morning mist rendered us speechless. These were not the normal hues this south Louisiana couple most often sees. The bayou was slick as a sheet of stainless steel, and a light fog steamed off the water warmer than the air. I declined to fire up the 4-stroke outboard and chose to drift down the west bank. Up close and far off, reds, rusts, oranges, browns, and yellows piled up the pixels; too many, I knew. Editing photos is much less pleasing to me than being here, but I could not stop clicking.

A great blue heron flushed off a midstream log. Its 6-foot wingspan stirred up the fog to announce the day had begun. Around the bend, a red-eared turtle soaked up the sun. He cared not as we passed by. Sentinels on the bayou bank were bald cypress while oaks, ash, and hickories decorated the natural levee. The occasional black gum stood out with its candy-apple red leaves. Climbing the bank, Sue and I hugged a large pine and barely could touch each other's hands. A startled doe charged off into the forest. How and why does TNC end up with acres such as these?

Bayou Dorcheat forms part of the 3,000-mile system of designated scenic rivers in the state. That system, administered by the Louisiana Department of Wildlife and Fisheries, is one of Louisiana's best assets. On the banks the forest is mature and diverse in most of its acres; the part in plantation pines will be thinned and restored. James "Butch" Bransford donated the land. Dan Weber, manager of TNC's Northwest Louisiana Office, filled us in on the story when we met him that fall morning. We tied up at the bayou bank and walked down the trail to find Dan on a four-wheeler waiting to give us a tour. After we passed through an area hit hard by a tornado ten years ago, our first stop was a beaver pond. Butch wanted Dan to help him get a logger back there to get the fallen trees. Dan talked him out of building a road. So in order not to waste the wood, together they cut a bunch for firewood and slowly hauled it out. Dan had met Butch when he was looking to donate the land to someone who would take care of it and leave it intact. He had grown up there when it was a working farm. Leaving Louisiana for Texas and college, he then worked as an engineer. When he retired, he came back to Sarepta, Louisiana, to buy back his family property. He pieced together the land that his family had once owned. When TNC expressed interest in taking care of the land, he donated a tract every year, and the balance was transferred when he died. It now totals 1,140 acres.

Butch disliked beavers because of their tree cutting, and Dan showed us the beaver dam that was torn down many times while he was alive. The dam is back now, proving how persistent this creature is and how well it can survive. Dan told us about the old homesite across Highway 2 and the area that was once a watermelon patch, now grown up in scratch pines. He also casually mentioned the good bottomland below the homeplace where Indian Creek flows into Bayou Dorcheat. Dan let

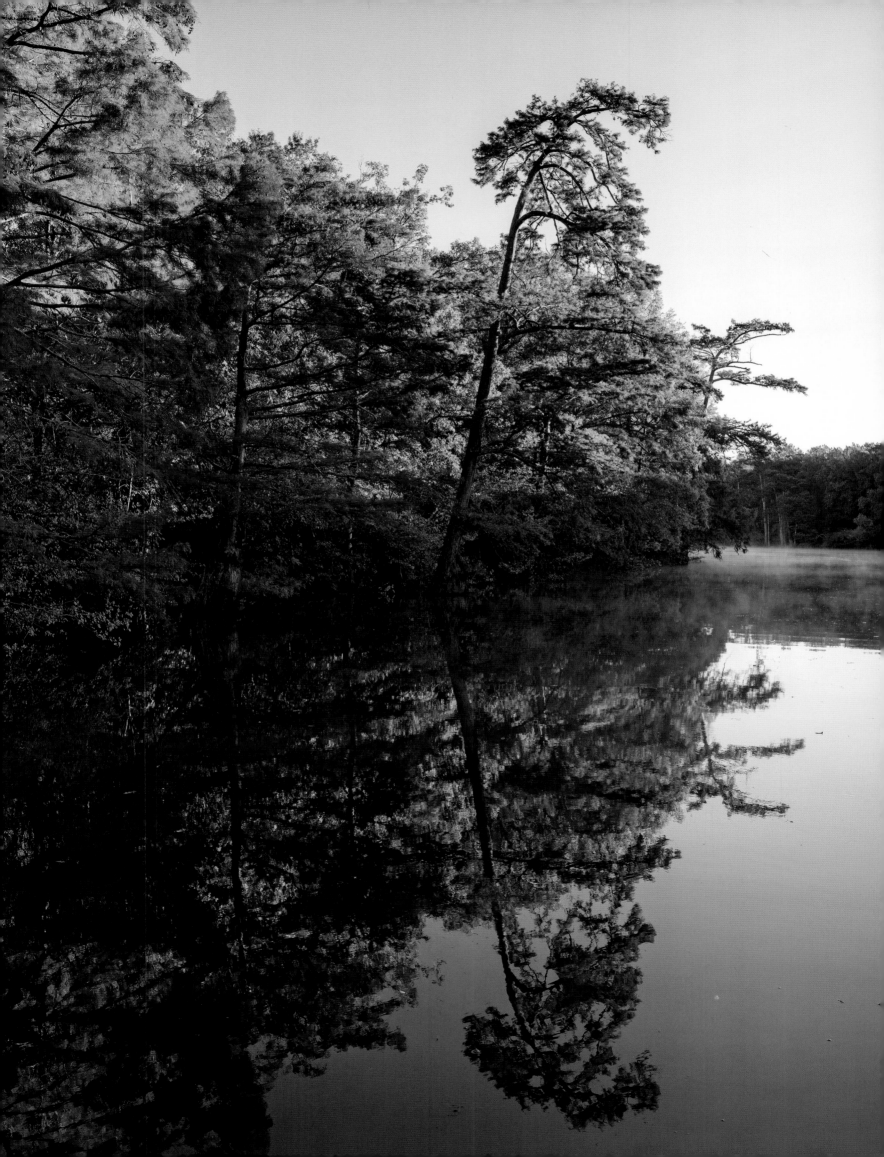

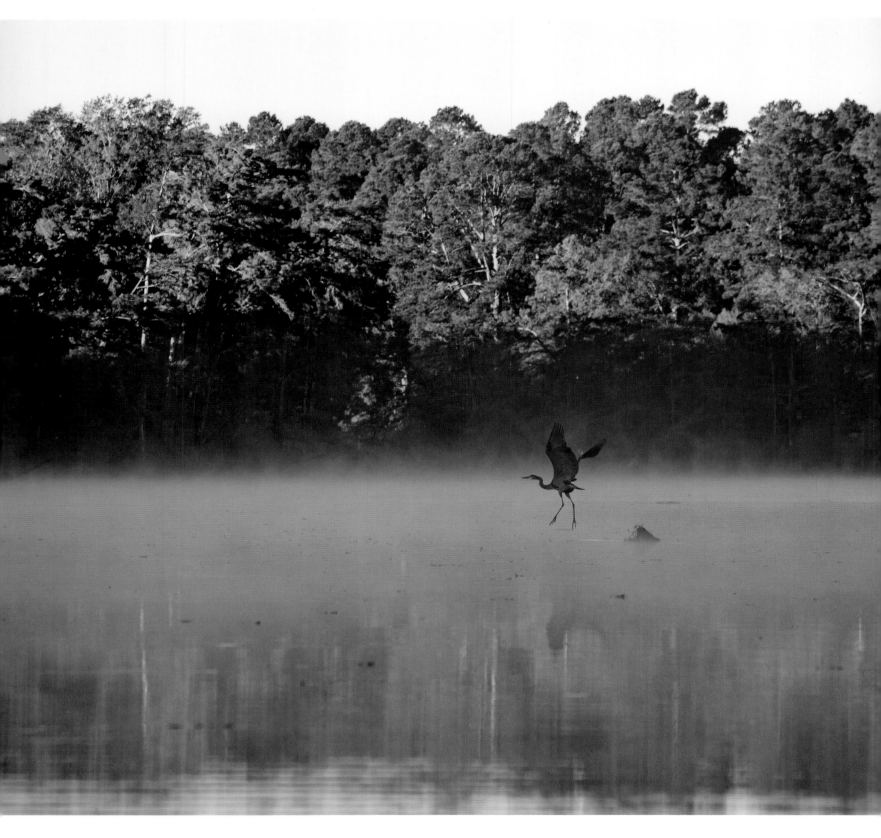

Above: Just as the sun lights the tree-tops, a great blue heron takes off for its fishing grounds from a log in Bayou Dorcheat.

Left: An orb weaver spider photographed the day after Halloween shows off its pumpkin-orange color.

56

us off about a mile from our boat. We walked the deer trails and found a huge lob-
lolly tree, eleven feet in circumference. Then I almost walked into a face-high spider
web before reflexes bounced me back. The big orange abdomen of the orb weaver
spider was remarkable. It was decorated in a black pattern that could have been
used for an ink-blot test. I had seen the shape previously, but not the color. Sue said
it looked like a pumpkin. Fancy that, since Halloween was just the night before. The
female spider kept to her work of spinning that web.

Near the end of the day, we got out of the bayou and headed to the homeplace.
As we were opening the gate, a young man named Whit Applegate, a member of the
hunting club that leases this property from TNC, stopped to see who we were. He
was a deer and squirrel hunter who was happy that this property would not be like
so many other acres here that are pine plantations. He said there is hardly any wild-
life in the pine plantations. TNC has another fan.

We parked in the scratch pines and walked toward the bottoms. At the escarp-
ment was a deer blind overlooking the drop from the piney woods to the bottom at
Indian Creek. Low, clear light made us feel like we were entering a pristine amphi-
theater with clean lines and no clutter. I thought it might be a hallway to heaven
or an English king's park. The forest floor was covered in the leaves of the overcup
oak and a few other species. The huge limbs arched over a carpet of leaves. The area
was almost level, sloping slowly toward the creek, which had about ten inches of
black tannic water in it. I had to scrape away fallen leaves to see the water. In this
fairyland, I had a crazy thought: "Do leaves fall unknowingly to their death, or do
they leap off to a new life of making dirt?" The blanket of leaves created the mosaic
flooring of this magical, cathedral-like scene. It very closely resembled an ancient
mature forest of this type. TNC knows how valuable and wonderful the forest is at
this age, as opposed to a clear-cut bunch of muddy weeds ruining a state scenic river
with turbid runoff. Mr. Bransford did well to leave this land to TNC.

Waterways have always been important in the settling of America. Years ago I
talked to Mrs. Tommie Campbell of Minden about the history of Dorcheat Bayou.
She told me about Newitt Drew, who came to the area and set up a sawmill where
Cooley Creek meets the bayou. This land had been an Indian winter campground.
The town of Overton sprang up. When the Red River was cleared in 1835, Overton
became an important riverboat stop as well as the parish seat. After a few years,
railroads and the old military road took away the importance of Overton. As people
moved away, sand and gravel operations chewed the town up, leaving only the cem-
etery. More interesting was a love story that concerned extreme weather in the late
1880s. A man who lived on the west side of the bayou and a woman who lived on the
east side planned to marry. When the wedding day came, the Dorcheat was in flood
stage and too swift to be crossed by boat. By the time the river dropped several days
later to a level safe enough for crossing, the woman had married someone else on
her side of the bayou. One can only speculate that she was in a big hurry to become
a wife! Another weather event happened in 1888 when the Dorcheat froze over. So
solid was the ice that a funeral procession crossed on foot. If only the lovers had
waited until winter to wed.

One thousand-plus acres is big to explore by foot, but small in its overall environ-
mental effect. By protecting the banks of a designated scenic river with nearby na-
tional wildlife refuges, wildlife management areas, and Kisatchie National Forest,
a continuous grouping of preserved areas is created. The combined entity is more
valuable than each area alone. TNC is working this way all over the state.

Sue and I returned in early January to where we stood near Indian Creek in late
November. On our first trip, we thought that winter could not be far off. But today

we saw the real winter. The trees were bare, with almost no color. The leaves on the ground were worn, broken, and muddy. It all looked very different from the soft carpet I had lain down on in November. Indian Creek was a trickle then; today it was 100 yards wide. It was not very deep now, but it had been. We could see current jams of leaves and sticks ten feet up the slightly sloping incline. This is a true hardwood bottomland swamp.

Sue said, "We are not in the same place." I knew that we were, but wondered how it could look so different in 43 days. How does nature change so fast, and why? Every season has a reason, and we humans are only beginning to unravel many of those mysteries.

The bottoms of Indian Creek, a tributary of Bayou Dorcheat, are home to towering white and overcup oaks, cathedral-like in stature and quiet.

Facing page, top: Higher up on the banks of Indian Creek, massive pines stretch to the heavens. *Bottom:* Freshly fallen oak leaves lie artfully on the creek's shallow waters.

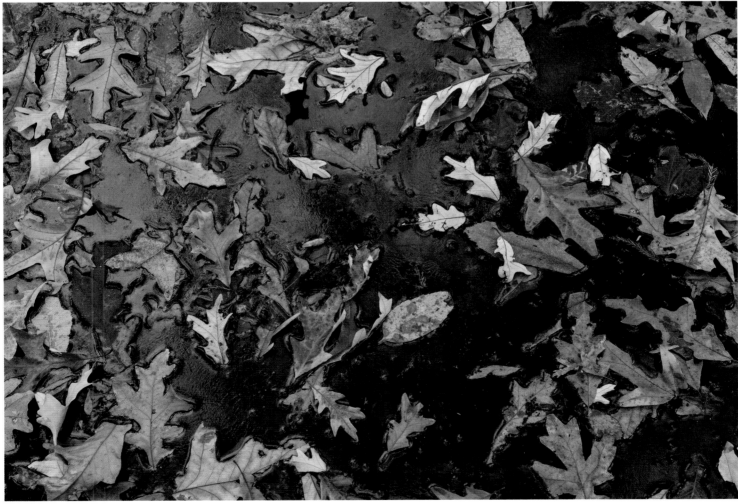

59

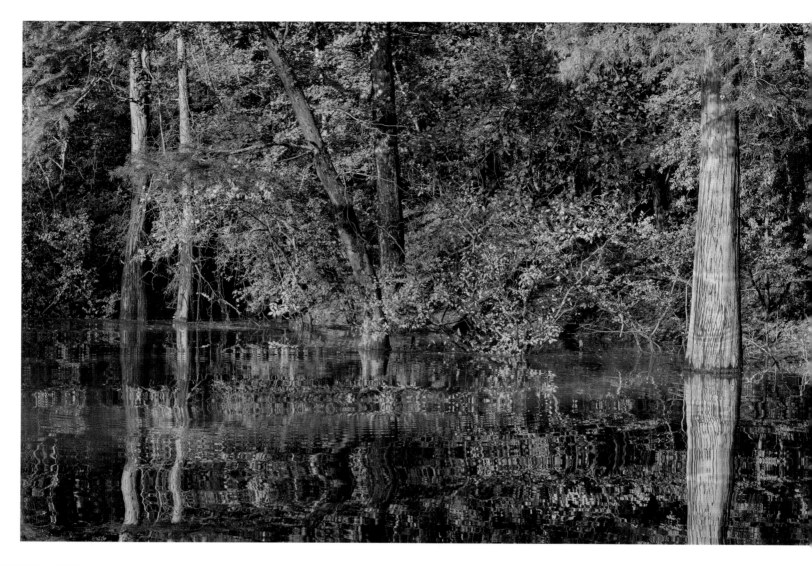

Above: Cypress, gums, and maples adorn the banks of Bayou Dorcheat, a state-designated scenic river.

Left: The Indian Creek bottoms flood in the winter months. The view is totally different than in the summer (page 58).

Facing page: Naked oaks contrast a blue sky on a cold winter day. Down below, their feet are wet as shallow waters cover the acorns that provide food for wood ducks and mallards.

Overleaf: The treasure of early morning on Bayou Dorcheat: water so still and reflective you can imagine rolling marbles across its surface.

Summerfield Springs

654 acres, Claiborne Parish

Upper West Gulf Coastal Plain

A shrew's eye view of an amanita mushroom.

Sidney Smith's eyes darted from Sue and me to my tires every few seconds as he learned of my intentions to photograph the aftermath of his selective cut at Summerfield Springs. Smith is a procurement forester, or timber contractor. When I started following his eyes, he finally said, "You might not make it over the water bars I just put in back there." I thanked him for his advice, and we bounced down the rough dirt road. A few minutes later we crossed the first barrier and my truck almost scraped the mound of erosion-control dirt. Sue was ready to scream, as usual, but with the proper angle I was going to make it over all them without high-centering my truck. When Sue saw thirteen turkeys cross the road, she became mute. I grabbed a quick shot out the window and the flock was gone. Time to hide, as Thanksgiving was only nine days away.

The selective cut looked pretty good. It was not the disturbed-earth view of a clear-cut in a pine plantation. That's about the ugliest land you can drive by in Louisiana. A plantation of pines is a desert habitat lacking scenic and wildlife values, and when it is clear-cut it becomes just plain ugly. Its only value is economic, and when it takes over too much space, disease can become a problem. Erosion, too, usually follows a clear-cut. TNC's philosophy is to manage the properties it acquires as best it can in order to bring the land back as close as possible to its historic habitat. Fire, of course, is a natural tool used in the longleaf and shortleaf pine habitats. Somewhat surprising to us was the use of timber management and herbicides to get that natural state back in sync. A month earlier, Dan Weber took Sue and me to Summerfield Springs as the loggers were just finishing. We watched them pile the big loblolly logs onto trucks. The cut included some old and big trees. Dan said they were of pole quality, so more money would be made to offset restoration costs. This part of the state was historically shortleaf pine. Dendrologists describe it as *Pinus echinata*, 80–100 feet tall by 2–3 feet in circumference; needles in bundles of 2 and 3 about 3–5 inches long; cones 1½–2 inches, ovoid and short stalked; bark irregularly shaped plates with reddish scales. Nature evolved with a plan—a plan that depends on habitat, soil type, and moisture.

TNC hired a timber consultant to mark the trees they wanted cut, all loblollies. Other work to be done here includes cutting the sweet gums and some of the oaks, as well as a few species of unwanted shrubs. A regular controlled burn will help in that regard. We took a walking tour of a few miles and watched in awe as the habitat changed. As we headed downhill to the Corney Bayou bottoms, we went from shortleaf to mixed pine hardwoods and then to an old-growth hardwood bottomland. Once at the bottom, Dan reported that we would be underwater if this were late winter or spring, as Corney Bayou would fill this woodland basement. Right now it was clear and open with new-fallen leaves. I asked about TNC's future plans for Summerfield. Dan said, "I hope they leave it alone to continue as it would have before man entered the scene." If I had a time machine, I would go back and look at

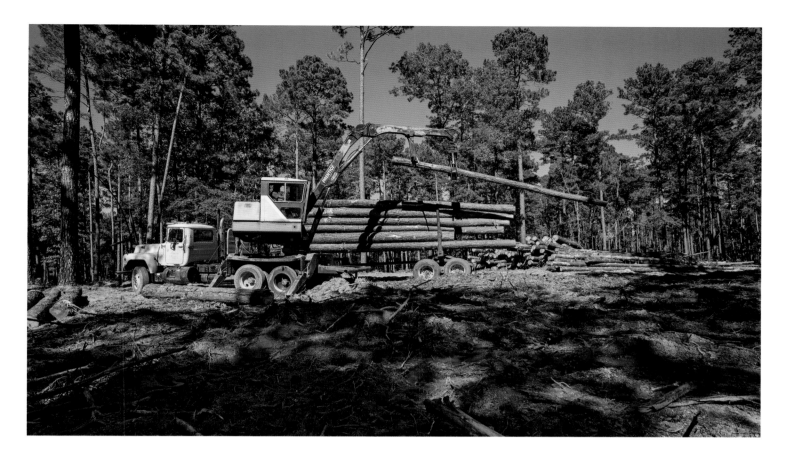

Cutting the loblolly pine to restore the shortleaf pine/oak-hickory habitat of Summerfield Springs also brings revenue to help fund the project.

all the forest habitats in Louisiana and see how they looked when the forests were virgin.

Managing forest areas with selective harvest and herbicides is a hard concept for some naturalists to swallow, but the cut we walked through looked like the cleaning of a crowded house. Man messed it up, so man has to clean it up and repair it. As we started down the hill through the oak-hickory habitat, Dan proclaimed it was a job well done and necessary for rebuilding this forest. As we entered the clean understory of the bottomland, no vines tangled our steps. It flattened out and the arrangement of the big cypress was artsy, yet orderly. It appeared as a true Magic Kingdom to all three of us. This swamp, this wetland, is now being preserved for its highest and best use—for clean air, water, recreation, and wildlife habitat. If this were cut, it would become a nasty mudhole filled with scrubby shrubs and worthless weeds and would remain in that state for years to come. Too wet to farm. Let it be.

Closer to Corney Bayou, I stopped in a dry channel to write a few notes. The wind picked up, and I felt a gentle pelting from above. What's this, I wondered? Inspecting the solid droplets, I found them to be the tiny seeds of the sweet gum—food for goldfinches. The seeds felt good peppering me as they mixed in with the fallen leaves covering acorns from the overcup oak. As the water rises in a few months, these acorns will be food for ducks, especially the dabbling wood ducks. Low sunlight from the side turned the brown and gray tree trunks into silver pillars. Small groups of blackbirds foraged on the forest floor while woodpeckers were noisy above. Owls hooted, titmice called, and the hungry searching vultures soared overhead.

As we returned to the top, the cutover land looked a bit worse since we were coming from the untouched bottomland paradise. I imagined the future when the cut limbs and branches will compost into rich soil. The cut will hardly be noticed in a few years as the shortleaf pine trees begin to outnumber the loblolly pine, and when that happens Summerfield Springs will shine from top to bottom. Donor Catherine Sale's vision of her gift to TNC being kept in its natural state lives on.

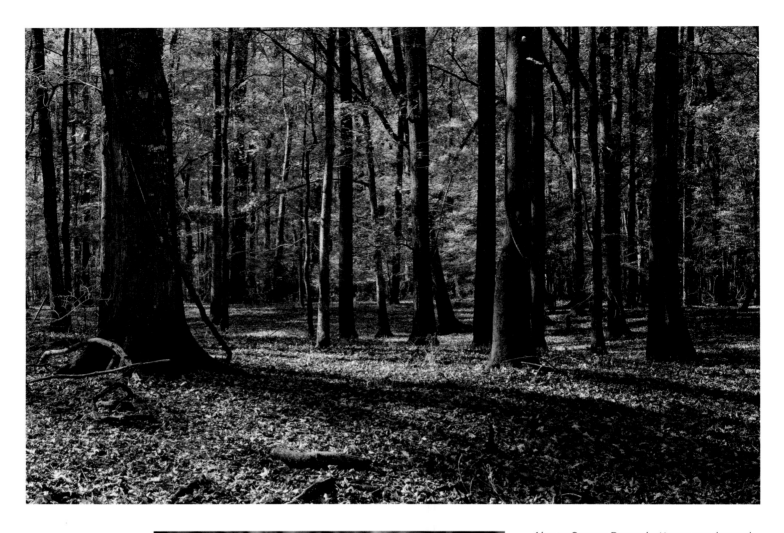

Above: Corney Bayou bottoms are dry and free of understory growth in the summer and fall.

Left: Higher up on the ridge, Eddy Sherman uses a call to attract wild turkey.

Louisiana Pine Snake

Rarest snake in North America

Bienville Parish

Co-op Project

The Louisiana pine snake.

The most striking creature we caught in the sandy soils of Bienville Parish was the six-lined racerunner. This colorful lizard looks like a piece of Navajo jewelry, with its turquoise belly, reddish orange legs, and pictographic lines running parallel the length of its physique. Two of these were among the eight coachwhips, two black rat snakes, a cottonmouth, seven southern leopard frogs, a bullfrog, two tarantulas, and a wolf spider caught in a special snake trap. This was all in a day's work for Natural Heritage zoologist Beau Gregory of LDWF. Beau is in the sixth year of a research project to learn more about the Louisiana pine snake, *Pituophis ruthveni*.

This secretive reptile is known as the rarest snake in North America and may soon be put on the endangered species list. If that happens, a training area at Fort Polk may have to shut down maneuvers in Vernon Parish because it's the only other prime habitat for this rare snake in Louisiana. The snake has been found in a couple of places in Texas, but recent studies suggest it is now extirpated there. TNC has stepped in to help the Army, Kisatchie National Forest, LDWF, and others to make a preserve in Bienville Parish on private land. This mitigation project would protect and set aside lands for the snake so that the Army can continue to use its training ground.

Beau tells Sue and me that there are upland sandy soil pockets all over the state, but this part of the pine snake habitat is the largest. These sandy areas were laid down in an ancient shallow sea. His first trap site is called the Sandyland Core Area, and he has five traps there. Following Beau to the next trap reminds me of walking on the back side of a Florida panhandle barrier island—sand covered by sparse plant life. We pass the stadium-like mound of the Comanche harvester ant. This ant is a recent migrant to the area from the West, circa 2006. The orange, black, and tan grains of sand give a telltale sign of the color of the earth below.

Although we did not catch a pine snake today, luckily Beau brought one to release that he caught a month ago. His procedure with captured pine snakes is to keep them for a month so he can see what they are eating from a stool sample. He takes blood, hopes for a shed skin, and inserts a pit tag under the snake's skin. A pit tag can be detected when you have a snake in hand, but not remotely by any type of radio equipment. Without legs, snakes are impossible to band like a bird.

The Louisiana pine snake is here because it likes to eat the Baird's pocket gopher, *Geomys breviceps*. The gopher is here because of the sandy soils. Between the ant mounds, we found numerous pocket gopher tunnels that had been made throughout this sandy soil. You rarely see either of these creatures because they live most of their lives underground. The best place to see one is in a zoo. Steve Reichling, curator of reptiles at the Memphis Zoo, has been studying this snake since 1984 and has seen only one outside of a trap. He is also the head of the species survival plan for this snake. He oversees 109 captive snakes housed in twenty-three zoos accredited

A Louisiana pine snake just released by Wildlife and Fisheries biologist Beau Gregory in Bienville Parish, where he is conducting research on this rare snake.

by the Association of Zoos and Aquariums. Each female lays 3 to 5 eggs; only 30 percent hatch. The threatened snake is rare because of loss of habitat and a slow reproductive rate. It will take a while to recover. The snake's eggs, five inches long, are the largest in North America, and the newborn young are the largest hatchlings, at eighteen inches long.

The first thing I thought of when I saw Beau's trap was that it looked like a Cajun has gone terrestrial. The 4' by 4' box has chicken-wire cones like a crawfish trap. The snake crawls in and rarely figures out how to find the small hole and escape. Four fences, each about 50 feet long, lead the snake up to the entrance. Two water jugs keep the captives hydrated, and towels make hiding places. Beau developed his own special tool out of coat hangers to open the trap door and look around the edges because you never can tell what other creatures will be in there. Bitten many times in his career—like anyone who works with wild creatures—he grasps the snake by the tail and runs a hand up the body to secure the head. On poisonous snakes he uses tongs. The coachwhip snakes were the most exciting when caught. Most are two toned and very slender. They whip around like their namesake and when released are off like a streak of proverbial greased lightning. Beau says the pine snake is a non-biter, but it is strong and rolls like an alligator when handled and also hisses loudly when irritated.

Looking around the second trap site near Kepler Lake, I saw more longleaf pines 15 to 20 feet tall. I was surprised to find out that the drought-tolerant longleaf can compete in dollars with the plantation loblolly pines in this sandy habitat. The current landowner has a contract with International Paper to supply a certain amount of lumber over the next fifty years. So this land will most likely stay in forest. This factor, along with the mitigation agreement between the landowners, TNC, LDWF, the Army, and Kisatchie, means that there is hope for the rarest snake. I read in a 1908 report by the Bureau of Soils that southern Bienville Parish was covered by virgin timber until 1837 with plenty of fish and game for those settling the region. With the team involved, we have a chance to bring some of that area back to its natural state and, with a little luck, this snake along with it.

Mollicy Farm

Upper Ouachita National Wildlife Refuge

Morehouse Parish

Co-op Project

We use machines to destroy habitat, so why not use them to repair it? TNC, the U.S. Fish and Wildlife Service, and other partners are doing just that at Mollicy Farm. The first time I saw Mollicy Farm was from a machine—Harris Brown's flying machine, a Cessna 185 Skywagon. We took off at dawn from a grass strip on his property and flew right over the heads of a herd of foraging whitetail deer. Once in the air, Harris said, "You will know when we are there, it will look like a big patch of brown surrounded by a whole lot of green." He then contrasted this with Tensas River National Wildlife Refuge (NWR), which he calls a big patch of green surrounded by the brown fields of Mississippi Delta farmland.

You see, this farm is smack dab in the middle of Upper Ouachita NWR. It was a farm—a failed farm—and one of the many patches of hardwood bottomlands that were cleared in the late '60s when soybean prices skyrocketed. Mollicy was bought and sold numerous times; many of the farmers there went bankrupt. It was finally

At Upper Ouachita NWR, the dense oak canopy shades out the forest floor. In extreme years the river can flood this area in excess of twenty feet.

69

Above: Trackhoes dig to replicate the original Mollicy Bayou, which was filled in and straightened in the 1960s when this area was converted to a soybean farm.

Below: Swamp sunflowers decorate the banks of a pond on Mollicy Farm.

switched to rice because it was so hard to keep dry enough for farming beans. The 16,000-acre farm took an 8-by-3-mile swath out of the Ouachita River bottomlands. The bald cypress and oaks were bulldozed into 100-foot-high piles and burned. Such a waste is a sad thing to see. A levee was built around the farm, and Mollicy Bayou, which runs through the farm, was straightened into a drainage ditch.

It was foggy as we flew in and Harris circled expertly as I took picture-perfect shots of the thick mist over the river, the farm, and a patch of bald cypress trees. Soon the rising sun heated the land up, and I saw two track hoes simultaneously moving dirt and digging a sensuous S-curved bayou. Between the two digging machines I could see a man with a measuring pole. I found out later that it was Chris Rice, TNC Northeast Project Assistant, and that he was directing the heavy equipment to re-create the waterway in the exact location that Mollicy Bayou once occupied. Core soil samples were taken earlier to map the historic path that the bayou had followed.

How cool is that—concerned humans working the disturbed earth and bringing it back as close as possible to nature's way? Harris continued to fly me around and

The levees around Mollicy Farm were breached by the Ouachita River in flood stage just before the Fish and Wildlife Service and The Nature Conservancy were planning to do it with machinery.

around the farm. We saw the two natural breaches in the levee where the Ouachita River broke through in the high water of 2009. This happened for free, just a few months before the construction crew was going to do it.

Brothers Keith Ouchley, director of TNC Louisiana, and Kelby Ouchley, manager of Upper Ouachita NWR, had a dream to do this when the U.S. Fish and Wildlife Service acquired the failing farm property. This may be the very first time that man has gone back and restored a bayou to its natural course—and, in the process, re-created many square miles of floodplain, ever so necessary to Monroe, Louisiana, and other surrounding towns to ease the Ouachita River's flooding outbursts.

The deer were gone when we landed. Sue and I headed up Highway 165 to meet Dan Weber for a land tour of this farm fifteen miles northwest of Monroe. He took us directly to the restoration area, where the heavy equipment operators were still hard at work. The drivers were good. Watching them, I envisioned robotic sculptors working in unison as Chris, the project manager, directed with his survey pole like a concert conductor's baton. At their lunch break, we met Chris. I told him I wanted to canoe this bayou as soon as it is connected; Chris told me he has been planning the same. He said the digging of the main part of the bayou was almost done. He explained, "Next winter we will plant bald cypress and flood-tolerant oaks along the banks. Then finally in the summer we will bust the plugs at each end and Mollicy will flow from its headwater to the east and back into the Ouachita River."

On a cloudy day in February I went back for the tree planting. About sixty volunteers from nearby areas were given lessons in planting and off they went down both sides of the restored bayou. They were having fun and helping in the final stages of this landmark project. Much of this type of work on all TNC properties comes from volunteers. The ones I talked to enjoy the work and the cause. TNC has planted

Refuges on the Mississippi Flyway

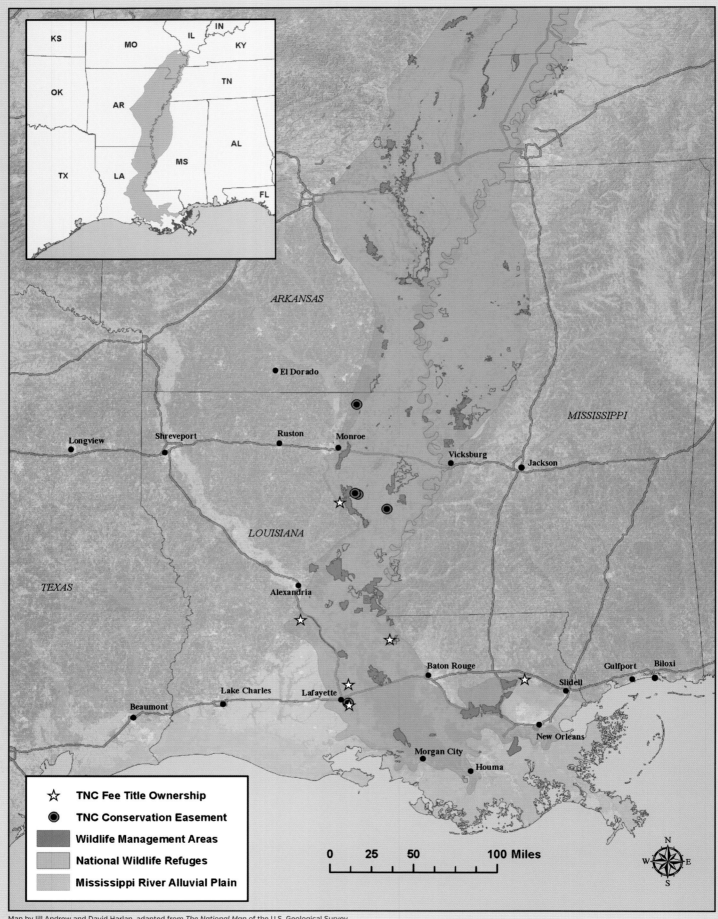

KS
MO
IL
IN
KY
OK
AR
TN
TX
LA
MS
AL
FL

ARKANSAS

● El Dorado

◎

MISSISSIPPI

Longview
Shreveport
Ruston
Monroe
Vicksburg
Jackson

☆ ◎
◎

LOUISIANA

TEXAS

Alexandria

☆

☆

Baton Rouge
Gulfport Biloxi

Lake Charles
Lafayette
☆
☆
Slidell

Beaumont
☆ ◎

New Orleans

Morgan City

Houma

Legend

☆ **TNC Fee Title Ownership**

◉ **TNC Conservation Easement**

█ **Wildlife Management Areas**

National Wildlife Refuges

Mississippi River Alluvial Plain

0 25 50 100 Miles

N
W E
S

Map by Jill Andrew and David Harlan, adapted from *The National Map* of the U.S. Geological Survey

Private and public refuges along the Mississippi Flyway may one day be linked, providing a protected corridor for waterfowl and mammals through the Mississippi River Alluvial Valley.

about 2 million trees so far in Louisiana. After the planting was done and the folks dispersed, I went to the observation tower to look for waterfowl. To the northwest are a few scattered bald cypress, maybe left as lunch trees. Many farms do this. I saw two bald eagles and a small nest of theirs. I found out later that the nest from last year was brought down in a storm; they are back and rebuilding. This wetland is a textbook habitat for our national emblem. With the breaches in the levee, these lands will return to their bottomland swamp cycle—flooded and wet in the winter and spring, and drying out in the summer and fall, with Mollicy Bayou and the other small streams to carry water year-round.

Areas like this are perfect habitat for wintering waterfowl, as Sue and I saw on one of the coldest days of the year in early January. After photographing ice on the shallow ponds at the edge of the flooded farm, I got out what I call "Big Bertha," my 600 mm camera lens, to watch and photograph about 2,000 ducks. It was mainly mallards feeding in the fading light. There is nothing prettier to me than a sunset with a flock of ducks, wings cupped, heading for their nightly feeding grounds. It was about 18 degrees when we got back to the truck. Down the narrow dirt road I saw something . . . naw, just a stump. I finished loading and looked again before starting the engine. It was three stumps now. I grabbed the binocs and saw wild hogs. They were digging in the road and crossing back and forth. In the low light I could see some color differences—black ones, black-and-white ones, and some colored with shades of reddish tan. Coming and going there must have been ten or twelve of them. I motored up slowly, freezing with the windows open. They left the road, but when I stopped I could hear them digging and rustling in the high brush. We observed wild hogs on many TNC properties and even watched them feeding on the side of I-49 in daylight hours. There are definitely too many of those invasive critters around. There seems to always be a problem that needs a solution in our wildlife world.

I flew Mollicy again in late spring, this time in an Air Cam. This unique plane is owned by Chris Kinsey, a TNC board member, and it was flown by his pilot, Clinton Camp. Even though it was May, we had a weirdly cold morning. I knew I was in trouble when I noticed that Clinton, already dressed in warm-looking coveralls, had added a leather jacket with a fur collar, insulated helmet, and gloves to his wardrobe. I was wearing only a light jacket. The reason this matters is that this fire engine–red airplane can be described as a hot dog or banana cut in two lengthwise. There is no top. That is the point; it is for photography. What a view, what a photography machine. And what an unforgettable, chilly ride!

I look back on my flights and realize how much more green is coming. TNC is on the cutting edge of linking refuges together. Along with the U.S. Fish and Wildlife Service, state wildlife management areas (WMAs), and other like groups, they are forming a corridor from top to bottom of the Mississippi flyway. Black bear, waterfowl, and many other creatures will have this natural passageway to roam freely. Maybe, just maybe, the bird they call "the Holy Grail"—the ivory-billed woodpecker—will have a secluded place to thrive, granting that any of the recent sightings in nearby Arkansas are true. A rallying cry is, "Let the floodplain flood!" This is good and logical, since that is the highest and best use of that land. Eighty percent has been cut and cleared, causing flood problems. If allowed to recover, those areas will do much to create an improved habitat, for both humans and wildlife alike.

Overleaf: Fog embellishes an aerial view of bald cypress trees on Mollicy Farm.

73

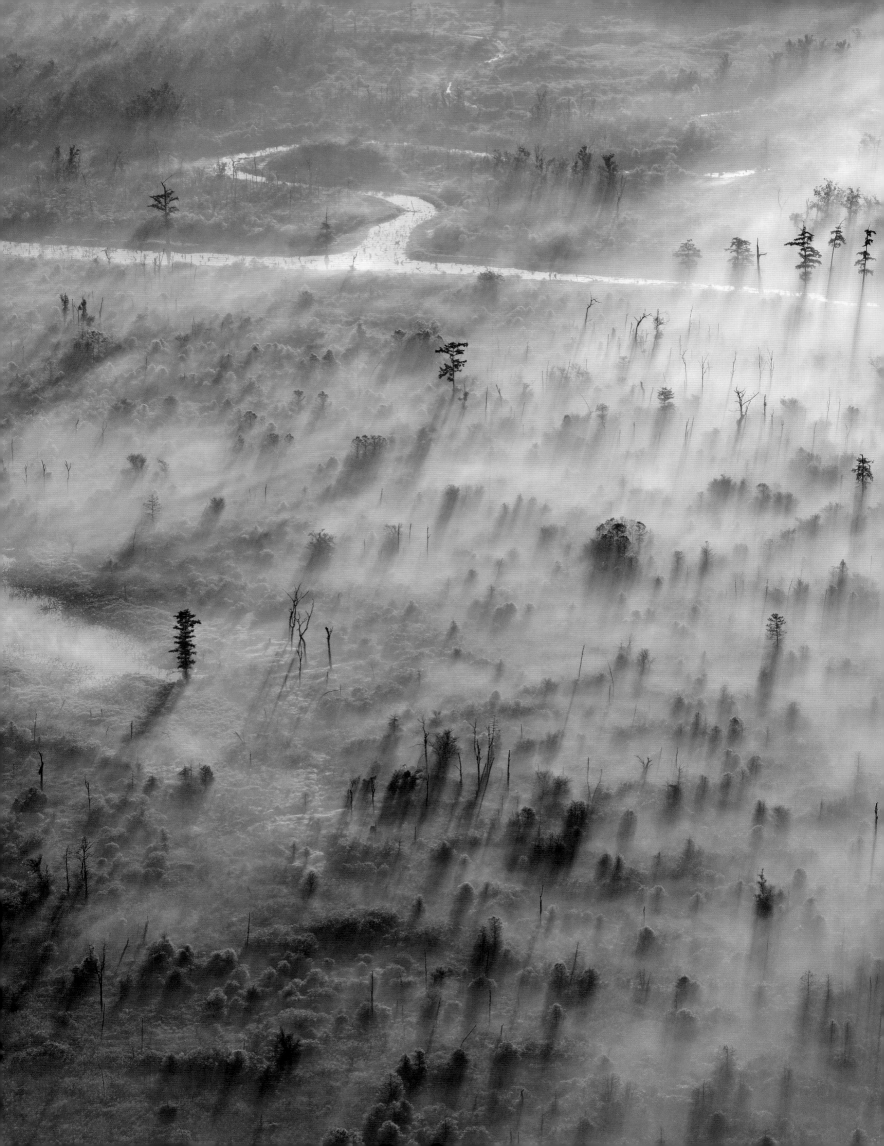

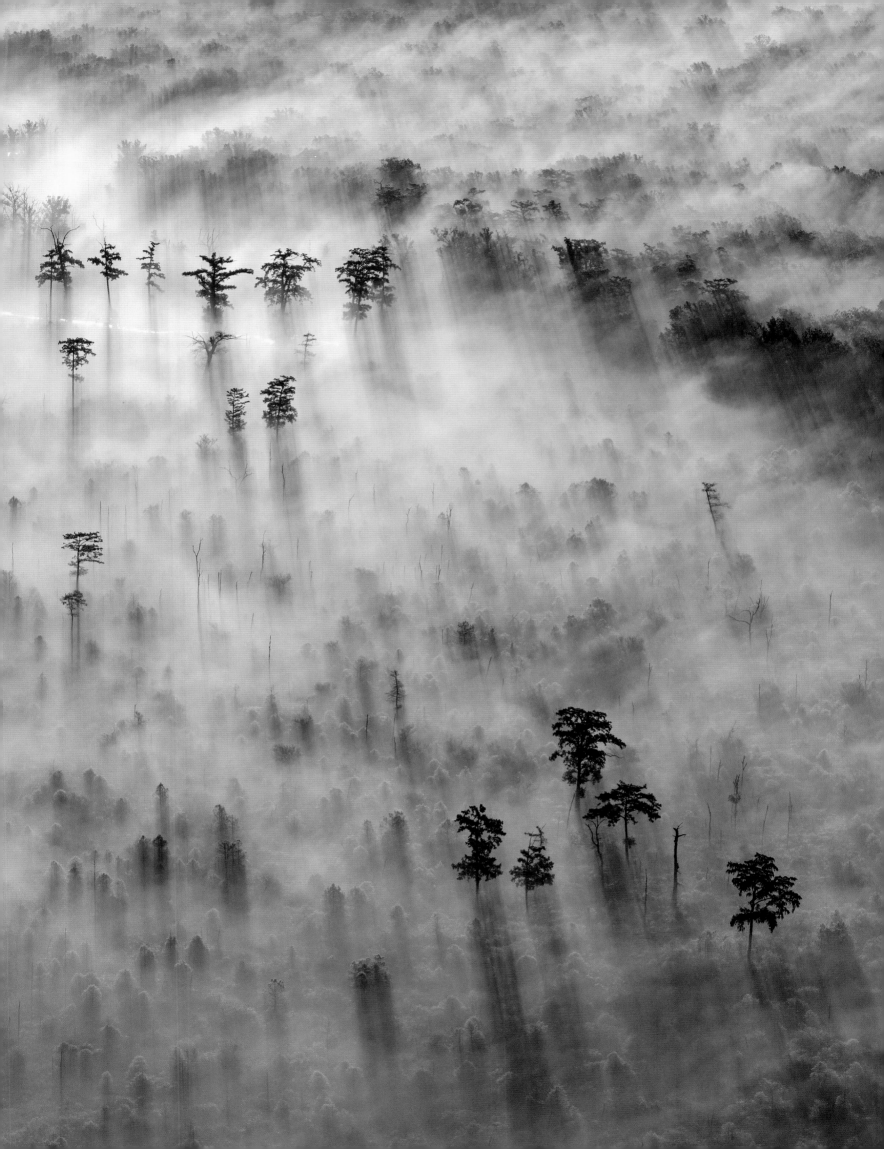

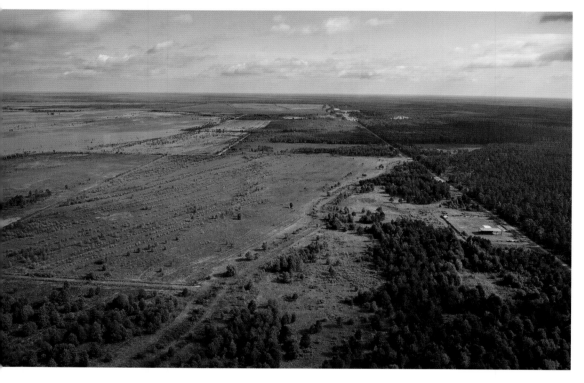

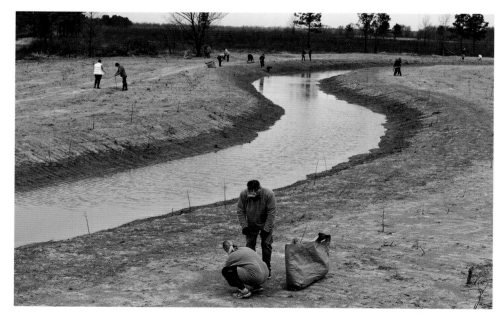

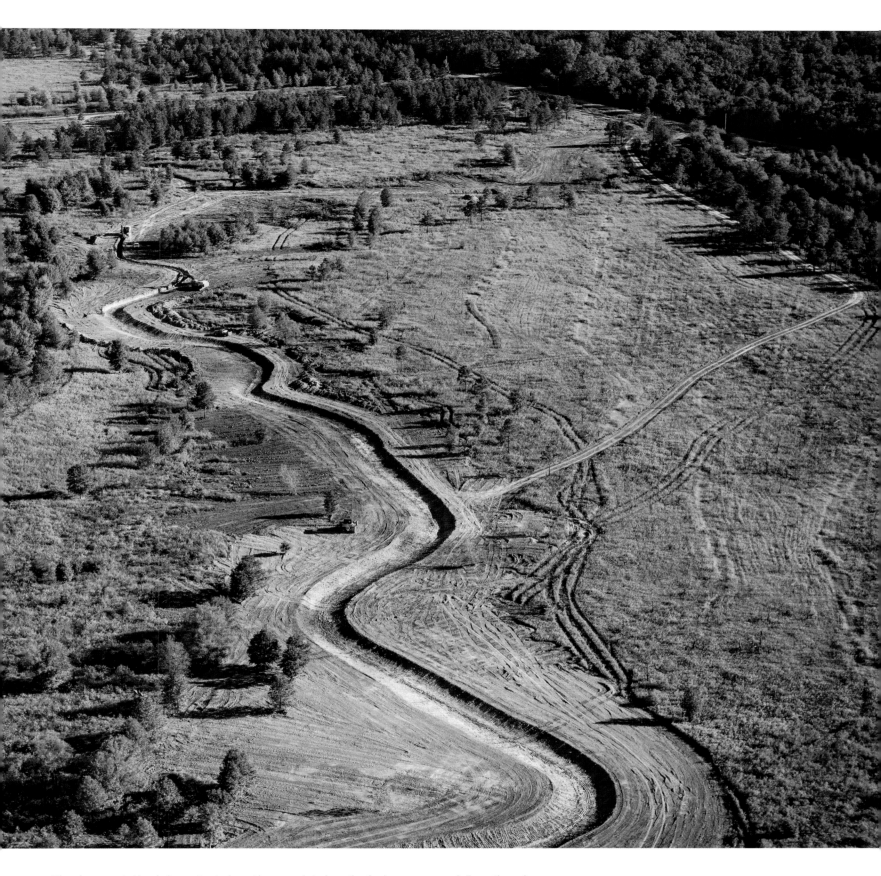

Riparian vegetation is important along the complete length of a bayou or canal. Even though the waterway (*top left*) passes through thick forest, part of it runs through bare farmland, causing continuing turbidity. The Mollicy Bayou restoration project as seen above from the air will bring the bayou back to its natural state with bald cypress- and oak-lined banks from volunteer planting (*bottom left*). Much restoration has already been done on the 16,000-acre farm (*middle left*). Its agricultural wetlands are being transformed back into hardwood bottomlands.

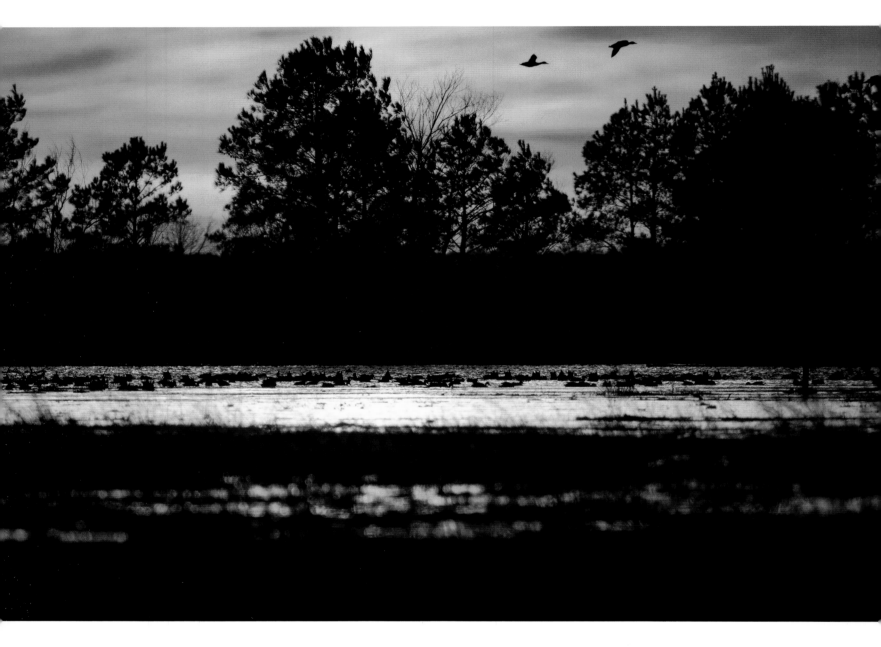

When the winter rains swell the Ouachita River overflowing Mollicy Farm, flocks of mallards and geese as well as other water birds congregate in the food-rich shallow waters.

Bats in Trees with Cypress Knees

Upper Ouachita National Wildlife Refuge

Chris Rice casually asked Sue and me if we were interested in bats. We said "yes" at the same time. Chris did his master's thesis on two species of bats that roost in trees in the Upper Ouachita NWR. During the three-year study starting in 2006, Chris took 122 trips into his focus area, which was a 1,700-meter stretch of a slough that drains into the Ouachita River. That's about a mile; we joined Chris on a hot and humid day in June to visit his study site.

On the west side of the refuge we started our hike into the area. The second-growth bottomland forest was level and fairy clean, making easy walking. The slough carved its trench about ten feet below the forest floor and had a few feet of semi-clear water running at a slow flow. At the water's edge both the bald cypress and the tupelo were old, wide based, and tall. I felt like a midget in a land of giant trees. At least sixty trees, Chris's study trees, had basal openings and were hollow. These qualities made them suitable for bats both to brood their pups and to roost. The two species of bats that use these trees in the summer months are the southeastern myotis, *Myotis austroriparius*, which have their nurseries in trees with a basal opening at ground level; and the Rafinesque's big-eared bat, *Corynorhinus rafinesquii*, which hangs on the side and can live in trees with holes at the top, bottom, or both.

Chris crawled in tree no. 7 and said he counted at least seventeen Rafinesque's big-eared bats. Then it was Sue's turn. She slinked in the muddy hole to take a look and came out buzzing with excitement. "The ears," she said, "are huge." Finally, I crawled in wheelbarrow style and lay my head down in a big pile of guano. In the illumination of my flashlight I saw those giant rabbitlike ears, which are 30 percent of the body length. The bats were staring at me nervously and echolocating me. It was breathtaking, dirty, and fascinating—and ten times better than the next stop at tree no. 27, where the southeastern myotis roosted about thirty feet up in a mass of about 200 bats. I say better because these bats were directly above me and the guano came down like smart bombs magnified in my 200 mm lens viewfinder. Click a photo, then, *boom,* the first strike was my left eyebrow with a little on my glasses, next my cheek, shoulder, chest, and finally the lens. This was becoming our dirtiest day of the year. Before sliding out, I caught a glimpse of a spider near the bats, so big I thought it was a crab. Creepy.

We walked Chris's entire study line and got in every tree that had room for me, my camera, strobe, and Q-beam. It was hard to hold the light and the camera to get a good focus, but with persistence I succeeded. The huge, rounded exposed roots of the tupelo were artsy, the bald cypress knees tall. We commented to Chris on the quantity of big trees and he replied, "Wait until you see the last one on my trail." He was right—a granddaddy bald cypress. It had a mostly solid trunk, but enough hollow where some bats roosted. Chris told us matter-of-factly he had lain down to peer in this hole one day while doing his work for his master's thesis. Before shining his light into the cavity, he noticed a water moccasin lying just 18 inches from his

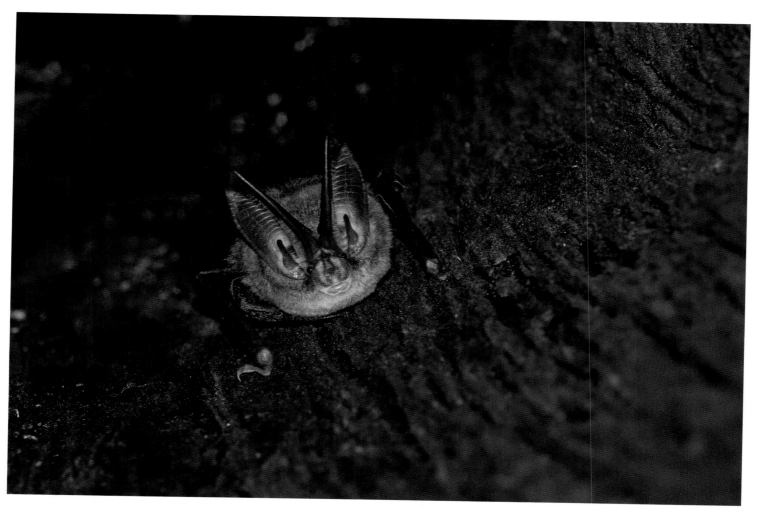

"All ears" is a good way to describe the Rafinesque's big-eared bat, whose ears take up 30 percent of its body.

neck. This kind of study is not quite the same as getting your master's in economics. He calculated that on all his trips out here, he encountered an average of six water moccasins per trip. For the record, we saw four that day. We lingered waiting for dark, hoping to see the bats leave their roost.

We set up near the base of tree no. 27. A pod of red-shouldered hawks screamed about 6:30 p.m., and at 7:40 the barred owls chimed in noisily. In the background we heard the constant rumble of thunder. Then at dark the bats came out, not in flocks like those at Carlsbad Caverns, but one at a time. Chris was hoping I would get a good clear shot of one coming out of the tree. Hours went by as I tried to time my shutter release with a bat flying out. So fast, they came like miniature rocket ships. About 11 p.m. we felt the first sprinkle. We were covered in guano, our glasses and camera lenses were fogged up with humidity, and we were tired, hungry, and now wet. The rain came warm and hard, and we ran covering cameras, holding headlamps. After the near-mile sprint, Chris told us how important these under-appreciated mammals are. Both species can eat their weight in insects every night. Chris said, "Some of these trees house 1,000 bats at a time. If a single bat can eat 4,500 insects in a night and 1,000 bats can consume 4.5 million, imagine what Louisiana's 13 native species can accomplish." Seems to me, bats are more valuable in insect control than the city trucks spraying mosquito poison.

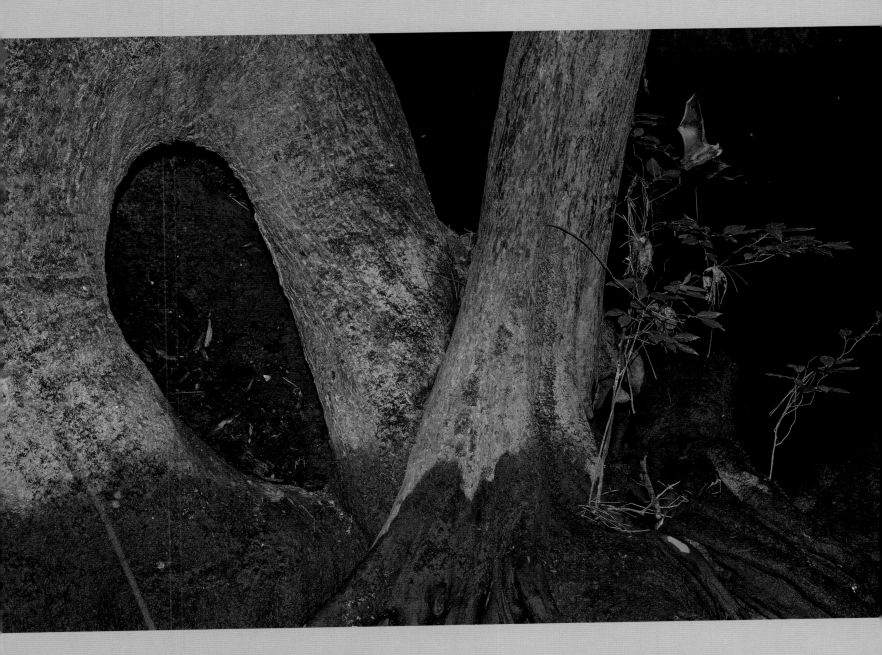

The southeastern myotis roosts in large
colonies. This tupelo tree had two hundred
bats in it.

Caddo Bayou Black

656 acres, Caddo Parish

Upper West Coastal Plain

A pair of common buckeye butterflies mating at Caddo Bayou Black.

This 656-acre biodiversity preserve was purchased as the only known protected example of western xeric sandhill woodlands in Louisiana and rare plants that like this soil type. It's as close to Arkansas and Texas as you can get, being about a mile from each of those states. Some of the rarer plants here have strange names such as pale umbrellawort, Louisiana squarehead, and panicled indigobush. As in any area in Louisiana, this refuge also has some swamp and bottomlands next to Bayou Black.

Before heading to the sandy area, I was looking around a black-water swamp pond when I saw a mushroom about three feet up in a small tupelo tree. It was growing in a crack. After tediously setting up my tripod—it is always hard low and close to a tree—I took a wider look at my scene. The pointed crack was the start of a basal opening on this tree. Chris Rice and I have discussed why this happens so often to water tupelo trees and sometimes to bald cypress. I would have thought this occurs when the tree is much bigger, but here it was on a tupelo young and small. The tree was right on the edge of the pond, just as the ones at Upper Ouachita were at the edge of the bayou. I could have pulled the piece out of the trunk. Chris speculates that the trees want to grow wide at the base for the wet soil and need the outer layers to grow faster, the inner dies and sloughs off, a chimney forms, and rain washes out the middle and keeps it from rotting. Good theories. And this process is all to make a home for bats, raccoons, opossums, and other creatures such as the spiders I saw in there.

On the sandy hills you could literally pull up a few plants and have a clean sandbox for your five-year-old to play in. Due to these harsh conditions, the flowering plants were spread out. I photographed while Sue searched for new species. The bees were busy, the big bumblebees somewhat cooperative. In fact, when you looked close, insects were all over these plants and grasses. The most special was a pair of common buckeye, *Junonia coenia* butterflies locked together mating. I watched and photographed and wonder why the top sides of the wings are so colorful and the bottom nearly plain. I found out from Dr. Gary Ross that quite logically the underside is dull so that when resting the insect is camouflaged. When mating, it shows off its fancy colors.

Caddo Bayou Black is off the beaten path and not visitor friendly, but a special and necessary refuge in TNC's catalog of diverse habitats in Louisiana.

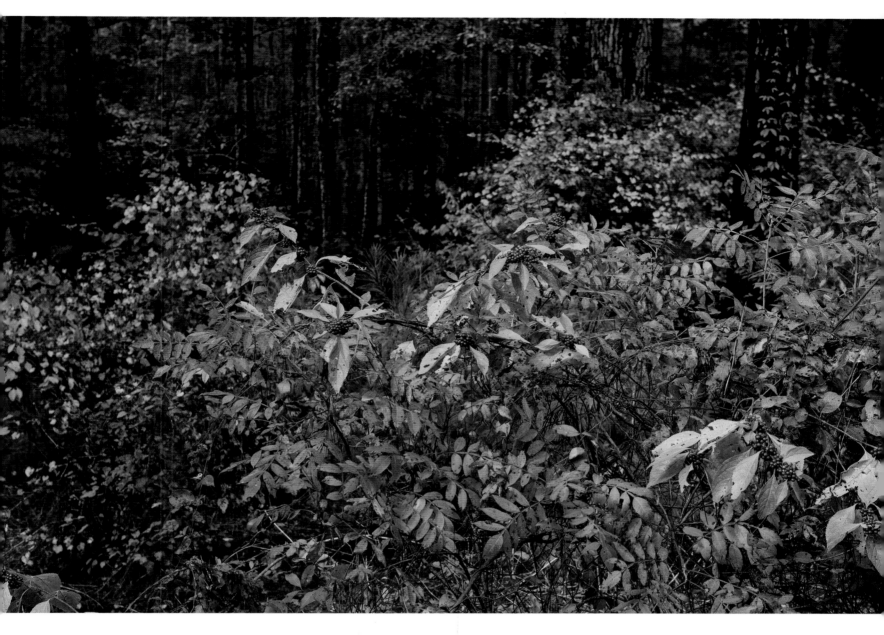

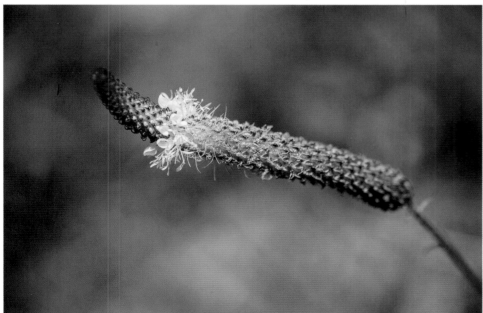

Fall brings the bright colors of sumac and French mulberry (*above*) as slimspike prairie clover blooms in the spring (*left*).

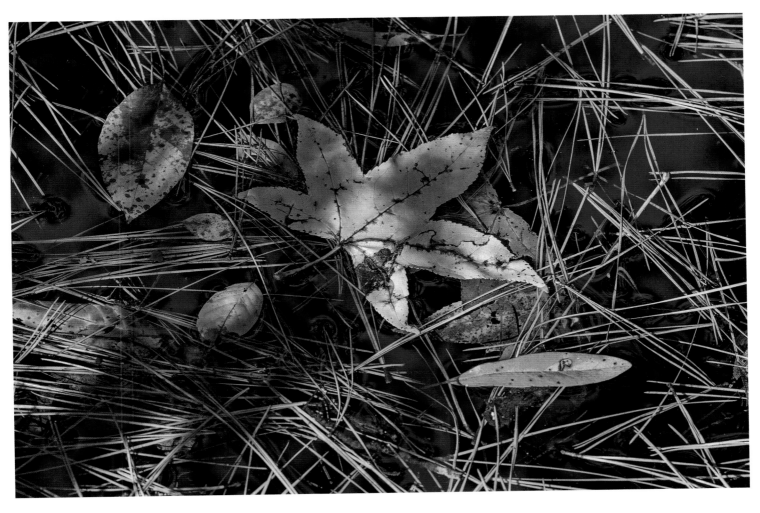

Above: A sweet gum leaf floats on a black-water pond with pine needles.

Left: Wild verbena blooms in the summer.

Facing page: In the fall, black gum turns a candy apple red.

Grand Isle, Lafitte Woods, Bollinger Marsh

157 acres, Jefferson Parish

Gulf Coast Prairies and Marshes

Louisiana iris on the trail at Lafitte Woods.

I love the work of Fonville Winans. I also had the pleasure of knowing the man. We talked photography and traded portraits of each other. In our genuine good times together, we relished discussing boats and bayous. Grand Isle was another of our joint joys. My houseboat was the *Bayou Wanderer,* where I lived tied to the banks of Bloody Bayou in the Atchafalaya Basin. Fonville's boat was memories only as it died and melted into the marsh at Avoca Island many years ago. Fonville's journal, published in 2011 as *Cruise of the Pintail,* is full of entries about his time on Grand Isle. Talking about the Grand Isle people, Fonville writes, "Born and raised on the island, these natives live in dilapidated houses that are scattered indifferently beneath the sea-blown and gnarled oaks that cover most of the higher ground. The wooded section is a veritable tropical garden. Everywhere the tall oleanders are in profuse bloom."

Around 1760 Captain James Cook visited Grand Isle on a mapping expedition for England. He mentioned that the island was covered in oaks and had a sweet smell. Jean Landry, TNC's Grand Isle program manager, tells me those were the live oaks that covered all the high ground on the island at that time and the smell was from the false indigo in bloom. Today funky cottages are still haphazardly tucked among the remaining live oaks as modern fishing camps line the beach in orderly fashion. Sadly, only 10 percent of the live oak habitat remains. Many of the trees that still exist are in a TNC preserve. The maritime forests attract bird-watchers, especially in the spring when neotropical migrants need these woods to stop and rest, drink and eat, after crossing the Gulf of Mexico. It took me four days to cross the Gulf in a sailboat; these birds, only a few ounces of muscle and feathers, do it in 20 hours. One weekend each spring, Grand Isle hosts a migratory bird festival. This year I had my big lens ready while walking TNC's well-manicured trails through the live oak forest. I was hot on the trail of bright and colorful migrants. My wife and Sherpa Sue was close behind with bird books, binoculars, and the rest of my lenses.

Red, scarlet tanager. Orange, orchard oriole. Yellow, Kentucky warbler. Rose, rose-breasted grosbeak. Gray, gray catbird. Brown, wood thrush. Blue, blue grosbeak. Green, painted bunting. Those colors are not descriptive enough—all these birds have more than one color. And when you see the painted bunting, it will startle you with its pleasantly shocking array of colors. Its bright blue head with hazel eyes sits above a red throat and belly, while dark wings contrast with a multicolored green back that sometimes looks kind of yellow. Hoping to see one, I was standing eyes glued to my big lens pointed toward a red mulberry. This tree is the gas station for avian migrants. For many species, the purplish berries are their first meal after their epic Gulf of Mexico crossing. About twenty other photographers and bird-watchers were beside and behind me including Dr. Michael Adams, a den-

Camouflaged, the great southern white butterfly rests on the seed of a black mangrove.

tist from Raceland, who was jabbering away about all the birds. He was identifying every bird that landed and relating relevant information to the others, especially one lady who was waiting anxiously to see a painted bunting. He was explaining that some people call it the "Oh my god bird." Former governor Mike Foster, an avid bird-watcher, has also mentioned this term of endearment to me.

The woman was discussing this bunting with the rest of the birders as tanagers, orioles, and grosbeaks flew in and out of the tree. When a male painted bunting finally showed up, she looked with binoculars and screamed, "Oh, my God!" Dr. Adams said, "I told you so." If you come in the spring, you will get to see most of these birds and more. Good bird-watchers can see 110 birds on a spring day if they cover the entire island. On a yearly basis, 324 different species of birds have been recorded on Grand Isle. Grand Isle has many habitats from the bay to the sea, so it's not only the spring and fall migrations that bring birds here. Besides the pelagic birds offshore, birds are attracted to the beach habitat, ponds, tidal mudflats, the live oak forest, the marsh, the back bay, and nearby small islands.

The Grand Isle Migratory Bird Festival, held each spring, brings lectures, field trips, food, arts and crafts, and plenty of bird-watching. Jean got it started in 1998 with about 50 participants and a pot of spaghetti. Nowadays the Grand Isle Sanctuary Group has taken it over and there are not quite as many birders as birds, but it feels like it.

Earlier at the Grilleta Tract, we ran into Michael Seymour and Dan O'Malley, who were setting up their bird-banding station. I told them about my book and Michael asked what I was looking for. I confessed that after 43 years of photography I had yet to get a good shot of a painted bunting. He said he would try to do something about that. The two ornithologists and helpers set up a bird-banding station

here each year. Three mist nets are strung up between ten-foot poles. Twenty to forty birds are caught each day. The birds are weighed, measured, sexed, aged, and banded before being released. This study is not only for research but also to educate the constant flow of bird-watchers. The extensive trails through the oak-hackberry forest set up by TNC in 2002 were the first birding trails in Louisiana. Sue and I hiked down the trail to check out the nets and were surprised to find a male and female painted bunting caught. We went back and told Michael. He retrieved the two birds and processed them while explaining what he was doing to the growing crowd.

The 125-acre Bollinger Marsh donation adds waterfowl and shorebird habitat to TNC's maritime forest. This tract of salt marsh is on the bay side of the island. On a cloudy fall day, Jean showed us the boundaries and shared some history. This land at the end of Plum Lane was a sugar plantation in the mid-1800s. The area was leveed and pumped dry by windmills. There were a few successful crops, but storms caused the sugar business to go bankrupt. Later the plantation home became a resort owned by John Krantz. The elegant "gilded age" of Grand Isle hotels was short

The brown pelican was successfully brought back from extirpation in Louisiana and thrives along the coast, with nesting areas near Grand Isle.

lived as the hurricane of October 1, 1893, brought total destruction. According to Jean, an island oysterman named Curtis Vezia who fished oysters here for local restaurants has a collection of over 5,000 artifacts he has found in this marsh from plantation days.

Sue and I saw blue-winged teal, marsh wrens, a bittern, and clapper rails along the trenasse (narrow, shallow waterway) that runs through the mangroves and salt marsh hay. The marsh was fairly dry. Mature black mangroves had fruit that looked like grapes of the marsh. I photographed a great southern white butterfly that landed on the mangrove seeds, and it was almost totally camouflaged. Both are a creamy greenish white.

The majority of these acres are covered by salt marsh hay or smooth cordgrass, *Spartina alterniflora*. This is the predominant marsh grass on this part of the coast. It's as strong as a championship football team when spread across miles of marsh. In small patches, it is not so strong—sinking, subsiding, and susceptible to erosion. It's also beautiful in broad view, swaying in the coastal breezes like a field of Kansas wheat, endless in places, fragile and eroding in others. I look and want to lie in its soft-appearing masses, but it is stiff and wiry when you feel it. It's only comfortable on days you are so tired you don't care what kind of mattress you have. Yet I love lying in it, lying in wild places—to touch our earth, unbraid my mind, shred my stress, and chill in nature. This marsh stretching to the homes on the bay side of the island is like a lawn you don't have to mow, protecting homeowners from the winter north winds that would otherwise pound them with salt spray and waves.

By late afternoon, the cold-front line was like a dome of clear sky to the northwest, all dark gray clouds elsewhere. The sun set near the left edge of the cloudy gray curtain. The colors started lighting up, giving an amazing view of this field of marsh. Five roseate spoonbills flew by, a bittern came in to rest, clapper rails clapped, and tiny wrens flitted about. Here at this treasure of Louisiana landscape, TNC preserves of oaks with their soil-holding roots and marsh with its wave-buffering power make both the birds and the people better off.

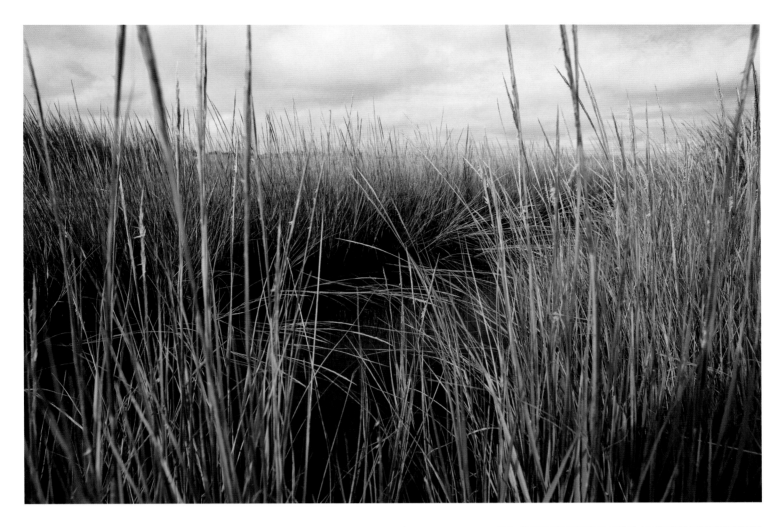

Above and top: Close inspection of the smoothcord grass in the Bollinger Tract reveals snails feeding on the stalks.

Right and lower right: A painted bunting is caught in a mist net and then banded by LWF ornithologists.

Overleaf: Sunset at Bollinger Marsh.

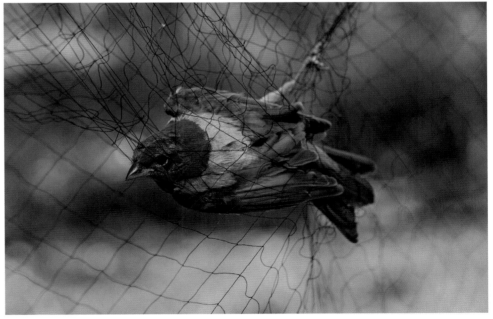

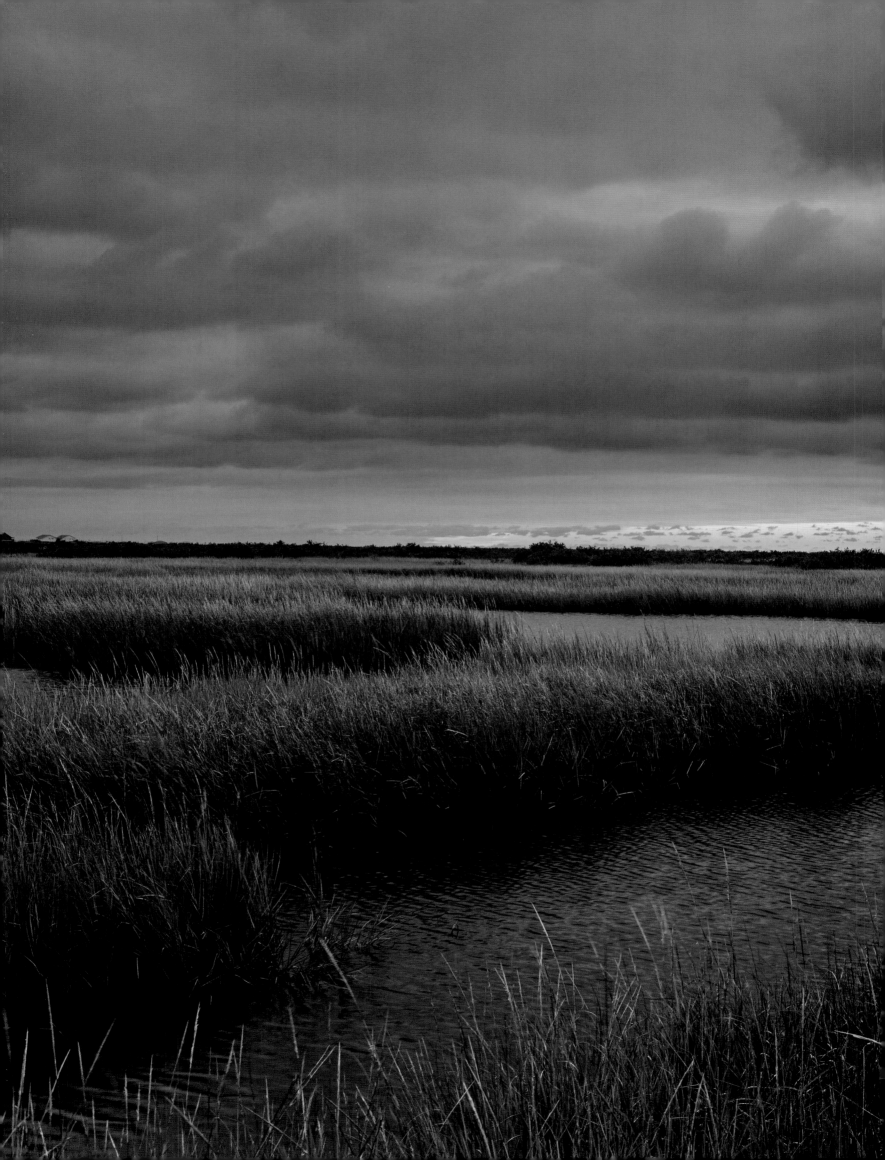

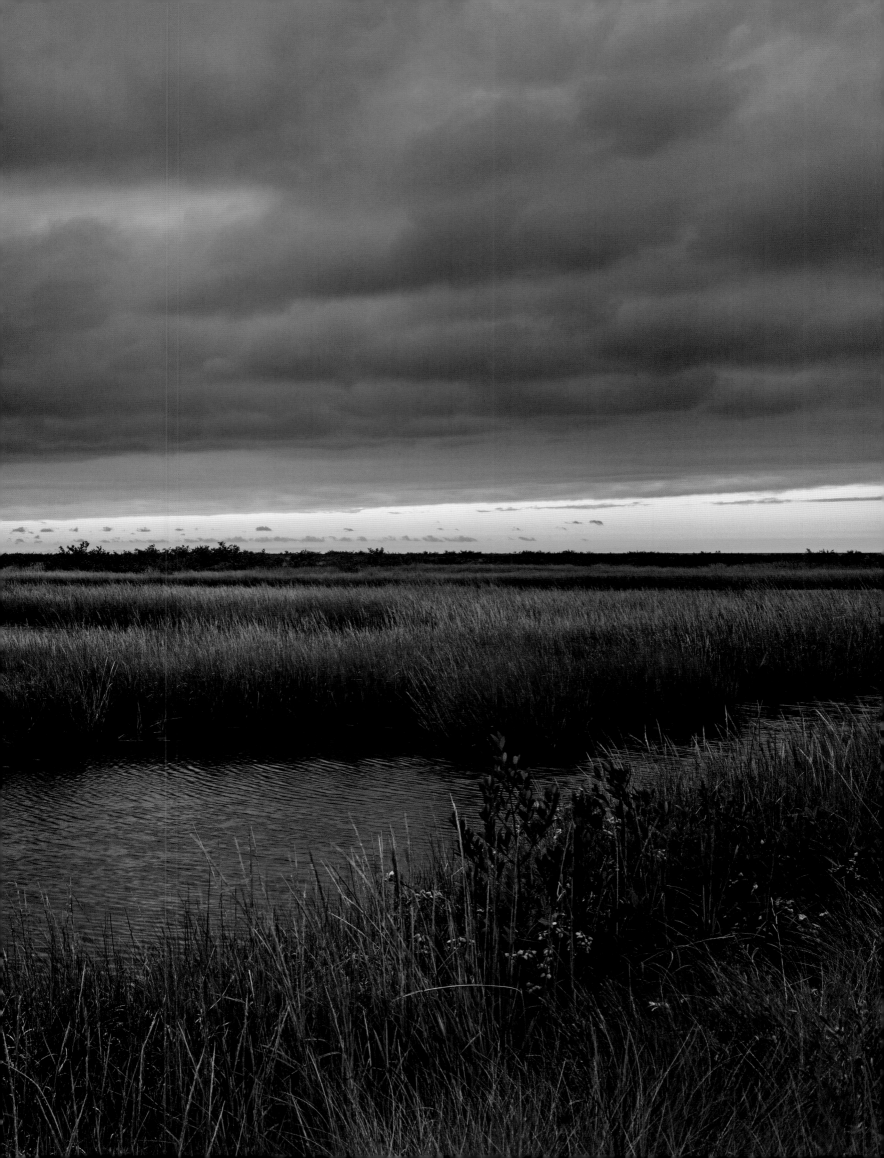

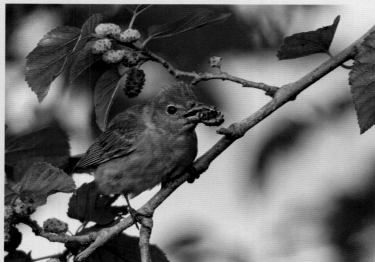

Bird-watchers can see scarlet tanager (*top*), summer tanager (*above left*), and catbird (*above right*) eating mulberries on the trees in Lafitte Woods.

Right: LWF ornithologist Michael Seymour and Dan O'Malley band birds at the Grand Isle Migratory Bird Festival.

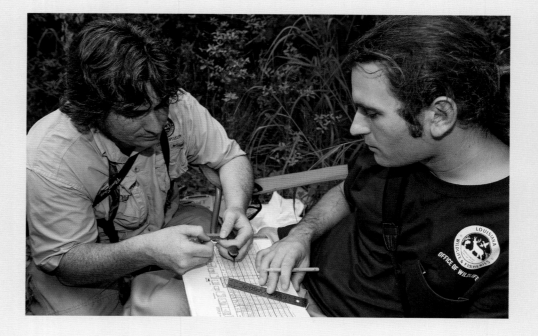

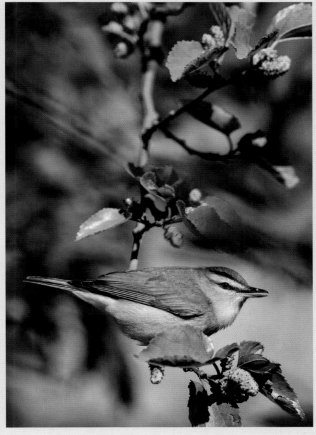

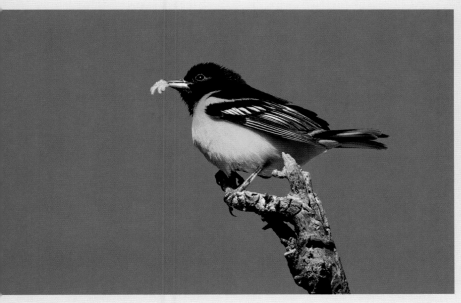

Orchard oriole (*top*), red-eyed vireo
(*above*), and Baltimore oriole (*left*).

Below: Many other birds such as the lesser
nighthawk are seen on Grand Isle.

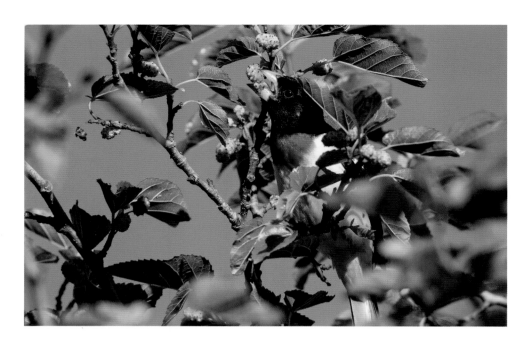

Facing page, top: Live oaks bent and twisted from the constant sea breezes make up most of the vegetation in the Lafitte Woods, an important stop for song-birds crossing the Gulf of Mexico in spring migration. *Bottom:* Smooth cordgrass looking lush and healthy.

The rose-breasted grosbeak (*top*) and brown thrasher (*middle*) are two more birds of Lafitte Woods. Bird-watchers that always look up may miss seeing the swamp cottontail rabbit (*bottom*) feeding at the forest edge.

Tchefuncte River Marsh

800 acres, St. Tammany Parish

Gulf Coast Prairies and Marshes, Oyster Reefs

The Tchefuncte River lighthouse was first built in 1838, but suffered enough damage in the Civil War that it was rebuilt to its current height in 1868. It now looks like a typical lighthouse but in poor condition. From the top, on a cool, foggy, and overcast day, I looked to the northwest to see the 800 acres TNC calls the Tchefuncte River Marsh tract. Far beyond the brown grasses swaying slightly in a light wind, I could make out a line of trees, appearing as toothpicks, marking the swamp on the north side of the property. From this perch I planned our entrance by boat. I could see three canals that touched part of the property and a few small trenasse made by trappers and hunters.

Climbing carefully down the rusty steel stairs of the old lighthouse (with one section totally missing), we made our way into the thick marsh. It was slow; the first trenasse was so shallow I had to jack my motor up until the prop was barely touching water. Even in winter the marsh grass was thick, and since it is freshwater, it will surely harbor some alligator nests in the summer. Nesting female alligators like to be away from bayous and deeper water where the big males hang out. Boating down the canal, we saw a red-tailed hawk as it swooped up from the marsh with a frog. Behind it was a marsh hawk flying low over the wetland, and sitting in a snaggy-looking tree near its nest was an osprey. It was warm enough for frogs to be calling while blackbirds sang in the distance. A few lone ducks flew by, and a common moorhen grunted from the maiden cane. Then we jumped a lesser scaup, which paddle-flew on the water's surface; maybe it was wounded, or perhaps it just wanted to stick to the water.

Highlighting the boat ride was a big flock of American coots. Seeing one bird is good, and seeing two hundred is exciting. As they swam by, I looked up at the huge power line that runs by TNC property and crosses Lake Pontchartrain. On one of the massive towers was a large nest, and you could tell there were birds in it. Eagles build here at times and it was as big as a bald eagle's nest, so we motored that way. As we rounded a bend, an alligator slipped off the bank and into the canal. We closed the gap to the tower and I got my big lens out and looked. Not an eagle and not an osprey, but two great horned owl chicks looking down with sleepy eyes toward us. Scanning the horizon Sue spotted the mama bird, watching from a bald cypress tree. Her owlets were too big, too noisy, and too irksome to sit with as she did when they were young and barely feathered. Eagles, hawks, and owls use the "feed and leave" plan when they have nearly fledged young.

TNC bought this land for the same reason as the north-south string of hardwood bottomland refuges. This marsh and wetland group would make wintering grounds for waterfowl and also do its part to prevent coastal erosion. With private, public, and NGO reserves along the Gulf Coast, we are rapidly closing the gap between Sabine NWR in the west and Pearl River WMA in the east.

TNC is involved in another way in protecting the coast through a project to build

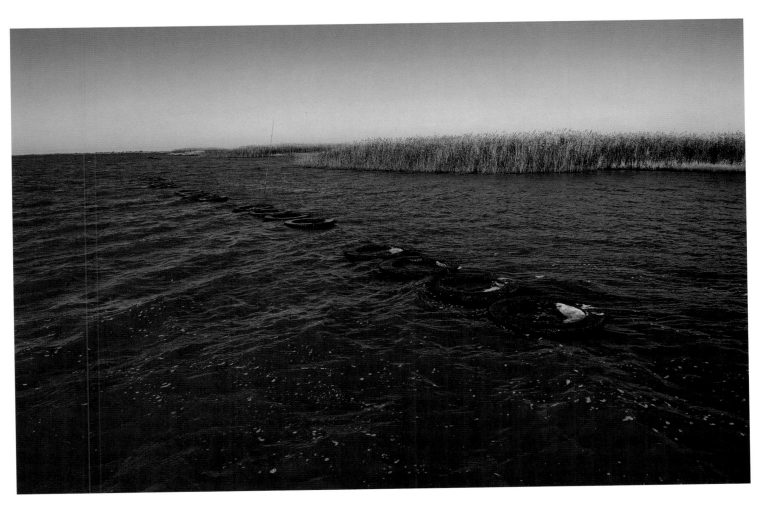

These rings made of Oystercrete mimic natural reefs that were dredged for road shell until we learned how valuable they are for Louisiana's subsiding coast. One of three such TNC projects, this one is at Marsh Island.

oyster reefs. LSU scientists have developed a concrete structure, using Oystercrete, to aid in restoring oyster reefs. TNC works along with LSU and other public and private entities including the Coastal Protection and Restoration Authority, the National Fish and Wildlife Foundation, Chevron, and Shell to build reefs in Vermilion Bay, Grand Isle, and St. Bernard Parish in the Mississippi Delta. One goal of the project is to bring back oysters, and the other is to build a living coastline.

Sue and I met Seth Blitch at Intracoastal City to visit the new reefs near Marsh Island in Vermilion Bay. Let me point out that hindsight is poor in most environmental issues. Pre-1980s shell dredging in Lake Pontchartrain and Vermilion Bay netted the state about 12 cents a ton as dredging companies shoveled up just about every shell in both places before they realized what environmental damage they were doing. In Lake Pontchartrain the dredging made the waters turbid and changed the habitat for the native fishes and aquatic vegetation, while in Vermilion Bay it unblocked the passes into this massive bay complex and let the tides flow faster and the waves come in stronger to eat away at an already vanishing coastline.

Seth captained a 22-foot bay boat and we headed south over a slight chop to the site. When we arrived, Sue and I immediately noticed it was not scenic like most of the properties we have visited, but functional, here to do a job, and that job is to provide substrate for oyster larvae to attach to. It was low tide, and the hollow concrete circles poked out of the muddy green ripples a few inches. It's a special concrete to stand up in these conditions and is gnarly and rough to make it easier for the oysters to attach. The reef structures are five feet in diameter and two feet tall; we saw fish swim by and blue crabs hiding on both the inside and outside. The structures are fairly new, and only a few oysters were visible. We could already see the reefs' value in protecting the marsh as the waves that hit these structures were tempered, reduced, and slowed. The water between reef and marsh was calmer,

Just-fledged barred owls in a bald cypress tree.

Facing page: Great egrets build their nest at Lake Martin.

Overleaf: Lush savanna vegetation grows under the fire-managed longleaf pines of Talisheek Pine Wetlands.

causing less abuse to the wiregrass wetland beyond. Seth said, "Healthy shellfish beds can have a positive effect on estuarine water quality."

To the aesthetic eye of this photographer, it will be a good day when the structures are completely covered in oysters, barnacles, and various other sea creatures, with no concrete showing. Making habitat for more oysters, crabs, shrimp, and fishes in turn makes food for egrets, osprey, and porpoises—and most necessarily today, supports a barrier against coastal erosion. Another win-win situation for all creatures nearby. We can manufacture a geometric progression: more reefs, more marsh, more clean water, less erosion, and more oysters for barbecue, raw, fried, and Rockefeller. Yum. You can call it a fancy coastal fence holding in the marsh, holding out the waves, while making more oysters.

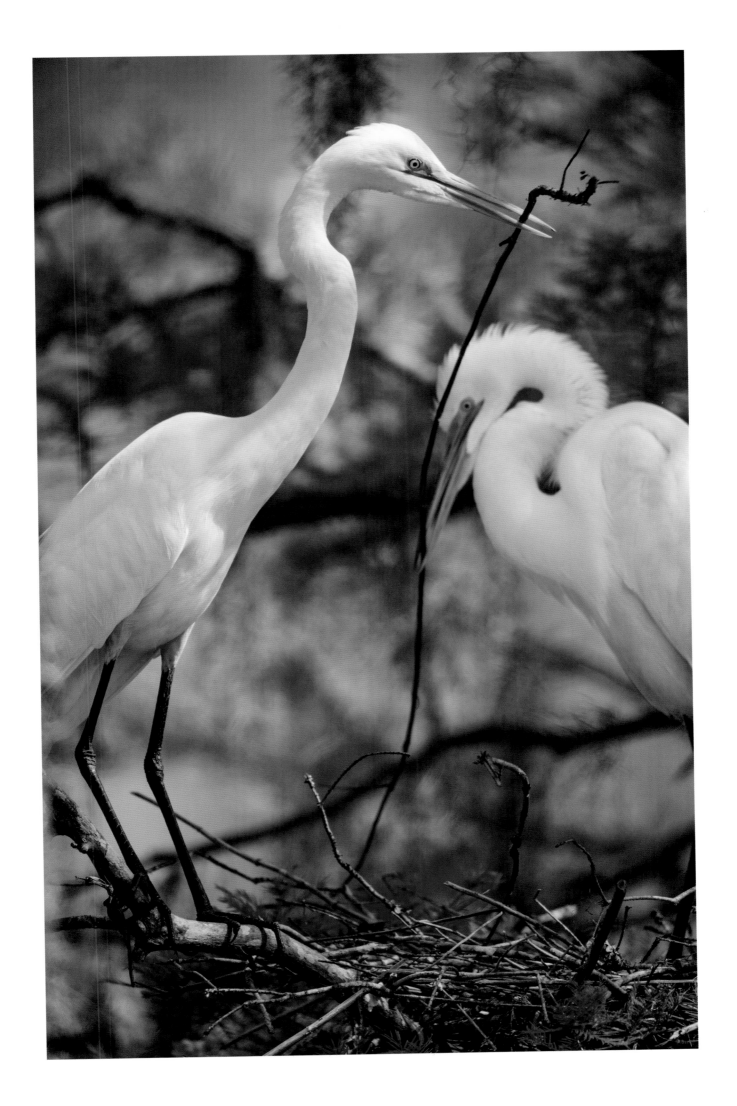

Lake Cocodrie

80 acres, Evangeline Parish

West Gulf Coastal Plain

Sue and I were more than pleasantly surprised by every place we visited. Lake Co-codrie ranks up there with Schoolhouse Springs as proof of this. Nobody with TNC had been there in a while, so TNC land steward Matt Pardue volunteered to go check it out. The only access was by boat or through another landowner's prop-erty. By launching my boat at Johnson's Landing, I could reach the 80 acres on Bayou Cocodrie. We found the property quickly, after a two-mile boat ride through a flooded cypress-tupelo forest that continued on TNC property. After we spent a few hours exploring, the evening arrived with its nice light. It was indescribable. Eyes, not words, can explain the beauty of this place to me. The trees were statues, centennials, poles, buildings, monuments, towers, columns, strong, wild looking, with holes and homes for wildlife, gray-brown and wintered except for the tiny lime green starts of cypress leaves. Those leaves are bursting out on this 75-degree first day of spring with blasting rays of life-giving light in a cloudless sky. *Boom,* spring has sprung right before our winter-weary eyes—and in such a wonderful place. Back to the cypress-tupelo . . . reflective, contrasting, staunch, close, hardy, quiet, beautiful, lovely, laced with serious shadowshine. A hidden gem.

Below and right: Lake Cocodrie, with its miles of flooded bald cypress and tupelo, seems like a reflective dream on a wind-less day.

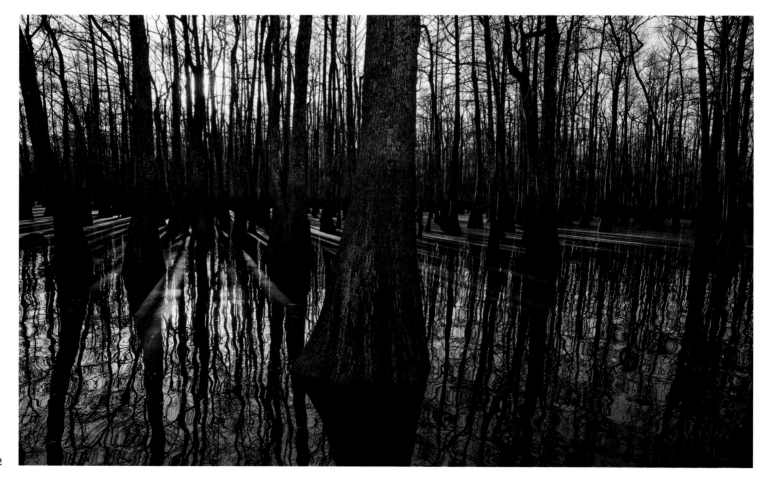

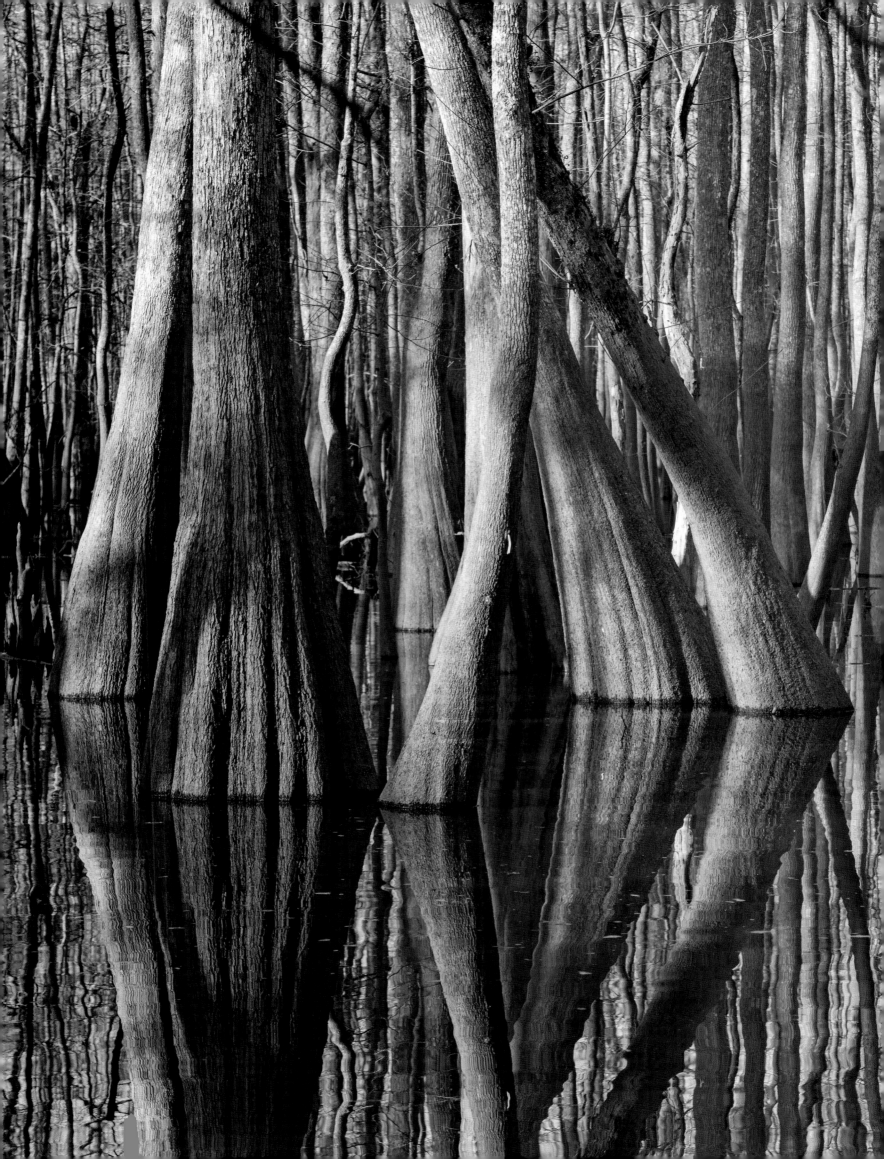

White Lake Conservation Area, Wildlife Management Areas

71,000 acres, Vermilion Parish

Gulf Coast Prairies and Marshes

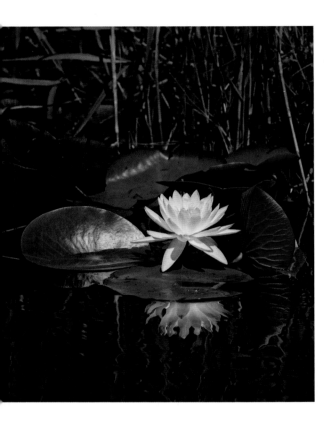

White Lake Conservation Area would be a Monet favorite if he were alive to see the fragrant water lilies here.

Around the turn of this century, Amoco wanted to give White Lake to TNC and Ducks Unlimited, but at the last minute BP bought Amoco and the deal changed to donating the land to the state. The Louisiana Department of Wildlife and Fisheries developed a management board and a scientific committee to manage the place. You can say TNC got the ball rolling in getting these 71,000 acres of pristine marsh set aside as a refuge. Located south of the Gulf Intracoastal Canal and north of White Lake, this healthy freshwater marsh links up with eight other refuges to form a line of preserves from the Atchafalaya Basin to the Texas border. In this time of subsiding wetlands, I think White Lake along with the Audubon Society's Rainey refuge and the private marsh of the McIlhenny family are some of the best-kept wetlands in coastal Louisiana. Success stories I wish the rest of the coast could follow.

Currently White Lake is the heart of the whooping crane reintroduction program, which releases ten chicks a year in hopes of restoring this nearly extirpated bird to Louisiana. The project is looking promising as birds from the first two batches are showing signs of courting and nest building. The LDWF not only uses the area for research projects such as this but also has both lottery duck hunts and fund-raising hunts to help offset the expense of maintaining the wetland. Biologist Justin Gilchrist gave Sue and me a tour in the main pond of 17,000 acres, which has a network of canals and trenasse that were put in during the Amoco duck-club days. Justin had put up 44 wood duck boxes; we stopped to check one that he found a nesting screech owl in. The parent bird flew out when he opened the box. Inside, two owlets covered in downy feathers slept next to a headless yellow warbler the parent owl had brought in to feed them.

After Justin went back to his duties, I settled in by a patch of maiden cane to watch a very secretive least bittern, *Ixobrychus exilis*. It is the smallest heron in North America and adept at camouflage. If it were not for the eye, yellow with a black pupil, I never would have spotted it. The maiden cane is a vertical habitat with parallel stalks shooting toward the sky; that round eye did not fit the pattern. The bird can straddle the marsh grass, which lets it fish in deeper water—awkward looking, but efficient. When alarmed it points its beak straight up and faces the danger; again the round eyes are the only thing that will give it away. We counted a bittern about every hundred yards along these miles of waterways.

Besides all the birds, spring is beautiful here for lush aquatic plants. Fragrant water lilies, fanwort, and sagittaria were blooming, except in one area. Just a week before they had burned a section of marsh such as is done in the piney woods. Walking on the mushy marsh soil at the edge of the burn, I could see the fresh green shoots of sagittaria and maiden cane poking out of the mud. It comes back quick and makes good groceries for geese and other water birds. Historically, lightning

Above: A southern flying squirrel uses a wood-duck box for a home.

Right: Great egret.

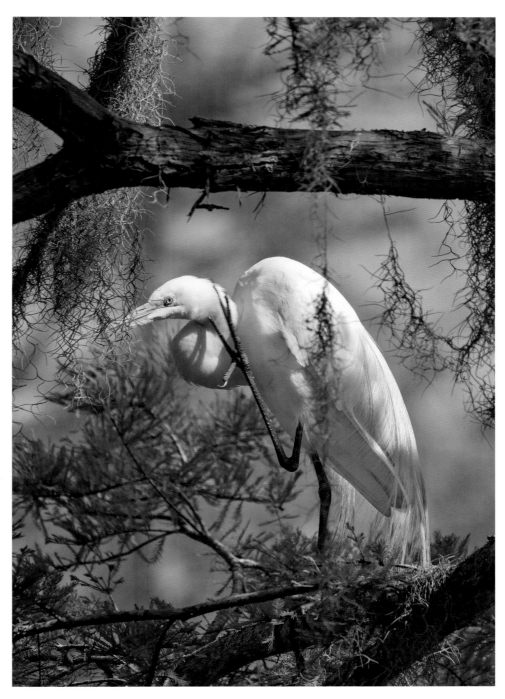

started marsh fires. Later we saw a small rookery of night herons, both the black-crowned and yellow-crowned, most with pale blue-green eggs. One had three chicks, like most heron babies, ugly—all mouth with a crop of feathers on their head that looks like uncombed hair.

Later back at the lodge, I spotted a pileated woodpecker, *Dryocopus pileatus,* pecking away on a dying pine tree. There are enough trees along the Intracoastal Waterway to attract this wide-ranging forest bird. Its 18-inch body and 28-inch wing span make a viewing of this bird unforgettable. The female was working on a nest. I watched her enter the hole and stick her head out, flinging 2-inch wood chips to the ground. The male relieved her occasionally, but while I was there the mama did most of the work. I saw them mate twice over a two-hour span. The lodge here sits on an island; the lawn is decorated with these pines and live oaks. Just across one of the canals is a wading bird rookery, and from the same hiding place by the pileated nest I could watch great egrets and roseate spoonbills courting and nest building.

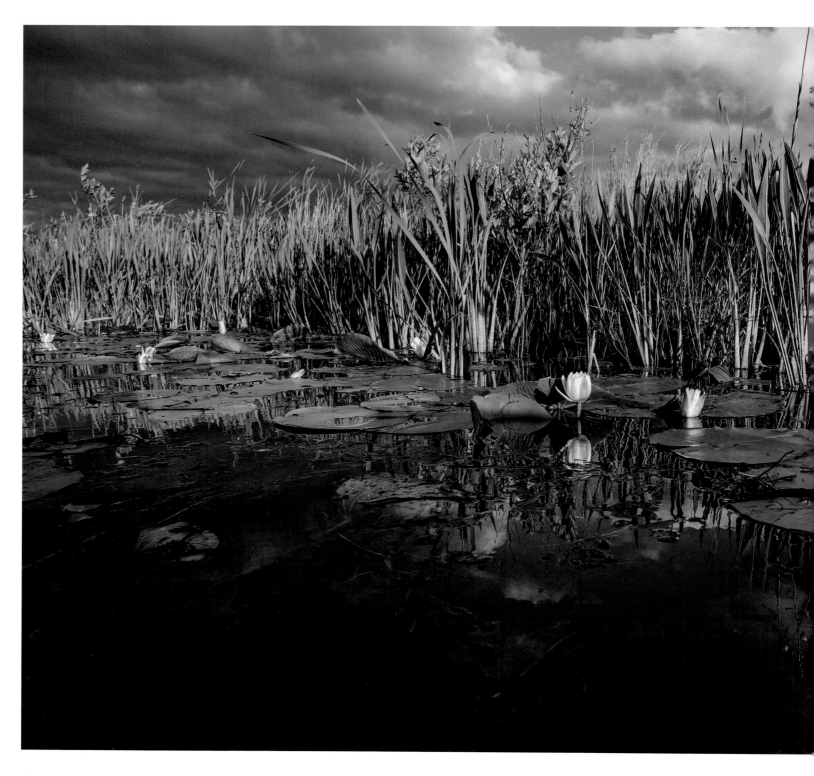

The freshwater marsh at White Lake is exceptionally healthy.

White Lake shines like a glistening white pearl among the 300,000 acres that the LDWF maintains, but, like a necklace of many pearls, it is only one of 66 refuges and wildlife management areas they control. Their WMAs cover the state like the colorful work of an artist who has wildly splattered some paint on a canvas shaped like Louisiana, offering recreational opportunities of all types and supplying habitat and refuge to wildlife big and small. TNC has been involved in procuring 11 of these areas of vital ground.

Speaking of pearls and their beauty, I visited Pearl River WMA where Donata Henry, professor at Tulane University, is in the tenth year of a migratory bird study. I arrived on a typical hot, humid, and mosquito-filled day in June. This is probably the last year of banding here due to the emerging canopy, which is not thick enough for the birds she wants to band. The trees are thirty years old after a clear-cut by the

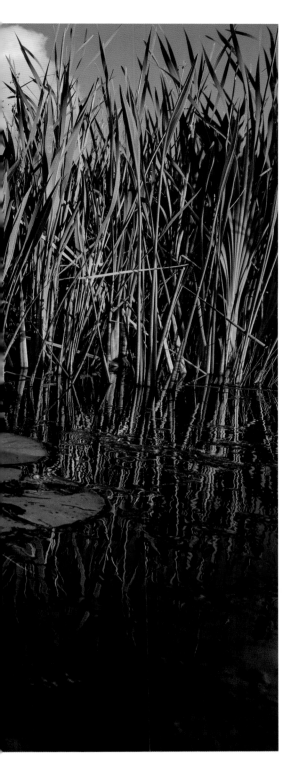

LDWF to make more habitats for deer and turkey. It's slowly turning into a mature forest. Donata's specialty is the Swainson's warbler, which likes a dark, thick habitat. Most warblers she nets are recaptures, and her theory is that the birds that have historically nested here return while their offspring look for new suitable habitat. She also said there was a big peak here after Katrina. That storm tore down many trees in the surrounding area but spared these because it was evenly aged—nothing was tall and old to be knocked down. It was an oasis for birds. A good reason that we have such places. It took three years for the species to get back to the normal nesting residents. Over ten years her team has banded 3,833 birds of 43 different species.

Whether taking a class on a field trip, hiking a wooded trail, catching a fish, stalking a deer, photographing a turkey, or helping out with a youth hunting and fishing day, LDWF's Wildlife Management Areas are important pieces of Louisiana's great outdoors.

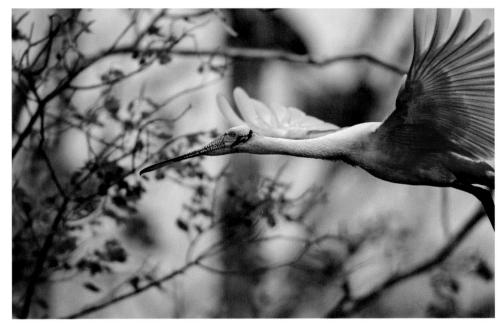

Among the birds of White Lake cherished by bird-watchers are the pink roseate spoonbill (*above*), the gorgeously ugly yellow-crowned night heron chicks (*bottom left*), and the secretive least bittern (*bottom right*), caught here without its standard camouflage pose.

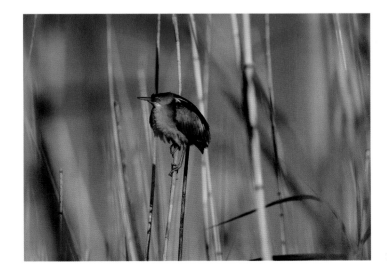

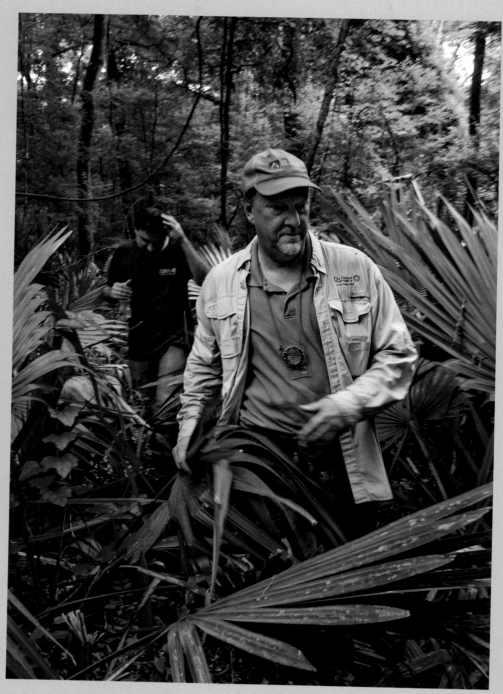

Above and right: Keith Ouchley and Chris Rice find a bird-voiced tree frog on a hike through the palmetto at Bayou Cocodrie NWR.

Below right: At Cypress Island, a bobcat peers intently through the palmetto leaves. The orphan cat was raised to be released in a safe area such as this.

National Wildlife Refuges

Bayou Cocodrie, Lake Ophelia, Grand Cote, Tensas River

(For others, see appendix.)

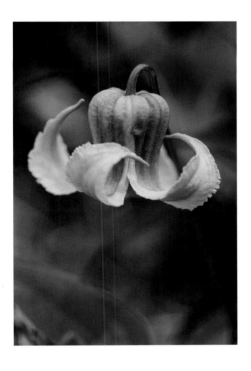

Leather flower.

In 1903, during Theodore Roosevelt's presidency, Pelican Island National Wildlife Refuge was established in east-central Florida as the first of 561 refuges that encompass over 150 million acres. There is at least one in every state; Louisiana has 24. TNC has helped in various ways on 11 of these 24. I visited Pelican Island in 1972, at the time when very few brown pelicans survived in Louisiana. Since then I have visited many of these U.S. Fish and Wildlife Service public properties across the United States, and all of those in Louisiana. With animals such as the American alligator and brown pelican brought back from endangered to thriving, this system has been an important cog in the health-and-habitat wheel of North American plants and wildlife.

You pass a third of a block from singer Jerry Lee Lewis's house when leaving Ferriday, Louisiana, on the way to Bayou Cocodrie NWR. This is an 11,255-acre tract that TNC bought from Fisher Lumber Company in 2001 and later sold to the NWR system. I can remember as a teenager being just as interested in cars and motors as I was in birds and white-water creeks, so seeing the logo on Chevrolet vehicles saying "Body by Fisher" stands out in my mind. Back then, in the 1960s, a much higher percentage of the big car companies' subsidiaries were closer to home in Michigan. For General Motors to buy hardwood bottomlands in Louisiana seems kind of strange, but they wanted a guaranteed supply of good hardwoods for car interiors and the paneling for those famous woody station wagons. Singer Sewing Machine Company did the same with the much larger Singer tract, which is now the heart of Tensas River NWR.

Bayou Cocodrie is high on the list of favorites for TNC's Keith Ouchley; he did his dissertation banding birds here. It was four years of work. Sue, Keith, Chris Rice, and I boated down Bayou Cocodrie to walk into Keith's study area. The trees are big—that's kind of sounding like the same old song on TNC forests across the state, but if we don't save some of these, I feel as though we have lost some of the heart and soul of nature. So when Keith showed me a sign on the edge of a 1,000-acre piece of this refuge that said, "Old Growth Forest Area," I was thrilled. So as well as being in a NWR, there is an easement put on this tract saying that nothing can be done to it. TNC and all of us have to restore and nurture all kinds of habitats throughout the state, but I love the fact that some such as this will grow totally as nature wants it to. Having hardly been cut at all by Fisher Lumber Company, the bottomland hardwoods at Bayou Cocodrie NWR have been noted as some of the last remaining and least disturbed timber in the Mississippi River Delta. Mature forest takes a long time to grow. Keeping the few big trees that remain is a good head start.

Because the Wetlands Reserve Program (WRP) and Conservation Restoration Program are restoring bottomland nearby, the initial 11,000 acres have become 13,000 acres. WRP landowners get 75 percent of fee value of their land to put it back into hardwood bottomlands. The farmer must prepare the soil for planting.

Trees usually come from grants. TNC sometimes provides these to help convince the farmer to do it. It's a shame we paid them to clear the bottomlands and plant soybeans in the 1970s and are now paying them to put it back. At least we are on the right track. Keith—who says, "Any day in my knee boots is a good day"—also told us about one white-eyed vireo he banded during his study, which came back to the same bush to nest three years in a row. I say that's remarkable for a bird that weighs four-tenths of an ounce and travels to Mexico every winter.

Waterfowl are quite the opposite of the vireo; they nest in Canada and fly south to use wintering habitat in Louisiana. Grand Cote and Lake Ophelia are among the Louisiana NWRs that provide this winter refuge. The 17,500 Lake Ophelia acres, of which most was in farms, break down into 8,400 acres of bottomland forest, 4,200 acres of reforestation, 3,400 acres of cropland, 500 acres of managed moist-soil wetlands, and 1,000 acres of lakes. Sue and I took our boat into the lake on a cold, clear winter day hoping to see some ducks from my boat blind. The lake was shallow, with abundant aquatic vegetation, and clear enough to see fish swimming below. We tied up to some shrubs growing on a small island and set up the blind. It wasn't long before a pied-billed grebe, *Podilymbus podiceps*, swam in close. The low light turned the water into a golden glow, and with no wind it was calm, very still, and showed a great reflection of the bird some people call dabchick or devil diver. The 12-inch bird prefers to dive to escape danger rather than fly. Soon I had fifteen in site, which is rare for me for I usually see singles and a few times up to three together.

A pair of American wigeon, *Anas americana*, finally flew in, and turned out to be the only ducks I saw today. While I was zoomed in on these, Sue poked me. I turned to look out the back of the blind and saw a 12-point buck standing between two bald cypress trees on the lake's edge, right in front of the setting sun. I tried to swing the big lens around, not an easy task in this set-up, and the buck ran away. Later as the waxing gibbous moon rose behind the tree line, flocks of cormorant flew by in formation, a fitting end to a short winter day.

The next day we headed to Grand Cote NWR, 27 miles to the west. We met Brett Wehrle, project leader for this group of refuges, and told him about the deer we saw. He reminded me of the big deer that can be found in Avoyelles Parish and said a young man got a 195-pound buck on the youth hunt this season. This 6,000-acre refuge was set aside to winter dabbling ducks. Sue and I headed out the elevated boardwalk to see some birds. The flooded fields were full of ducks, but pretty far away. Even so, we enjoyed the ducks feeding, splashing, and flying in and out. We stayed until sunset and watched the now full moon rise.

Tensas River NWR lies close to my heart for a number of reasons. Not only did I have college buddies from the area and spent time visiting there before my photography career, but I was stirred to excitement listening to birding stories by LSU professor and ornithologist Dr. George Lowery while taking courses under him. When he told of his visits to the Singer Tract with James Tanner looking at the ivory-billed woodpecker, I was instantly motivated to search for this stately bird that had not been seen since 1943. Upon graduation I did research on the area, traveled the back roads, and paddled down the Tensas River twice, all the while thinking nobody was looking for this bird as hard as me. What I did discover was that the entire area was under threat from ten-dollar soybeans. Hardwood bottomlands that were previously unsuitable and unprofitable for farming were being cleared at an unprecedented rate, and sitting on the table of the Army Corps of Engineers' Vicksburg office was a plan with a $25 million price tag to dredge and channelize the Tensas River. This project would hasten the ruin of the last home of the ivory-bill and red

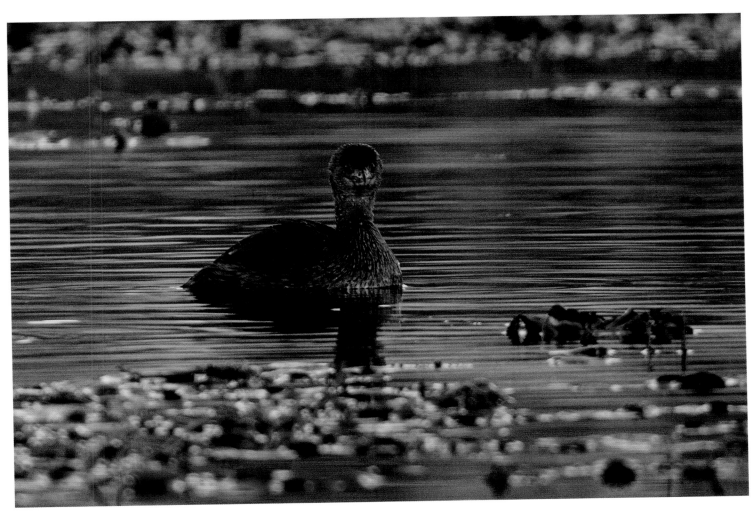

A pied-billed grebe swims in the copper glow of twilight.

Overleaf: A winter full moon rises over Lake Ophelia.

wolf. The black bears and many more creatures would suffer. Before beans were valuable, this same channelization project was rejected twenty years earlier.

The first Earth Day had happened two years before in 1971 and I don't recall even knowing about it. Heck, I hardly knew we had any environmental problems at the time. Growing up in Arkansas with only 1.7 million people, I wasn't aware of any problems; the state was clean and beautiful with crystal clear creeks and rivers flowing out of the Ozarks. The threat to the Tensas changed my perspective, and Robert Murray of LDWF was my coach in an environmental crash course. I helped start the Baton Rouge chapter of the National Audubon Society, joined the Sierra Club and the National Wildlife Federation, and in doing so met and learned from their environmental committees. And we started writing letters, both personally and through our organizations, to everybody. My files have copies of letters to Presidents Nixon and Ford, Governor Edwards, Senators Long and Johnston, the secretary of the interior, colonels and generals in the Army Corps of Engineers from Vicksburg to Washington D.C., along with state politicians, newspapers, and television stations.

We stopped that dredging project, but more was needed. Even if the ivory-billed woodpecker was extinct, the bottomlands of the Singer Tract and the Chicago Mill Lumber Company needed to be set aside as a refuge. The flora and fauna needed this place to live; humans needed a place to hunt, fish, hike, and take pictures; the trees needed to stay and soak up water and let the spring floods spread out among them. That's where Skipper Dickson became involved as one of the founders of the Tensas Coalition. This organization helped get what is today 80,000 acres of good second-growth bottomlands into the National Wildlife Refuge System. TNC chipped in by temporarily buying 4,941 acres in 1993 and 2,360 acres with the

Graduate student Becky Shuman takes data on a whitetail fawn before attaching a radio collar and releasing it at Tensas NWR.

Trust for Public Land in 2005; both tracts are now part of the refuge. The Tensas is what got Skipper and me together.

My most recent visit to Tensas River NWR was to learn about white-tailed deer studies that University of Georgia graduate students Taylor Simoneaux, Betsy Cooney, and Becky Shuman will be working on for three years. The study is trying to find out what is killing fawns. It is speculated that the increasing hog, bear, and coyote populations are doing more damage than in the past. The study is a complicated and time-consuming process that starts with a doe captured in late January after the rut—the period between late December and early January when deer mate. A vaginal transmitter is inserted into the female deer, whose internal temperature is 102 degrees. When she gives birth in the early summer, the transmitter drops out. It starts beeping when light hits it or the temperature drops to 86 degrees. The students who walk through the area with earphones and a receiver three times a day can pick up the now-beeping transmitter and look for the newborn fawn.

A white-tailed fawn is birthed fully furred and ready to stand up at twenty minutes old. Yet it is weak legged and stays put for a few days. The doe licks the four- to eight-pound baby clean. The fawn not only is camouflaged with its spots, but also comes out scentless, so predators can't smell it. It is born with the instinct to stay put and hidden until it has eaten enough and grown to run like the wind with the white flag of a tail bouncing wildly.

On the second night we were there, Betsy got a birth signal. I accompanied the three students to collar the newborn. Not one but twins. Most everybody has seen a newborn fawn on some wildlife TV show, but up close and personal with twelve-hour-old twin fawns was amazing. The big brown eyes, spots, and spindly legs make you want to hug them, but that is not the drill. The students want to get their measurement and put a collar on the young deer and get out of there in two minutes. If and when the fawn stops moving, a different-sounding beep from the collar alerts the researchers to find the animal and make the determination on how it died. After the fieldwork is completed, the students crunch the data and draw conclusions.

It's been over forty years since my first canoe trip down the Tensas River. I am planning another trip with Sue this fall; it will be much more pleasant than my first voyage. The trees are taller, the bears are back, and there is refuge rather than farmland on each bank. If the ivory-billed woodpecker was still here someone should have seen it, yet I hold out hope that maybe someone has and is keeping it a secret.

The spindly legs of this twelve-hour-old fawn will mature quickly. In a few days it will be running with its mother.

Easements

LOGGY BAYOU EASEMENT

Bienville Parish, Bossier Parish

Upper Gulf Coastal Plain

Skipper Dickson, Shreveport businessman, studied biology in college and has been protecting wildlife habitat ever since. He was also founding board chairman of the Louisiana chapter of TNC. Being friends with him as well as Nancy Jo Craig, TNC Louisiana's first director, I gladly donated a slide show for the budding chapter to use to explain the importance of their work. Early in our friendship Skipper told me, "Any land in private ownership is doomed to commercial exploitation at some point in time." Makes sense that he later put some of his property into a TNC conservation easement.

Bates Mountain is a real highlight of this property, at 340 feet tall; it's the westernmost peak in the range that contains Mount Driskill, the highest point in Louisiana at 535 feet. It was bald and bare when I camped on it in 1983 as Skipper had just bought the property from a paper company that had clear-cut it. The view is awesome over the Red River floodplain, one of the best vistas in Louisiana, and now the trees are back and it's a forested mountain. The hilly forest is SOH as the botanists like to call it—shortleaf pine, oak, and hickory. At the western edge are bayous, lakes, and ponds touching Loggy Bayou, where thousands of waterfowl winter. Skipper is a duck enthusiast; in fact, while I was visiting he was working on getting the duck stamp fee raised a few dollars. That money would go to making sure the prairie pothole region that ducks nest in won't be cleared for high-priced corn. I sure hope we don't make the same mistake with corn as we did with soybeans. There is a highest and best use for all our land, and corn for cars is not anywhere near the best use for this marginal farmland. Corn is food, not fuel.

I enjoy photography hikes on Skipper's land, for there is always wildlife to see on these well-preserved acres. Sue and I climbed up what I would call the Eiffel Tower of deer stands, at least 50 feet tall. We saw white-tailed does eating on the surrounding food plots; they looked so small.

Below: With its turquoise color, the six-lined racerunner looks like a piece of Navajo jewelry.

Right: One of the fastest snakes in Louisiana is the coachwhip.

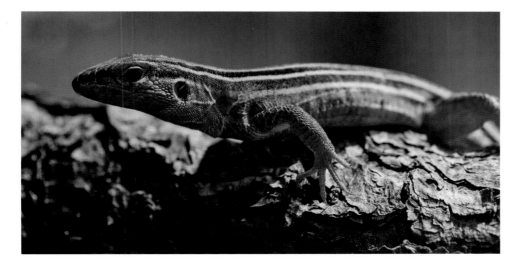

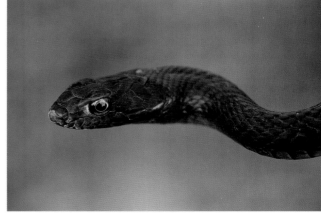

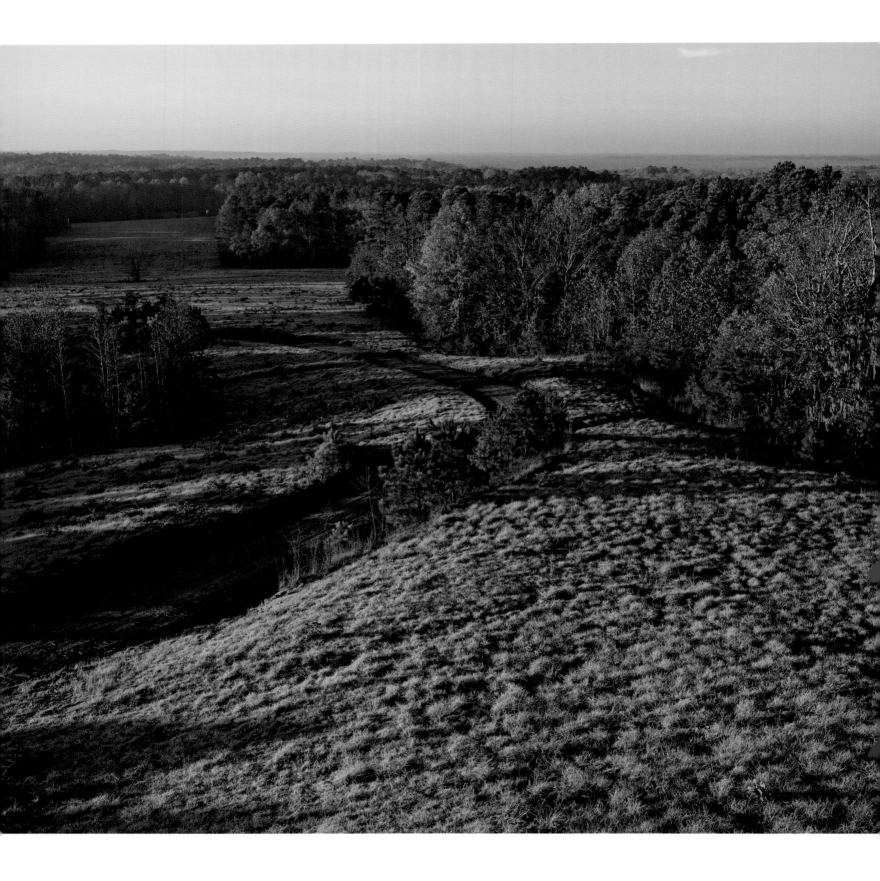

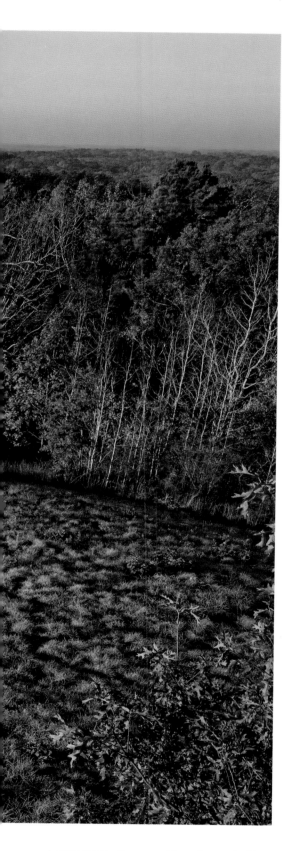

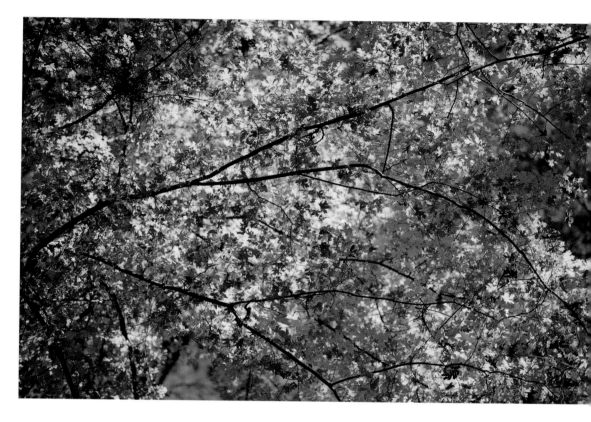

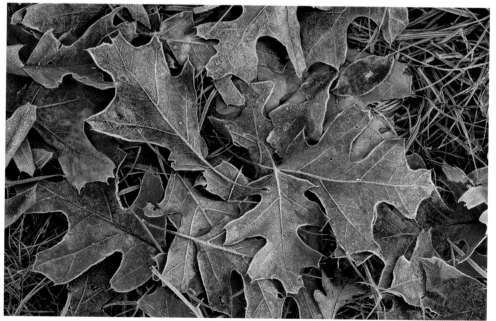

Loggy Bayou Easement is a diverse habitat ranging in elevation from the Red River bottoms to the top of Bates Mountain, where late fall temperatures turn the southern sugar maples yellow and cover oak leaves in frost.

Overleaf: Bates Mountain in April displays the green of spring.

117

WAFER CREEK RANCH EASEMENT

Lincoln Parish

Upper Gulf Coastal Plain

At the edge of Wafer Creek, Johnny Armstrong asked me if I could capture the shadowshine with my Nikon. I said, "What?" He was eyeing the bank on the other side of the creek, which was flowing briskly with clear water. The sun was low in the winter morning sky, and I saw it, something I have seen before. I never thought to name it or even if it had a name. Johnny named it and used *Shadowshine* as the title of his novel. Shadowshine—it's the rippling light of the sun reflecting off moving water. Here it projected on the steep banks of the creek. It also shows up well on the big bases of trees in the swamp. I knew I could not capture it with a still shot, but snapped off a few anyway. Then I popped the lever over to video and captured that light dancing on the creek bank.

Dr. Armstrong, pathologist, cowboy poet, rancher, botanist wannabe, and short-leaf pine lover, has most of his Wafer Creek Ranch protected by a TNC easement. The night before, over a chicken spaghetti dinner with his wife Karen and son Cody, Johnny read to us from his cowboy poetry and later explained his reason to take easements out on his ranch. He told us he was looking for a way to save it from future development.

A conservation easement, in a nutshell, reduces the value of your land in a development sense. The language in the easement document can be worded to restrict logging, subdividing, or any other land-use restriction you care to put in it. With these limitations, the value of the land decreases and the landowner usually receives a tax deduction. As development moves closer to his property, Johnny can be assured that his tract of shortleaf pine/oak-hickory habitat will remain undeveloped as it is passed down to heirs and even future buyers. Conservation easements are available through many NGOs and government organizations. Johnny's is one of four administered by TNC that Sue and I visited.

Sue said, "Johnny I can see why you did this," as we walked up the hill dressed in fall colors. Johnny said, "You can't buy land at Walmart. It's what I want to do with my property." It is not virgin forest, but a nearly mature second growth. Part was a cotton plantation a hundred years ago. In the 1930s CCC boys did some erosion

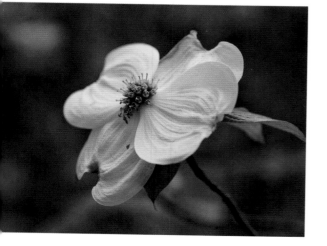

Wafer Creek Easement is blessed with healthy dogwoods (*above*) and beautiful native wild azaleas (*right*).

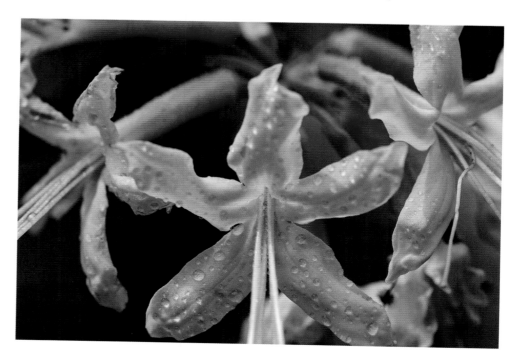

120

work and tree planting. Johnny has become fast friends with Latimore Smith, who is teaching him about the grasses and other plants that should be in this habitat. He uses fire and thinning of the off-site loblolly pines. Soon it will get closer and closer to native habitat.

Later that day we saw a group of people walking through the woods. Johnny said they were Louisiana Tech forestry students. He lets them use it for an outdoor classroom. Research and education take place on a lot of TNC's projects.

Wafer Creek Easement is being restored to its historic shortleaf pine, oak, and hickory habitat.

Right: A tiger swallowtail butterfly feeds.

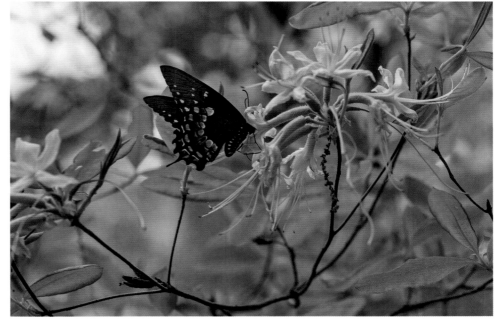

HAMMER CREEK EASEMENT

119 acres, West Feliciana Parish

Upper East Gulf Coastal Plain

Crossing the Highway 61 bridge over Thompson Creek heading north into the Tunica Hills is an exhilarating experience. This landscape holds such diverse and wonderful areas. My mother-in-law tells of adventures in the 1940s when her wild bunch of friends would skip school and head to the beach. She has embellished stories of near drownings and quicksand with much hilarity, as they played in the waters and on the shores of Thompson Creek and Bayou Sara. Touching the banks of Thompson Creek is TNC's first conservation easement. In 1996, board of trustees member Dorothy Prowell set aside 80 percent of this hilly tract of Tunica forest. She calls it a project of sustainable living. Which is true, for the few cabins on the land blend in so well you can hardly find them.

On our hike at this easement, three deer surprised us, white flags up and running away fast. Then a flock of turkeys strutted by. We were most impressed by the huge tulip trees, *Liriodendron tulipifera*, so staunch and strong appearing. On the few trails, the walking was easy with a lot of ups and downs as is typical Tunica Hills forest habitat. Near Thompson Creek the going got tough with heavily brushed thickets and wet soils. Then we broke out into the wide expanse of the creek, where two more white-tailed does were slowly walking across the sandbars. It was curious to see them in the open at midday. We walked the two miles to The Bluffs resort, a charming development tucked in these rural hills, with a golf course and biking trails. Then we noticed trees cleared and bulldozer tracks making more and more lots, carving up the forest between the clubhouse and Hammer Creek Easement. It is easy to see how important set-asides of private land like this are.

A sandbar on Thompson Creek is part of the Hammer Creek Easement.

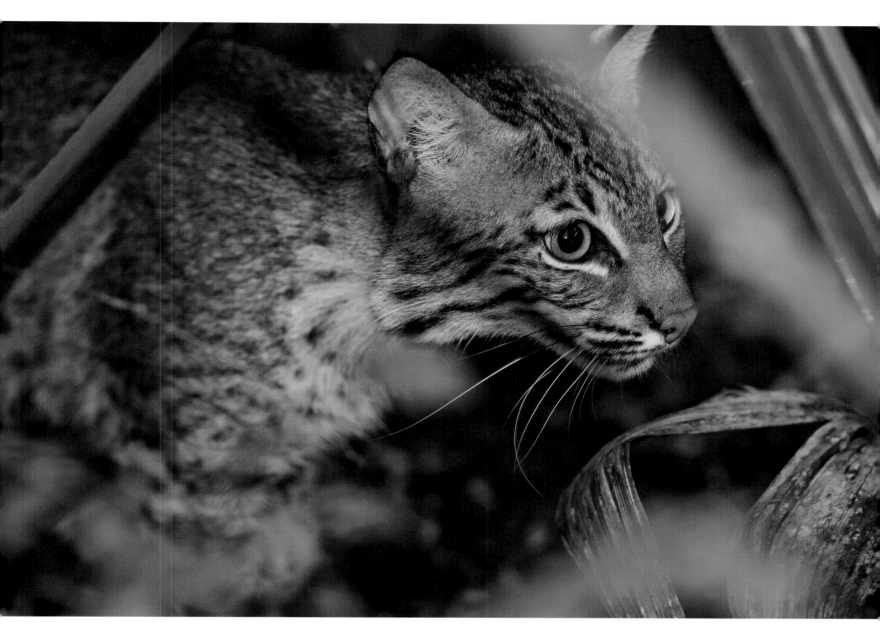

Cypress Island is a perfect home for the
secretive bobcat.

Bluebonnet Swamp

88 acres, East Baton Rouge Parish

East Gulf Coastal Plain

Tucked neatly within the city limits of Baton Rouge is one of the first natural areas TNC helped purchase. With little effort, and a small entrance fee, one can hike two and a half miles of trails and boardwalks, quietly and peacefully, through a densely forested hillside and into a cypress-tupelo swamp. On-site is the Bluebonnet Swamp's nature center, with a small museum, photography exhibits, and a newly built education center offering programs for all ages. Sue and I walked along with docent Jessi Ryan and a class of thirty second-grade students from the International School on a warm May morning.

There is no telling what you might see in this urban swamp, and today was no exception. The inquisitive kids were happy to see a ribbon snake race across the trail before entering the boardwalk, where a five-lined skink rested on the rail for the students to gawk at. Jessi pointed out the less-than-liked poison ivy and then the blooms of the Virginia creeper, a bloom you rarely see low, brought down by a fallen limb. What seemed to be a very tame dragonfly perched on her hand turned out to be a perfectly preserved dead one.

The climax of the day came when the reptile-crazy kids arrived at the lowest elevation of the trail. The wetland was unusually dry, and minnows of various species had amassed in the last pools of water causing an accumulation of predators, including about 30 broad-banded and diamondback water snakes, both nonpoisonous varieties of wetland snakes. Some were trying to snag the fish, others rested on the top of dry logs, and there were two knots of tangled snakes, mating, and looking like Medusa's hair.

Down the trail John Hartgerink, the preserve's hardworking volunteer, showed

the kids a Carolina wren nest and told of all the bird studies done here. There is a summer camp for kids, and on one of the camp days a group of grad students come to capture birds in mist nets for various research projects. Hands-on avian education for the campers. Today the swamp was teeming with life. After the excited youngsters entered the education area for more knowledge, John took us to see the nest of a white-eyed vireo, *Vireo griseus,* he was monitoring. The nest is described as cuplike in bird literature, but to me this one has a basket shape, such as you might see in a museum of Native American artifacts. Hanging from a privet branch, anchored by pieces of spider web, the nest is made of strips of bark, hair, twigs, and soft grass. The white eye—which only two species of birds in North America have—looks like "pop art," starkly standing out against the yellow and gray head. The bird is a close sitter, which means he or she will let you get very close to the nest.

On the way out we stopped at a profuse array of Indian pink, *Spigelia marilandica,* one of our most attractive wildflowers. According to John, this patch of beauty had been here since the early days of the preserve. The red tubular flower points skyward with an interior that is a bright and showy yellow, a treat on a hike. The little critters and the birds are the most notable wildlife here. Look hard for the barred owl; it blends in with its camouflage colors. Bluebonnet Swamp is a welcome patch of flora and fauna in the capital city; it is now managed by BREC.

Bluebonnet Swamp in Baton Rouge was one of TNC's first projects. Today it is run by BREC and is used to educate children and the general public about Louisiana's native swamps. It is also home to colorful plants like the Indian pink (*previous page*) and many nesting birds such as the white-eyed vireo (*top right*).

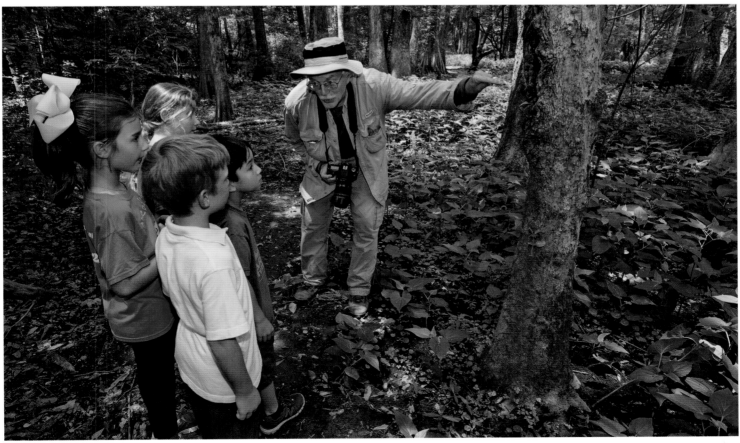

127

Tunica Hills

Cat Island National Wildlife Refuge, 10,549 acres

Tunica Hills Wildlife Management Area, 3,941 acres

Mary Ann Brown Preserve, 110 acres

West Feliciana Parish

Upper East Gulf Coastal Plain

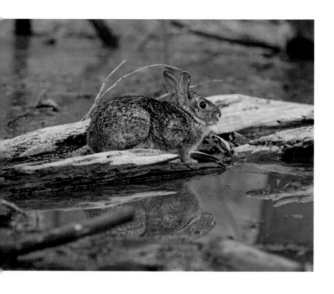

A swamp rabbit calmly waits out the high water floating on a log.

In May of 2011, I pointed my camera out of a doorless Jet Ranger helicopter toward the churning white-water fury of the Mississippi, which was passing through the floodgates of the Morganza Floodway. This was a historic event as it was only the second time this structure was used since completed in 1954. So furious was the flow I could almost hear the roar of the melee over the loud jet engine of the chopper. The floodway was opened because the mighty river was reaching the top of the levees throughout Louisiana and endangering communities from Baton Rouge south. This was very strange because most of Louisiana was in near-drought conditions at the time. Not so in the rest of the pie-shaped chunk of North America that drains two-thirds of the United States as well as two Canadian provinces into the Mississippi River. This huge area was soaking wet, up to and over the banks in some places. In April four major storm systems drenched this drainage basin with rain, and that weather event synced perfectly with the spring thaw of snow. The event of 2011 was named a 500-year flood, and it was compared with the 1927 and 1983 floods. TNC's floodplain reclamations should be applauded!

Twenty-five miles to the south of the spillway lies Cat Island NWR, home to the National Champion bald cypress tree as well as numerous other relic trees. I first saw the big tree, which is 56 feet in circumference, in 1983 when the land was still owned by Georgia-Pacific. I reached around its gargantuan base, and it took nine and a third of me to complete the circle; seven big NBA players could reach around touching hands. The tree is impressive, and I always wanted to see it with water around its base. The floodwaters of 2011 allowed me to launch my boat in St. Francisville on a flooded city street. I took off up Bayou Sara using seat-of-the-pants navigation. I found the gates to the NWR and headed toward the tree. It was different and strikingly beautiful boating through the treetops, and I mean tops, for the swamp was 30 and 40 feet deep in places. Quickly and somewhat sadly, I recognized the fact that the 96-foot-high tree would be showing only its top 50 feet or so. The big base would be totally obscure; no way to pick it out without GPS coordinates. Even then it would look like all the other treetops, or more like boating through huge azalea bushes.

Cat Island floods every year, sometimes for many months, and this is one of the reasons that so many big bald cypress remain here. Throughout the last few decades levees were tried to take these last large tracts of hardwood bottomland swamp away from the Mississippi, but failed as they were washed away in spring floods. As many as 21 million acres of such bottomlands used to flood from the Mississippi overflow each year; now less than 1 percent do. Millions of acres of floodplain are

A three-toed box turtle ambling down the hiking trail in Mary Ann Brown Preserve.

behind levees, and most of these are cleared and in farmland. Lisa Creasman, associate director of TNC Louisiana, told me, "It's hard to see the forest for the tree." I love that big tree, but the fact is that this refuge is so much more important for being the largest swamp still interacting with the river than for just a champion tree. Lisa was the director of TNC Louisiana at the time Georgia-Pacific decided to sell this unique tract and told me working with the local community was important to completing the deal.

In April of 2014 Sue and I went back by boat to find the big tree, with spring floodwater at a much lower level. We tried to get in from the Mississippi in two places, but the natural high banks blocked us. Finally we found a canal that connected to a few lakes, and then finally into a known road in the refuge. We spotted the trail sign to the big tree barely sticking out of the water and then easily found our goal. I was guessing the water was about ten feet up. The crotch where the trunks split was visible. Sue called my eye to a beautiful barred owl. It was in a tree to the left, and then we heard the crying sound of two full-sized but not quite flying baby owls in the champion tree. Wow! We got here just in time to see two wonderful creatures hatched and raised in a tree that might be 1,500 years old. That tree stood right here a thousand years before the day that explorer Alonso de Pineda reached the mouth of the Mississippi River in 1519. I am awed to think how many owls, woodpeckers, raccoons, black bears, and countless other creatures have used that tree for nesting, hiding, and feeding over that time.

On the way back, going slow and watching for wildlife, we spotted a swamp cottontail rabbit sitting on a log. These soft-furred creatures are survivors. If a big owl, such as the great horned, doesn't find him, this rabbit will survive until the water recedes. When the river drops to about 18 feet on the Baton Rouge river gauge,

the birds come in droves. On a late August afternoon, with roadside ditches full of water, and obviously containing a multitude of fish, the egrets, herons, wood storks, and roseate spoonbills lined the banks by the hundreds, fishing. It was a feeding frenzy. A few weeks later we visited again. The river had dropped, the ditches were almost dry, the fish there consumed or moved with the falling water, and the birds had gone elsewhere. I did see seven deer, a nutria running across the road, two raccoons, and a snake. The value of this habitat lies in its ever-changing nature. High water, low water, sometimes even no water, but in harmony with the Mississippi River.

TNC bought this property from Georgia-Pacific with the intent to sell it to the U.S. Fish and Wildlife Service as funds were appropriated. It happened, and Cat Island is one of three properties in West Feliciana Parish that TNC has preserved. The other two are higher and dryer in the Tunica Hills, a pleasant change from the bottomlands of Cat Island. The vegetation here mimics that of the Appalachian Mountains, and the hills were formed by windblown loess soils that originated in the Pleistocene epoch. In this time period glaciers ground up raw sediment, the Mississippi River carried this soil to Louisiana, and westerly winds blew the dirt into piles that became the Tunica Hills. The steeper of the two properties is Tunica Hills WMA, which TNC purchased, made some nice trails in, and later sold to the Louisiana Department of Wildlife and Fisheries. LDWF expanded those trails, and you can get some good exercise hiking there; it is really steep. My favorite takes you along a hogback ridge before dropping down to Como Creek. This creek is dry most of the time, its sand fine grained and white as the sugar beaches of the Florida Panhandle.

I saw the creek sand even whiter on the second of two rare snows. A snow event does not happen much in south Louisiana. It was really more sleet, but enough to make everything white. Walking was quiet—strange because I thought the ice-covered leaves would crunch more. I saw two men up ahead, and it kind of looked like they were hiding from me. Maybe I would have missed them, for they were dressed in full-on camouflage including masks, but the snow made them stand out. They had been bow-hunting deer. This WMA has a lot of deer hunters as well as squirrel and turkey hunters. The two men headed toward their truck for a rest and a snack. I got off the trail to find some untouched snow on the tan and brown leaves. Glancing up, I saw a triptych of sorts. On the edge of the drop-off was a bare-branched cow oak, noble in the winter sky, bookended by the leathery green leaves of southern magnolia and on the other side by the coppery leaves of the American beech. The leaves of this tree are persistent and sometimes stay on until the new spring growth pushes them off. At another angle, the dark green of the magnolia turns almost black. Most of the leaves had a patch of snow on them. It looked like a tree full of open-faced Oreo cookies.

The blue sky of the cold front was above. It was beautiful. There were many birds—maybe some more came south with the cold and sleet to take a break from early migration. They sure were feeding hard, turning over the frozen leaves; I guess they need more energy in the cold. I-10 was closed in Baton Rouge due to snow, but here there were no FEMA trucks passing out water and energy bars. These creatures don't have closed roads and rules. The birds are on their own; all they need is a healthy habitat and they will survive. As I watched, the sound of melting snow dripping from the treetops was music to my ears.

Less steep and smaller, but still with two miles of scenic hiking, is Mary Ann Brown Preserve, the only preserve in the parish TNC still owns and maintains. One way to honor a loved one is with a legacy of land, to honor a life by giving life, and

that is exactly what Mr. and Mrs. L. Heidel Brown did by donating these 110 acres in the memory of their daughter Mary Ann. It is a platform preserve that is open to the public and well worth a visit. I chose this preserve to set up a time lapse mount, to take photographs from a permanent position every month, thus capturing the changing of the seasons. Different habitats and seasons are the secret of plant and wildlife diversity. To me it would be pretty boring to see the fresh green of spring twelve months a year.

This place is for people and wildlife alike, and is used by hikers, trail runners, Boy Scout groups, bird-watchers, and photographers. On most of my many visits I saw others enjoying the trails in this Tunica forest and watching wildlife. One fall day I was walking to my time lapse mount, and here comes an eastern three-toed box turtle. I say, "How do you do, are you enjoying the trail?" The turtle walked on without a word. I glimpsed whitetail deer on at least every other trip. The small pond, which by the way has great reflections early and late, is also surrounded by wood duck and bluebird boxes. To take a peek, I stretched to my tallest tiptoe to peer into one of the wood duck boxes and startled a flying squirrel resting inside. It looked out the hole, jumped on the roof of the box just long enough for me to get a

Tunica Hills WMA offers some of the steepest terrain and most interesting hiking in Louisiana.

quick shot, and then zipped back in. On another trip I saw my first cicada, *Magicicada tredecim,* and later found out it was the 13-year hatch. This hatch is known as the Baton Rouge group, and they range from the state capital all the way up to Natchez, Mississippi. The ever-present buzzing chirps lasted over three weeks and at midpoint were about as loud as a rock concert, but once used to it I found the sound pleasingly noisy. This cicada was brown and black with round red eyes, very cool looking. There is not a curious six-year-old kid who would not go bonkers over these unique creatures.

To shoot my time lapse, I first find a scenic spot that I'm hoping will look good in all four seasons. Next I bury a 4' by 4' pole and attach a special box I made to fit my camera. I come back monthly at about the same time of day and take a photo. I bracket the exposure varying the shutter speed; using the same aperture as well as the same lens makes it easier to line up the images for a slide show. Finally, I get to scrutinize the subtle changes while getting some exercise on a nice walk. Twenty years ago it was hard to find a place to hike near Baton Rouge, but thanks to TNC there are now three great places with miles of trails through varied habitat less than fifty miles away. Each of these preserves protects habitat for plants and animals alike. Take time to go see "the forest" and "the tree."

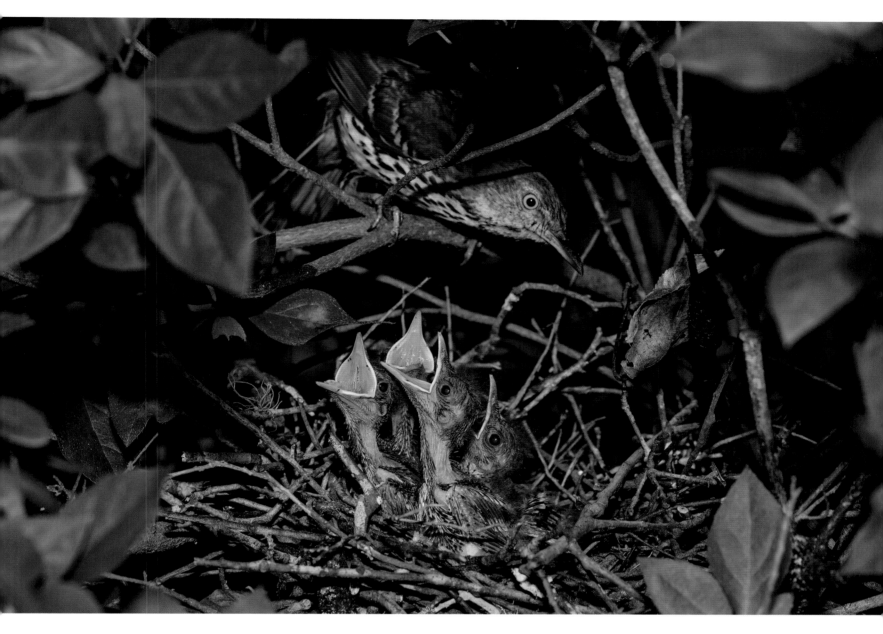

The hiking trails at Mary Ann Brown Preserve cover two miles and cross creeks and ravines many times (*far left*). On a hike you may see a half-eaten acorn on a rare snowy day (*left*), a nest of brown thrashers in the spring (*above*), or a cicada in the summer (*far top left*).

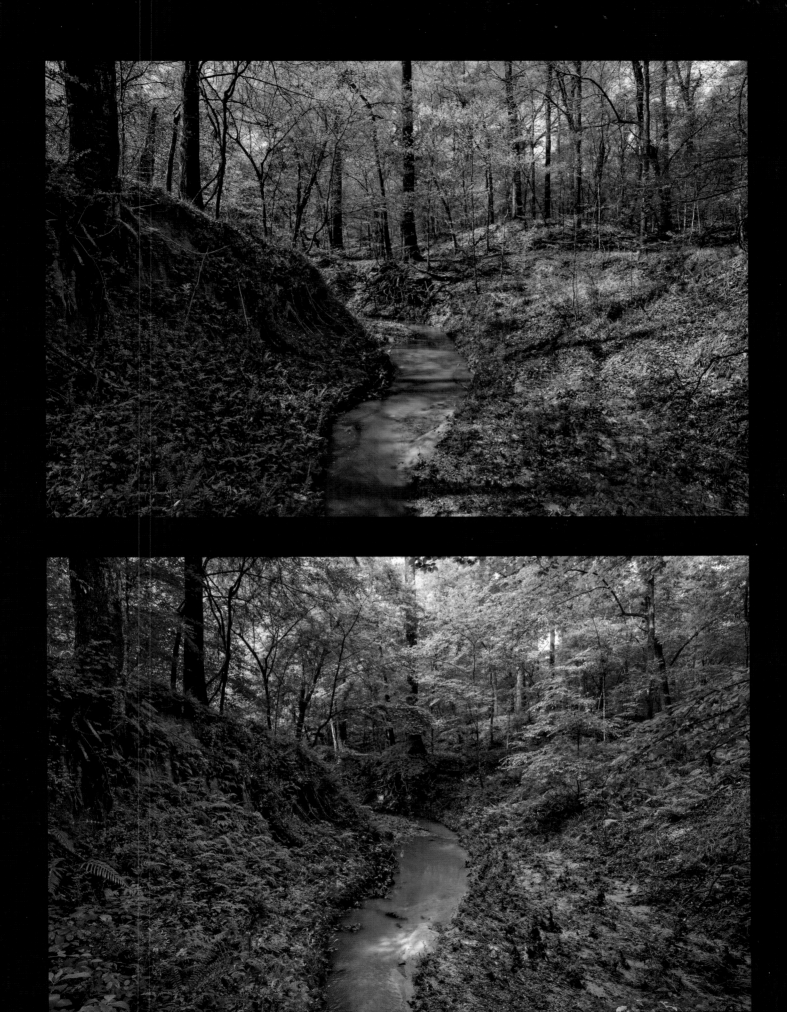

Seasons are as important as habitat to man and animals alike; here you see
fall, winter, spring, and summer on a creek at Mary Ann Brown Preserve.

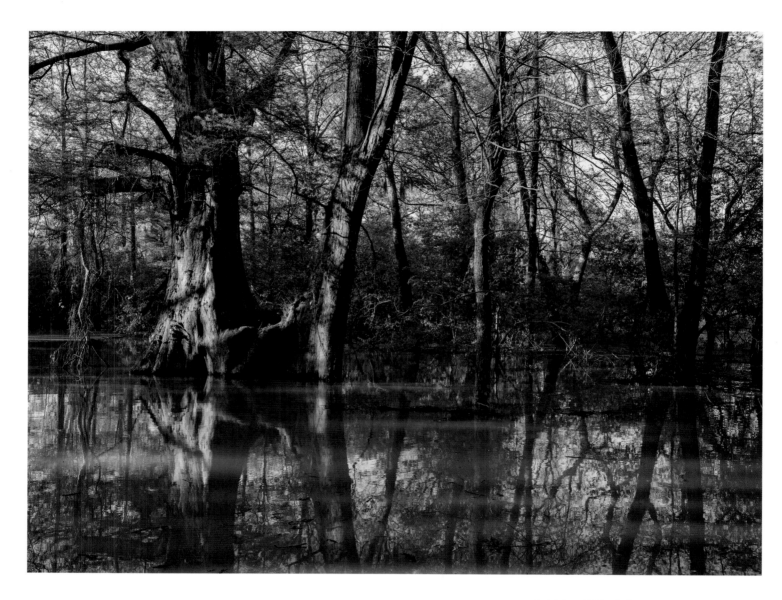

Cat Island NWR is home to the National Champion bald cypress tree, seen here at high water when the Mississippi River over-flows its banks (*above*) and at low water in the late fall (*right*). The massive tree is 56 feet in circumference, truly a feather in the cap of this important refuge.

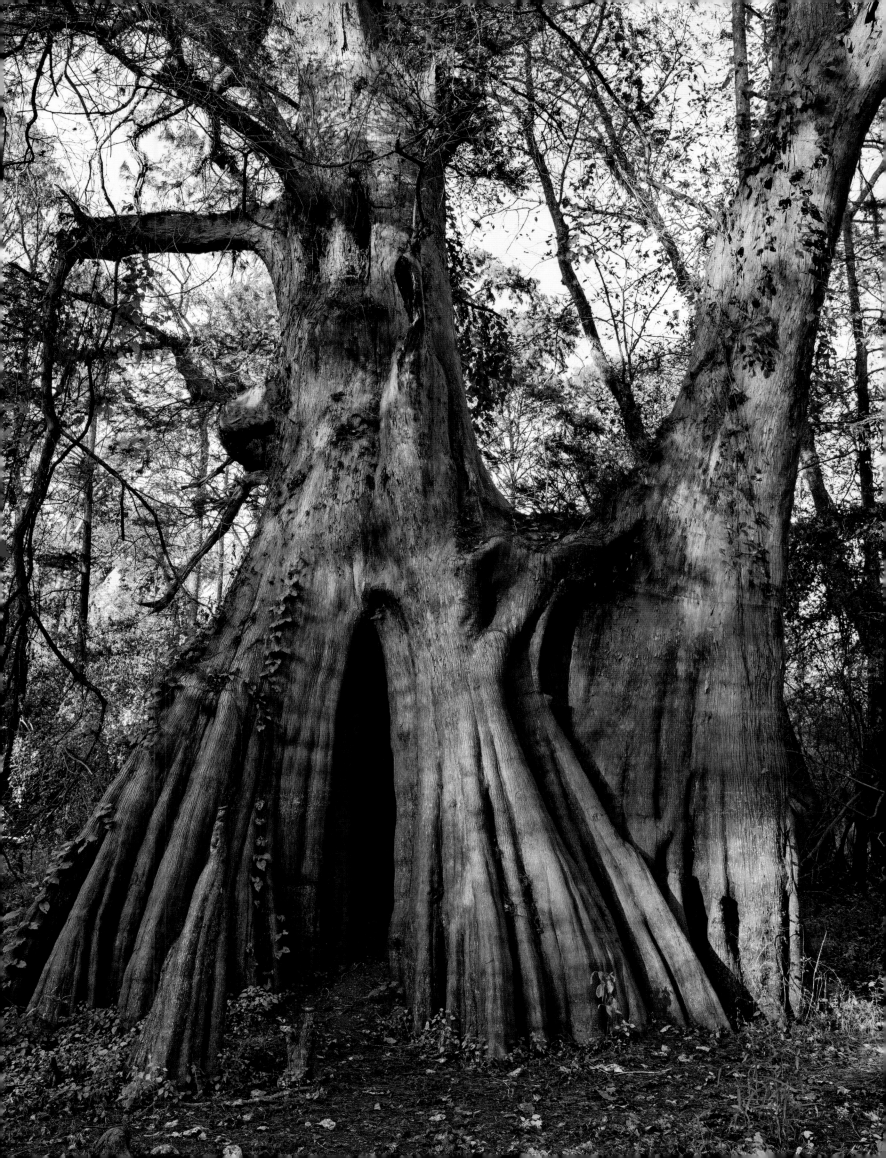

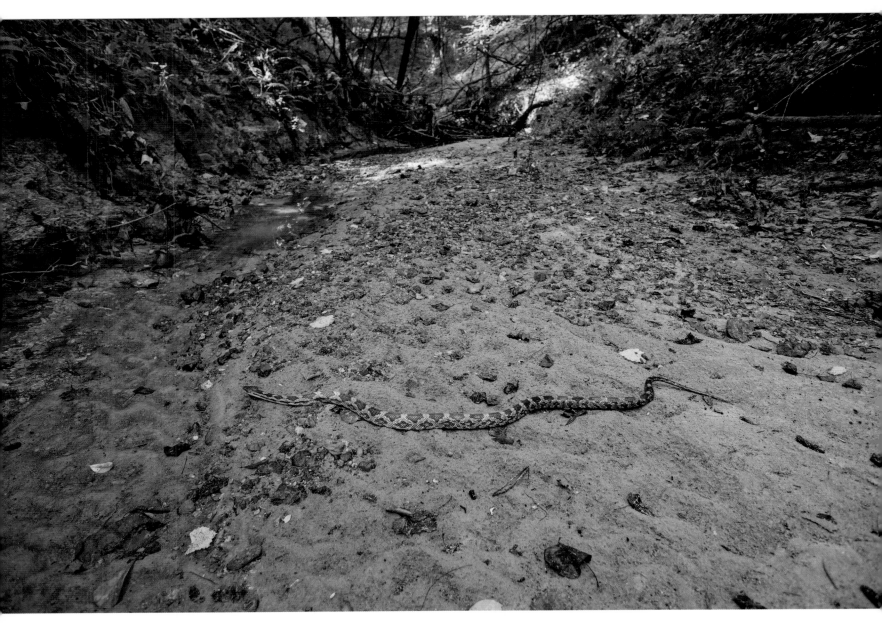

A Texas rat snake crosses the dry creek bed
at Mary Ann Brown Preserve.

Epilogue

Elliott's bluestem grass.

Newlyn McInnis, TNC mitigation program manager, told me that TNC is not a mitigation organization, but "when a good match comes along that meets our goals, we use it." They have four mitigation bank units in southeast Louisiana and four in the west. CC Road Preserve started as a mitigation bank unit.

Before humans, natural environments were constantly changing due to a multiplicity of events. For millions of years, however, natural changes usually occurred gradually, thus minimizing the stress on most species of flora and fauna. Human changes are different—harsh and rapid—and this is the reason we have so many rare, threatened, and endangered plants and animals. When industrial interests in the Lake Charles area needed to develop some wetlands, they purchased mitigation credits at CC Road. TNC took on the project, and it quickly became known as Back Flip Savanna when Latimore Smith discovered the federally endangered American chaffseed, *Schwalbea americana,* The plant is not as showy as the pine lily and not as important in one sense as the edible plant wheat, but it is one that has been affected by the rapid decimation of the longleaf pine forest across the southeastern United States.

Giving the chaffseed a chance by restoring a longleaf pine savanna, or giving a Louisiana black bear a chance by restoring a hardwood bottomland forest, is critically important. When you do so, the rare and wonderful habitat is there for all other species, too, and well worth the time and effort. The speed of development and technology is constant and rapid. Some manmade environments, such as skyscrapers, shopping malls, and subdivisions, are too difficult and near impossible to bring back to historic habitat; so, intelligently, we take loblolly pine plantations and flood-prone soybean farms and restore them to the highest and best use of the land. TNC is made up of scientists, technicians, and administrators who can find and figure the best ways to get, restore, maintain, and rebuild lands to their historic habitat.

Richard Martin was discussing how much area of native habitat we need to restore to have a reasonable opportunity to maintain the full suite of plants and animals native to Louisiana, the United States, and the world. He popped out with the idea, What if 150 years ago we had made a deal with the developers and those benefiting from the use of our natural resources to set aside 10 percent of every habitat type to be preserved as nature made it? He speculated that these groups would have said, We get 90 percent, it's a deal! Although that doesn't sound like a great deal for the conservation community, given that we currently have less than 5 percent of our native prairie, longleaf pine wetlands, shortleaf pine uplands, virgin cypress swamp, bottomland hardwoods, etc., remaining, we would be much better off than we are today. The point is moot, though, because it cannot be done now.

The Nature Conservancy works by buying critical habitat, taking donations of land, administering conservation easements, and buying land and holding it until

Prairie blazing star thrives among rough coneflowers in the later stages of their bloom.

a government entity such as the U.S. Fish and Wildlife Service gets congressional approval to purchase it. The organization also assesses lands for others and makes recommendations to restore it. TNC is making good headway in promoting a clean, healthy, and diverse planet.

On the forefront is an important purchase of property in the Atchafalaya Basin. Accomplishing a sweep of habitats from north to south in Louisiana would not be complete without a chunk of this great wetland. TNC has been working with a land-owner to acquire some acreage. The piece is varied and beautiful and consists of a bald cypress–tupelo swamp in the central part of the basin. Hopefully that purchase will go through before this book gets off the presses.

Now that Sue and I have finished the fieldwork on this project, I think back to the miles of trails, bayous, lakes, swamps, marshes, and dirt road we have traveled in all four seasons to visit these special places with a TNC stamp. I want to go back and sit on a log in the Corney Bayou bottoms, feeling the sweet gum seeds rain on me. I want to dangle my feet off the bow of my bateau at Lake Cocodrie, wondering why some of the cypress knees curl into arches. I want to lie on the soft carpet of new-fallen leaves at Bayou Dorcheat, hoping one will land on me. I want to watch a soft white butterfly circle the mangrove trees in the Grand Isle marsh. I want to climb a longleaf pine as effortlessly as a white-nosed Bachman's fox squirrel. I want to see the first poke of an orchid popping up in the savanna at Abita Creek among the car-nivorous pitcher plants. And I want to do it all without my camera and without my pen. I want to soak all this beauty into my soul and feel as one with the ground, the water, the wood, and the air. Because TNC is here, building disturbed earth back to its natural state, I am assured that those kinds of days are possible, now and in the future.

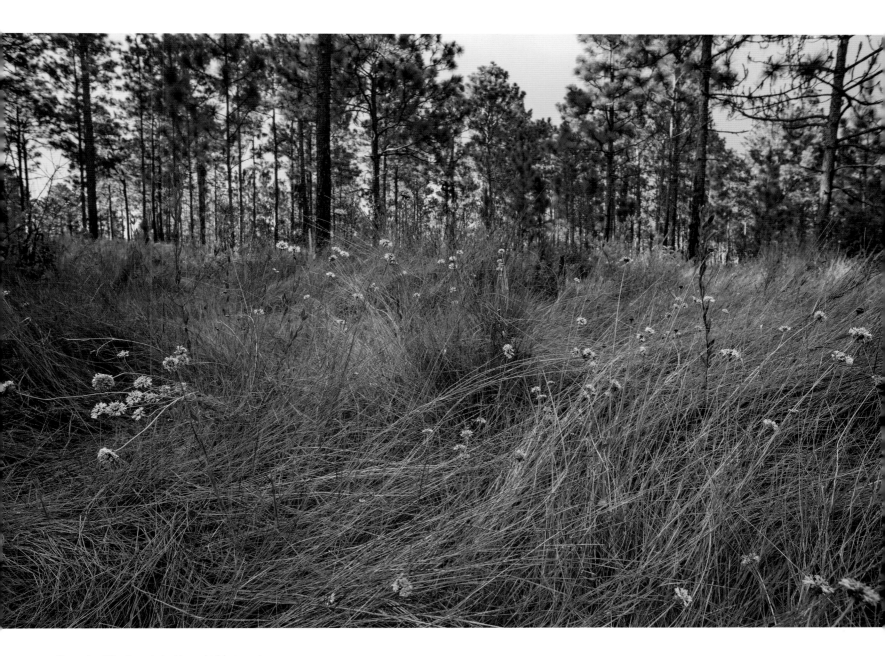

Grassleaf Barbara's buttons in bloom at
CC Road.

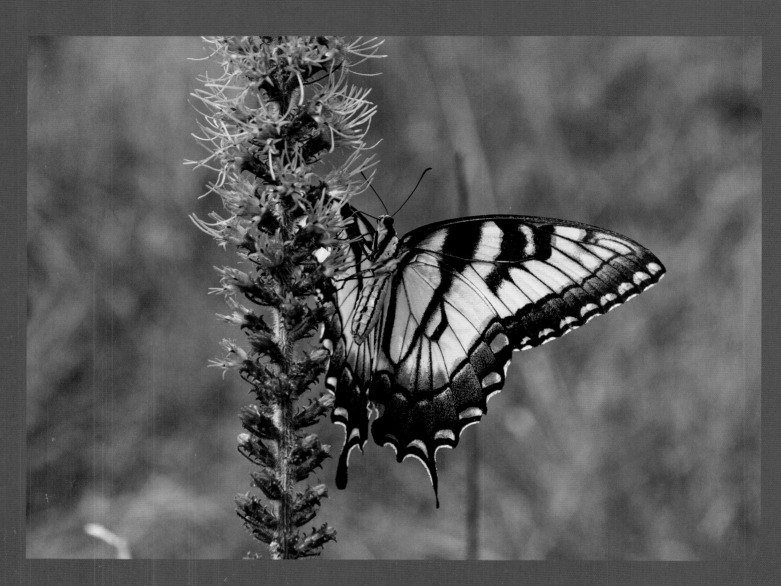

A tiger swallowtail feeds on a prairie blazing star.

Moonrise over the young longleaf pines
that are being restored at Lake Ramsay.

Overleaf: Mature longleaf pines reach for
the sky as a few young ones grow nearby.

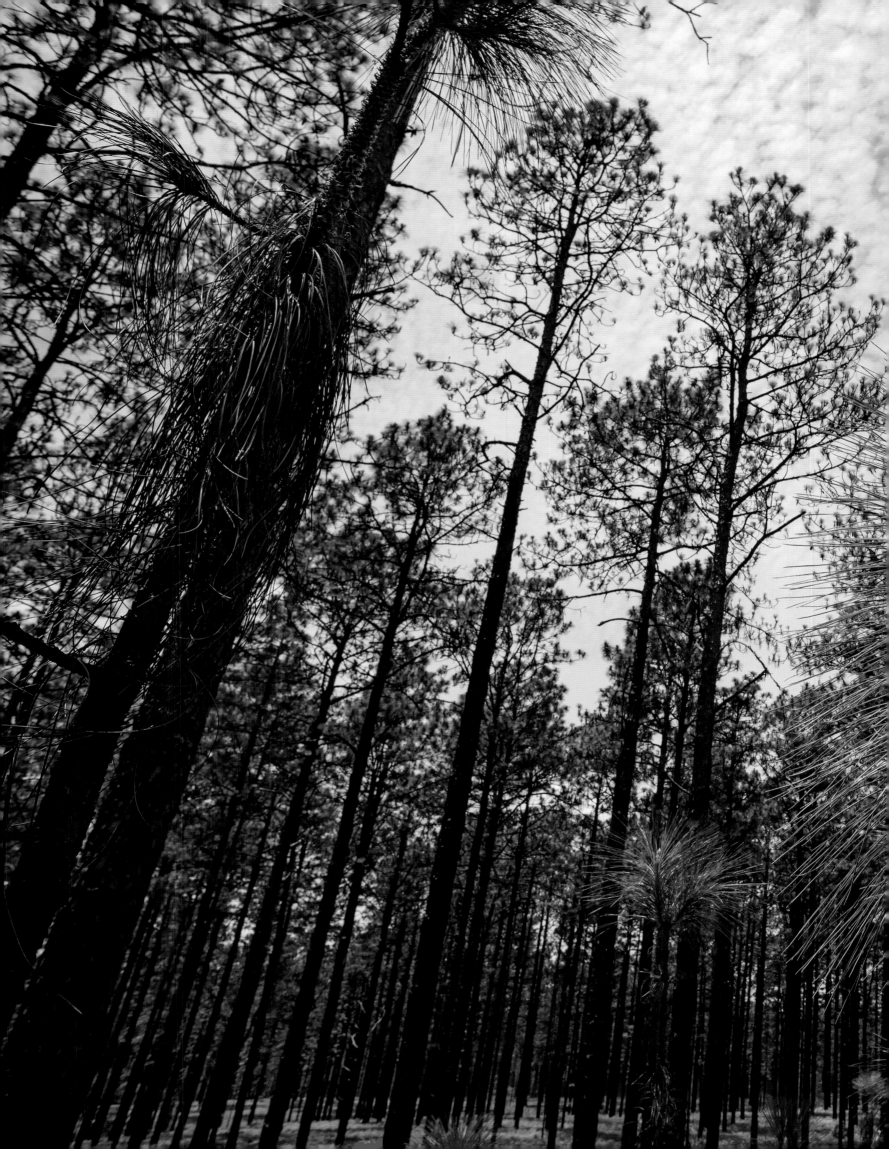

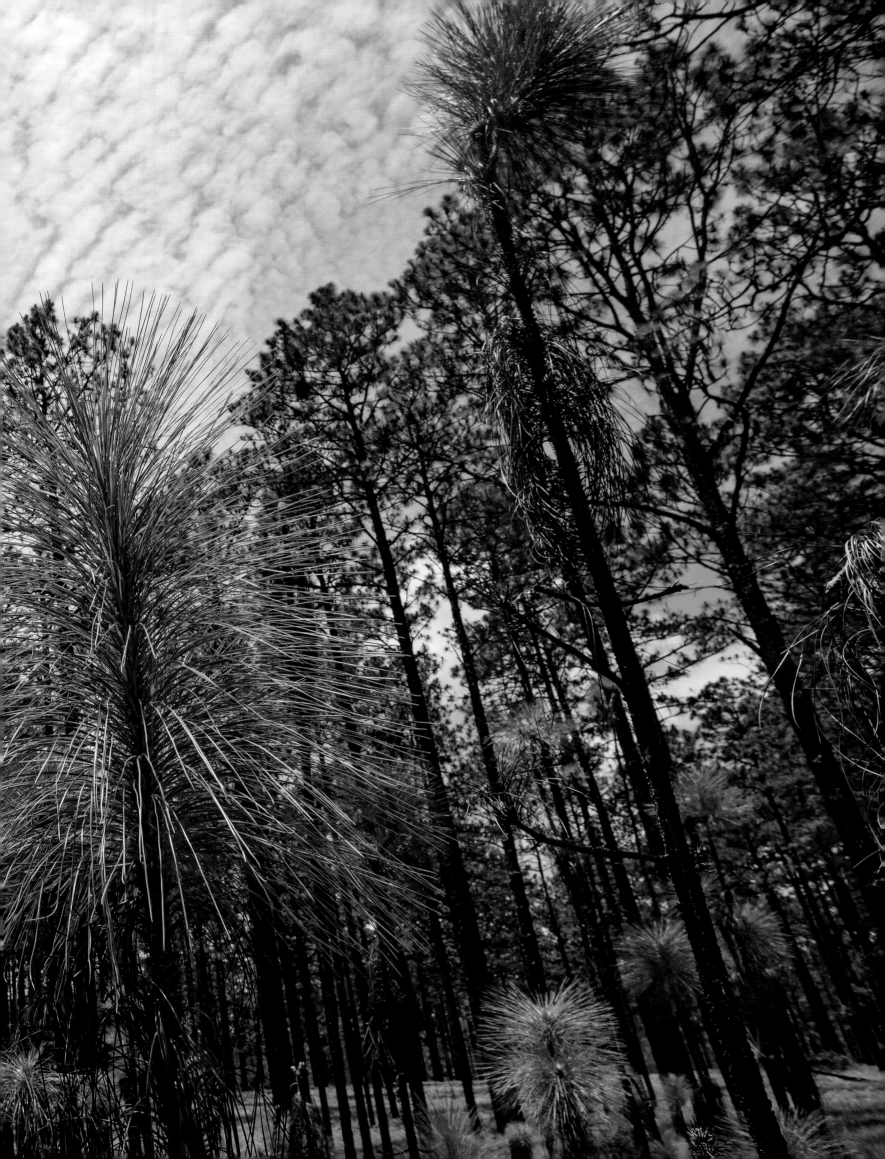

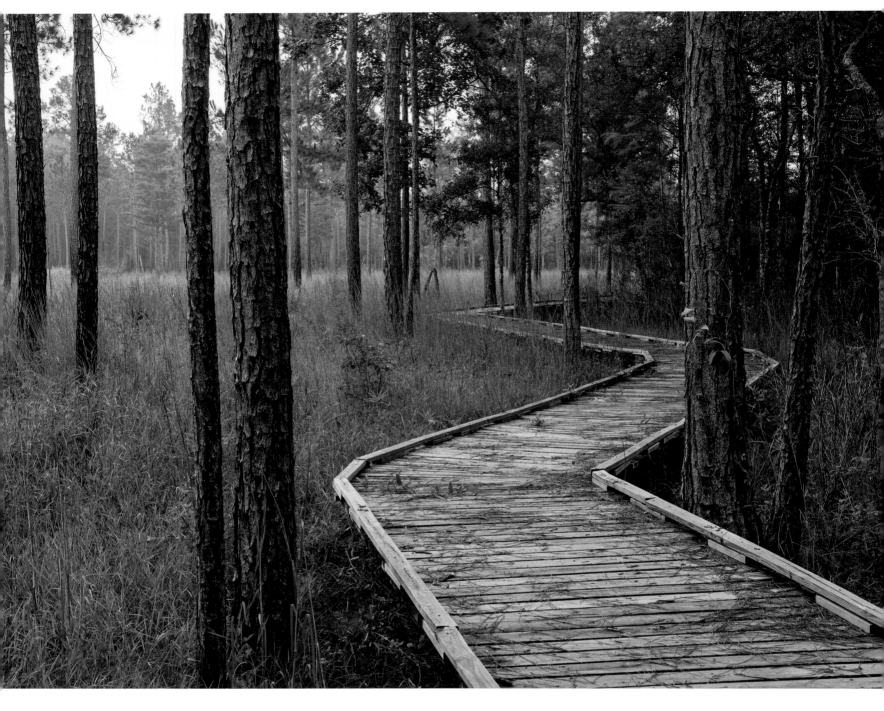

Trail on the interpretive walk at Abita Creek.

Appendix

Projects of The Nature Conservancy in Louisiana

SITE	ACREAGE	PARISH(ES)	ECOREGION(S)
FEE TITLE OWNERSHIP, TNC			
Abita Creek	999	St. Tammany	East Gulf Coastal Plain
Bayou Dorcheat	1,140	Webster	Upper West Gulf Coastal Plain
Bogue Chitto River	1,328	St. Tammany	East Gulf Coastal Plain
Caddo Black Bayou	656	Caddo	Upper West Gulf Coastal Plain
Cat Island	122	West Feliciana	Mississippi River Alluvial Valley
CC Road Savanna	477	Allen	West Gulf Coastal Plain
Charter Oak	147	St. Tammany	East Gulf Coastal Plain
Copenhagen Hills	997	Caldwell	West Gulf Coastal Plain
Cypress Island	9,374	St. Martin	Mississippi River Alluvial Valley
Fort Polk Buffer Tracts	1,322	Vernon	West Gulf Coastal Plain
Frederick's Swamp	76	St. Martin	Mississippi River Alluvial Valley
Lafitte Woods	166	Jefferson	Gulf Coast Prairies and Marshes
Lake Cocodrie	160	Evangeline	West Gulf Coastal Plain
Lake Ramsay	579	St. Tammany	East Gulf Coastal Plain
Mary Ann Brown	110	West Feliciana	Upper East Gulf Coastal Plain
Persimmon Gully	656	Calcasieu	West Gulf Coastal Plain
Pushepatapa	22	Washington	East Gulf Coastal Plain
Schoolhouse Springs	30	Jackson	Upper West Gulf Coastal Plain
Summerfield Springs	654	Claiborne	Upper West Gulf Coastal Plain
Talisheek Pine Wetlands	3,014	St. Tammany	East Gulf Coastal Plain
Tchefuncte River Marshes	800	St. Tammany	Gulf Coast Prairies and Marshes
Total	22,829		

Cooperative Projects

SITE	ACREAGE	PARISH(ES)	ECOREGION(S)
FEE TITLE OWNERSHIP, OTHER			
Attakapas WMA (LDWF)	230	St. Mary	Mississippi River Alluvial Valley
Bayou Bodcau WMA (COE)	752	Bossier	Upper West Gulf Coastal Plain
Bayou Cocodrie NWR (FWS)	11,403	Concordia	Mississippi River Alluvial Valley
Bayou Pierre WMA (LDWF)	580	Red River	Upper West Gulf Coastal Plain
Ben Lilly CA (LDWF)	247	Morehouse	Mississippi River Alluvial Valley
Black Bayou Lake NWR (FWS)	15	Ouachita	Upper West Gulf Coastal Plain
Bluebonnet Swamp (BREC)	88	East Baton Rouge	East Gulf Coastal Plain

SITE	ACREAGE	PARISH(ES)	ECOREGION(S)
Bogue Chitto NWR (FWS)	23,131	St. Tammany	East Gulf Coastal Plain
Cat Island NWR (FWS)	10,549	West Feliciana	Mississippi River Alluvial Valley
Grand Cote NWR (FWS)	6,137	Avoyelles	Mississippi River Alluvial Valley
Holleyman-Sheely (BR Audubon)	2	Cameron	Gulf Coast Prairies and Marshes
Lake Ophelia NWR (FWS)	7,703	Avoyelles	Mississippi River Alluvial Valley
Loggy Bayou WMA (LDWF)	504	Bossier	Upper West Gulf Coastal Plain
Mandalay NWR (FWS)	4,600	Terrebonne	Coastal Marshes and Prairies
Pearl River WMA (LDWF; White Kitchen)	586	St. Tammany	East Gulf Coastal Plain
Point au Chien WMA (LDWF)	1,793	Lafourche	Coastal Marshes and Prairies
Red River NWR (FWS)	3,992	Red River	Upper West Gulf Coastal Plain
Tensas NWR (FWS)	4,941	Madison	Mississippi River Alluvial Valley
Tunica Hills WMA (LDWF)	997	West Feliciana	Upper East Gulf Coastal Plain
Upper Ouachita NWR (FWS)	4,752	Union	Upper West Gulf Coastal Plain
Total	83,002		

ASSISTED PROJECTS

SITE	ACREAGE	PARISH(ES)	ECOREGION(S)
Bayou Sauvage NWR (LDWF)	18,937	Orleans	Gulf Coast Prairies and Marshes
CIAP Bayou Sale (CPRA)	5,117	St. Mary	Gulf Coast Prairies and Marshes
CIAP Blind River (CPRA)	29,630	multiple	Mississippi River Alluvial Valley
CIAP Hard Times Plantation (CPRA)	922	St. Martin, Assumption	Mississippi River Alluvial Valley
CIAP Outside Island (CPRA)	613	Vermilion	Gulf Coast Prairies and Marshes
Curlew Island (LDWF/State Lands)	1,400	Plaquemines	Gulf Coast Prairies and Marshes
Holleyman-Sheely (BR Audubon)	31	Cameron	Gulf Coast Prairies and Marshes
Joyce WMA (LDWF)	13,569	Tangipahoa	Mississippi River Alluvial Valley
Tensas NWR (FWS, TPL)	2,360	Madison	Mississippi River Alluvial Valley
Tunica Hills WMA (LDWF)	2,944	West Feliciana	Upper East Gulf Coastal Plain
Upper Ouachita NWR (FWS)	23,850	Morehouse	Upper West Gulf Coastal Plain
White Lake Cons. Area (LDWF)	71,000	Vermilion	Gulf Coast Prairies and Marshes
Total	171,973		

EASEMENTS: 15 TRACTS TOTALING 10,448 ACRES

Total	10,448		
Grand Total	**288,252**		

ABBREVIATIONS: BR Audubon: Baton Rouge Audubon Society
BREC: Recreation and Park Commission for the Parish of East Baton Rouge
CIAP: Coastal Impact Assistance Program
COE: U.S. Army Corps of Engineers
CPRA: Coastal Protection and Restoration Authority
FWS: U.S. Fish and Wildlife Service
LDWF: Louisiana Department of Wildlife and Fisheries
NWR: National Wildlife Refuge
TPL: Trust for Public Land
WMA: Wildlife Management Area

Notes on Photographs

Custom prints of most photographs in this book are available in limited quantities. See www.cclockwood.com.

All photographs were captured with a Nikon D-800 digital camera and various Nikon lenses. They are listed below by page number with image title, lens, shutter speed, aperture, ISO, and when appropriate the scientific name of plant or animal.

Endsheet Misty. 70–200mm f/2.8. 1/250 at f/8. ISO 200.

Endsheet Grandfather. 70–200mm f/2.8. 1/125 at f/8. ISO 200. *Taxodium distichum.*

Pages ii–iii Clouds Closing. 24mm f/2.8. 1/500 at f/8. ISO 200.

Page iv Prairie Splendor. 20mm f/2.8. 1/250 at f/9.5. ISO 400. *Monarda fistulosa. Rudbeckia hirta.*

Page v Gliding Past. 70–200mm f/2.8. 1/350 at f/9.5. ISO 200.

Page vi: 1 Lovely Lavender. 105mm f/2.8 macro. 1/125 at f/16. ISO 200. *Monarda fistulosa.*

Page vi: 2 Piney Wood Purple. 105mm f/2.8 macro. 1/60 at f/11. ISO 200. *Alophia drummondii.*

Page vi: 3 Parachute. 105mm f/2.8 macro. 1/180 at f/13. ISO 400. *Sarracenia alata.*

Page vi: 4 Golden Eye. 70–200mm f/2.8. 1/4000 at f/4. ISO 200. *Nelumbo lutea.*

Page vi: 5 Bouquet. 105mm f/2.8 macro. 1/750 at f/6.7. ISO 200. *Glandularia canadensis?*

Page vi: 6 Star Burst. 105mm f/2.8 macro. 1/125 at f/11. ISO 200. *Rhododendron canescens.*

Page vi: 7 Echinacea. 105mm f/2.8 macro. 1/180 at f/4.8. ISO 200. *Echinacea purpurea.*

Page vi: 8 Dogwood. 105mm f/2.8 macro. 1/60 at f/8. ISO 400. *Cornus florida.*

Page vi: 9 Lacey. 105mm f/2.8 macro. 1/500 at f/8. ISO 200. *Agalinis fasciculata.*

Page vi: 10 Shooting Star. 105mm f/2.8 macro. 1/90 at f/6.7. ISO 400. *Gaura lindheimeri.*

Page vi: 11 Fireworks. 105mm f/2.8 macro. 1/60 at f/9.5. ISO 800. *Spigelia marilandica.*

Page vi: 12 Monet's Lily. 105mm f/2.8 macro. 1/750 at f/9.5. ISO 200. *Nymphea odorata.*

Page viii Bird Hotel. 70–300mm f/4.5. 1/250 at f/8. ISO 400. *Mycteria americana.*

Page ix Flame Flower Fountain. 105mm f/2.8 macro. 1/125 at f/8. ISO 200. *Macranthera flammea.*

Page x: top Foxy. 600mm f/4. 1/500 at f/4. ISO 800. *Sciurus niger bachmani.*

Page x: bottom Catesby's Lily. 105mm f/2.8 macro. 1/750 at f/4.8. ISO 200. *Lilium catesbaei.*

Page xi Get Your Bearings. 24–70mm f/2.8. 1/750 at f/9.5. ISO 400.

Pages xii–xiii A Room with a View. 20mm f/2.8. 1/15 at f/11. ISO 200.

Page xiv Ruth's Way. 70–200mm f/2.8. 1/125 at f/11. ISO 400.

Page 1 Star Blazing. 70–300mm f/4.5–5.6. 1/60 at f/8. ISO 400. *Liatris pycnostachya. Mantis religiosa.*

Page 2 Open My Eyes. 20mm f/2.8. 1/1000 at f/11. ISO 200.

Page 3 Bats in Trees. 20mm f/2.8. 1/60 at f/5.6. ISO 400. *Taxodium distichum.*

Page 4: left Cone Flower Elegant. 105mm f/2.8 macro. 1/350 at f/3. ISO 200. *Echinacea purpurea.*

Page 4: right Wild Field. 20mm f/2.8. 1/3000 at f/2.8. ISO 200. *Echinacea purpurea.*

Page 5 Yellow Puff. 105mm f/2.8 macro. 1/180 at f/9.5. ISO 200. *Neptunia lutea.*

Pages 6–7 Flaxen Waves. 27–70mm f/2.8. 1/180 at f/6.7. ISO 100. *Schizachyrium scoparium.*

Page 8: top Maple Magnificence. 85mm f/1.4. 1/8 at f/8. ISO 400. *Acer floridanum.*

Page 8: bottom Leaflike. 105mm f/2.8 macro. 1/250 at f/8. ISO 400. *Tettigoniidae* sp.

Page 9: top Modern Art. 85mm f/1.4. 1/250 at f/2.8. ISO 200.

Page 9: bottom Bee Balm. 24–70mm f/2.8. 1/1000 at f/5.8. ISO 200. *Monarda fistulosa.*

Page 10 *Baccharis* Bouquet. 20mm f/2.8. 1/60 at f/8. ISO 400. *Baccharis halimifolia.*

Page 11 Woody. 600mm f/4. 1/1000 at f/8. ISO 200. *Dryocopus pileatus.*

Page 13: top Microworld. 24–70mm f/2.8. 1/15 at f/8. ISO 800. *Nelumbo lutea.*

Page 13: middle Outbreak. 105mm f/2.8 macro. 1/350 at f/9.5. ISO 400. *Nelumbo lutea.*

Page 13: bottom Droplet. 105mm f/2.8 macro. 1/250 at f/11. ISO 400. *Nelumbo lutea.*

Page 14: top See Page iv: 4.

Page 14: bottom Red Wing. 105mm f/2.8 macro. 1/125 at f/11. ISO 200. *Acer rebrum drummondii.*

Page 15 Whistlers. 600mm f/4. 1/500 at f/8. ISO 400. *Dendrocygna autumnalis.*

Page 16 Swinging Sparrow. 600mm f/4. 1/2000 at f/5.6. ISO 400. *Zonotrichia albicollis.*

Page 17: top left Nature's Pallet. 600mm f/4. 1/350 at f/5.6. ISO 400. *Passerina ciris.*

Page 17: middle left Fish Hawk. 600mm f/4. 1/250 at f/8. ISO 400. *Pandion haliaetus.*

Page 17: middle right Red-Shouldered Roost. 600mm f/4. 1/500 at f/5.6. ISO 200. *Buteo lineatus.*

Page 17: bottom Humble Home. 600mm f/4. 1/500 at f/8. ISO 400. *Melanerpes carolinus.*

Page 18 Shadowshine. 24–70mm f/2.8. 1/ 6 at f/9.5. ISO 200. *Nyssa aquatica.*

Page 19 Sunny Silhouette. 70–200mm f/2.8. 1/180 at f/9.5. ISO 400. *Taxodium distichum.*

Page 20: top Plunge-diver. 600mm f/4. 1/180 at f/4. ISO 400. *Phalacrocorax brasilianus.*

Page 20: bottom Velvet Duck. 600mm f/4. 1/350 at f/9.5. ISO 200. *Melanitta fusca.*

Page 21: top Hanging Out. 70–200mm f/2.8. 1/1000 at f/5.6. ISO 200. *Alligator mississippiensis.*

Page 21: bottom Naptime. 70–200mm f/2.8. 1/750 at f/4.8. ISO 200. *Alligator mississipiensis.*

Pages 22–23 Cypress Splendor. 24–70 mm f/2.8. 1/125 at f/8. ISO 200. *Taxodium distichum.*

Page 24: top Nesting Glow. 70–200mm f/2.8. 1/3000 at f/3.3. ISO 800. *Ardea alba.*

Page 24: bottom Cowboy Kayak. 70–200mm f/2.8. 1/180 at f/6.7. ISO 400.

Page 25: top Louisiana Sunrise. 20mm f/2.8. 1/350 at f/9.5. ISO 200.

Page 25: bottom Rainbow Bog. 24–70mm f/2.8. 1/180 at f/9.5. ISO 400. Probablehybrid of *Iris giganti-caerulea x fulva x hexagona.*

Page 26 GBH. 600mm f/4. 1/1000 at f/8. ISO 400. *Ardea herodias.*

Pages 26–27 Goodnight Lotus. 24–70mm f/2.8. 1/250 at f/8. ISO 200. *Nelumbo lutea.*

Page 28 Pitcher's Aflame. 24–70mm f/2.8. 1/350 at f/9.5. ISO 200. *Sarracenia alata.*

Page 29: top left Meadow Burn. 20mm f/2.8. 1/500 at f/11. ISO 400. *Coreopsis nudata.*

Page 29: bottom left Walk the Line. 24–70mm f/2.8. 1/500 at f/8. ISO 400.

Page 29: right Cooked. 24–70mm f/2.8. 1/500 at f/8. ISO 200. *Sarracenia alata.*

Page 30: top Fiery Dance. 70–200mm f/2.8. 1/750 at f/9.5. ISO 400.

Page 30: bottom Engulfed. 24–70mm f/2.8. 1/750 at f/9.5. ISO 400.

Page 31 The Haze. 24–70mm f/2.8. 1/250 at f/8. ISO 200.

Page 32: top Result. 20mm f/2.8. 1/125 at f/8. ISO 200. *Liatris pycnostachya. Pinus palustris.*

Page 32: bottom Energized. 24–70mm f/2.8. 1/250 at f/8. ISO 200. *Pinus palustris.*

Pages 32–33 Rocket Phase. 24–70mm f/2.8. 1/250 at f/8. ISO 200. *Pinus palustris.*

Page 34: top Charred. 105mm f/2.8 macro. 1/30 at f/8. ISO 200. *Pinus palustris.*

Page 34: bottom Tres Tres. 105mm f/2.8 macro. 1/20 at f/13. ISO 200. *Tradescantia hirsutiflora.*

Page 35: top Enlightenment. 70–200mm f/2.8. 1/350 at f/4.8. ISO 200.

Page 35: bottom Toddler. 24–70mm f/2.8. 1/125 at f/11. ISO 200. *Pinus palustris.*

Page 36: top Seedlings. 20mm f/2.8. 1/1000 at f/4 ISO 200. *Pinus palustris.*

Page 36: bottom Future Foresters. 20mm f/2.8. 1/750 at f/9.5. ISO 400.

Page 37: top left Sassy Squirrel. 70–300mm f/4.5–5.6. 1/250 at f/8. ISO 400. *Sciurus niger bachmani.*

Page 37: far top right Pinwheel. 105mm f/2.8 macro. 1/125 at f/8. ISO 200. *Echinacea pallida.*

Page 37: top right middle Purple Perfection. 105mm f/2.8 macro. 1/500 at f/8. ISO 200. *Stokesia laevis.*

Page 37: top right bottom Honeycombhead. 105mm f/2.8 macro. 1/125 at f/8. ISO 400. *Balduina uni-flora.*

Page 37: bottom left Li Lium. 105mm f/2.8 macro. 1/180 at f/9.5. ISO 200. *Lilium catesbaei*

Page 37: bottom right Southern Cricket Frog. 105mm f/2.8 macro. 1/125 at f/8. ISO 800. *Acris gryllus gryllus.*

Page 38 Twins. 24–70mm f/2.8. 1/100 at f/8. ISO 800. *Pinus palustris.*

Page 39: top Flowering Pitcher. 105mm f/2.8 macro. 1/500 at f/8. ISO 400. *Sarracenia alata.*

Page 39: bottom Close-up *Liatris.* 105mm f/2.8 macro. 1/350 at f/9.5. ISO 200. *Liatris pyc-nostachya.*

Page 40: top Lynx in a Trumpet. 105mm f/2.8 macro. 1/250 at f/8. ISO 400. *Peucetia viridans. Sarra-cenia alata.*

Page 40: bottom Otter Family Fun. 70–300mm f/4.5–5.6. 1/250 at f/8. ISO 400. *Lontra canadensis.*

Page 41: top Sticky Sundew. 105mm f/2.8 macro. 1/250 at f/11. ISO 400. *Drosera brevifolia.*

Page 41: bottom Nightlight. 20mm f/2.8. 15 at f/3.3. ISO 1600.

Pages 42–43 Here's to the Land of the Longleaf Pine . . . 70–300mm f/4.5–5.6. 1/180 at f/9.5. ISO 200. *Pinus palustris.*

Page 44: 1 Yellow Colic-root. 105mm f/2.8 macro. 1/250 at f/16. ISO 800. *Aletris lutea.*

Page 44: 2 Pinebarren Deathcamas. 105mm f/2.8 macro. 1/250 at f/8. ISO 200. *Zigadenus leiman-thoides.*

Page 44: 3 Grasspink Orchid. 105mm f/2.8 macro. 1/1500 at f/9.5. ISO 400. *Calopogon tuberosus.*

Page 44: 4 Small Spreading Pogonia. 105mm f/2.8 macro. 1/60 at f/8. ISO 400. *Cleistes bifaria.*

Page 44: 5 See Page vi: 3.

Page 44: 6 Fewflower Milkweed. 105mm f/2.8 macro. 1/750 at f/9.5. ISO 400. *Asclepias lanceolata.*

Page 44: 7 Georgia Tickseed. 105mm f/2.8 macro. 1/350 at f/9.5. ISO 200. *Coreopsis nudata.*

Page 44: 8 Toothache Grass. 105mm f/2.8 macro. 1/125 at f/8. ISO 400. *Ctenium aromaticum.*

Page 44: 9 See Page vi: 10.

Page 45 Singing to the Stars. 20mm f/2.8. 1/125 at f/8. ISO 200. *Rhynchospora latifolia. Sarracenia alata.*

Page 46 Heart of Pines. 20mm f/2.8. 1/125 at f/11. ISO 200. *Pinus palustris.*

Page 47: top left See Page vi: 10.

Page 47: top right Grasspink Glory. 24–70mm f/2.8. 1/350 at f/3.3. ISO 200. *Calopogon tuberosus.*

Page 47: bottom Piney Flatwoods. 24–70mm f/2.8. 1/250 at f/8. ISO 200. *Pinus palustris. Schizachyrim tenerum.*

Page 48: top After Fire. 20mm f/2.8. 1/500 at f/8. ISO 400. *Sarracenia alata.*

Page 48: bottom Cousin It. 70–200mm f/2.8. 1.5 at f/4.8. ISO 400. *Pinus palustris.*

Page 49 Baygall Groceries. 20mm f/2.8. 1/15 at f/8. ISO 400. *Crataegus opaca.*

Page 50 Slippery Salamander. 105mm f/2.8 macro. 1/6 at f/9.5. ISO 400. *Desmognathus conanti.*

Page 51: top Schoolhouse Springs. 24–70mm f/2.8. 1/8 at f/8. ISO 400.

Page 51: bottom Chocolate Salamander. 105mm f/2.8 macro. 1/45 at f/8. ISO 800. *Desmognathus conanti.*

Page 52: left The Corkscrew. 105mm f/2.8 macro. 1/4 at f/11. ISO 200.

Page 52: right Mating Hearts. 105mm f/2.8 macro. 1/180 at f/6.7. ISO 400. *Calopteryx masculata.*

Page 53: top Silent Springs. 24–70mm f/2.8. 1/6 at f/9.5. ISO 400.

Page 53: bottom Patriarch. 24–70mm f/2.8. 1/60 at f/6.7. ISO 400. *Chelydra serpentina.*

Page 54 LSU. 24–70mm f/2.8. 1/180 at f/6.7. ISO 200. *Callicarpa americana.*

Page 55 Rusty Reflections. 24–70mm f/2.8. 1/60 at f/8. ISO 200.

Page 56: top Morning Dance. 70–300mm f/4.5–5.6. 1/500 at f/11. ISO 800. *Ardea herodias.*

Page 56: bottom Trick or Treat. 105mm f/2.8 macro. 1/350 at f/9.5. ISO 800. *Neoscona crucifera.*

Page 58 Carpeted Cathedral. 20mm f/2.8. 1/15 at f/11. ISO 200.

Page 59: top Column. 24–70mm f/2.8. 1/180 at f/3.3. ISO 200. *Pinus taeda.*

Page 59: bottom Resting Place. Cycles. 24–70mm f/2.8. 1/6 at f/6.7. ISO 200.

Page 60: top Carnival of Color. 70–200mm f/2.8. 1/180 at f/6.7. ISO 200.

Page 60: bottom Linear Visions. 24–70mm f/2.8. 1/45 at f/9.5. ISO 200.

Page 61 Naked. 24–70mm f/2.8. 1/350 at f/13. ISO 400. *Quercus lyrata.*

Pages 62–63 Golden Bayou. 70–200mm f/2.8. 1/180 at f/6.7. ISO 200.

Page 64 Umbrella. 20mm f/2.8. 1/15 at f/8. ISO 400. *Amanita daucipes.*

Page 65 Hand of Man. 20mm f/2.8. 1/350 at f/6.7. ISO 200.

Page 66: top Bottomland. 24–70mm f/2.8. 1/30 at f/8. ISO 200.

Page 66: bottom Turkey Talk. 70–300mm f/4.5–5.6. 1/125 at f/4.5. ISO 1600.

Page 67 Serpent of the Pines. 105mm f/2.8 macro. 1/1000 at f/5.6. ISO 200. *Pituophis ruthveni.*

Page 68 Louisiana Pine Snake. 24–70mm f/2.8. 1/500 at f/11. ISO 400. *Pituphis ruthveni.*

Page 69 Light in the Leaves. 70–300mm f/4.5–5.6. 1/30 at f/8. ISO 200.

Page 70: top Building Back the Bayou. 24–70mm f/2.8. 1/500 at f/8. ISO 200.

Page 70: bottom Peaceful Pond. 20mm f/2.8. 1/125 at f/5.6. ISO 200. *Helianthus angustifolius.*

Page 71 Breach. 24–70mm f/2.8. 1/2000 at f/2.8. ISO 250.

Pages 74–75 Ghost Flight. 85mm f/1.4. 1/1000 at f/4.8. ISO 400.

Page 76: top Muddy. 24–70mm f/2.8. 1/6000 at f/4. ISO 800.

Page 76: middle Field to Forest. 24–70mm f/2.8. 1/8000 at f/4. ISO 800.

Page 76: bottom Mollicy Rebuilt. 70–200mm f/2.8. 1/250 at f/8. ISO 400.

Page 77 Nature's Way. 24–70mm f/2.8. 1/2000 at f/4. ISO 400.

Page 78 Evening Flight. 600mm f/4. 1/1000 at f/8. ISO 400.

Page 80 All Ears. 70–200mm f/2.8. 1/60 at f/6.7. ISO 800. *Corynorhinus rafinesquii.*

Page 81 Bat Cave. 70–200mm f/2.8. 1/60 at f/6.7. ISO 800. *Myotis austroriparius.*

Page 82 Spring Love. 105mm f/2.8 macro. 1/250 at f/11. ISO 200. *Junonia coenia.*

Page 83: top Mardi Gras. 24–70mm f/2.8. 1/250 at f/8. ISO 400. *Rhus copallinum* and *Callicarpa americana.*

Page 83: bottom Tu Tu. 105mm f/2.8 macro. 1/1500 at f/4.8. ISO 200. *Dalea phleoides.*

Page 84 Scarlet. 24–70mm f/2.8. 1/250 at f/8. ISO 200. *Nyssa sylvatica.*

Page 85: top Floating World. 70–200mm f/2.8. 1/20 at f/9.5. ISO 400. *Iris* sp.

Page 85: bottom See Page vi: 5.

Page 86 Lone Iris. 600mm f/4. 1/180 at f/4.8. ISO 400. *Iris* sp.

Page 87 Vivipary Visitor. Camo on the Mangrove. 105mm f/2.8 macro. 1/160 at f/6.3. ISO 800. *Avicennia germinans. Ascia monuste.*

Page 88 Pelican Patrol. 70–200mm f/2.8. 1/250 at f/8. ISO 400. *Pelecanus occidentalis.*

Page 89: top Salt Marsh Byway. 20mm f/2.8. 1/320 at f/9. ISO 200. *Spartina alterniflora.*

Page 89: middle left Hanging. 105mm f/2.8 macro. 1/640 at f/8. ISO 400. *Spartina alterniflora.*

Page 89: middle right Banding a Beauty. 105mm f/2.8 macro. 1/180 at f/6.7. ISO 400. *Passerina ciris.*

Page 89: bottom Bird Banding. 105mm f/2.8 macro. 1/125 at f/5.6. ISO 200. *Passerina ciris.*

Pages 90–91 Sunset Wedge. 24–70mm f/2.8. 1/15 at f/10. ISO 200. *Spartina alterniflora.*

Page 92: top Crimson Beauty. 600mm f/4. 1/180 at f/4.8. ISO 400. *Morus* sp. *Piranga olivacea.*

Page 92: middle left Berry Pickin'. 600mm f/4. 1/350 at f/4.8. ISO 400. *Piranga rubra.*

Page 92: middle right Catbird. 600mm f/4. 1/3000 at f/6.7. ISO 800. *Dumetella carolinesis.*

Page 92: bottom Careful Captures. 24–70mm f/2.8. 1/90 at f/4.8. ISO 200. *Geothlypis trichas.*

Page 93: left top Dainty Oriole. 600mm f/4. 1/1000 at f/5.6. ISO 400. *Icterus spurius.*

Page 93: left middle Orange and Black. 600mm f/4. 1/1500 at f/6.7. ISO 400. *Icterus galbula.*

Page 93: left bottom Lesser Nighthawk Hiding. 600mm f/4. 1/350 at f/9.5. ISO 200. *Chordeiles acutipennis.*

Page 93: right Red-Eyed Vireo. 600mm f/4. 1/1500 at f/6.7. ISO 400. *Virio olicaceus.*

Page 94: top Refueling. 600mm f/4. 1/500 at f/8. ISO 400. *Pheucticus ludoricianus.*

Page 94: middle Thrilling Thrasher. The Singer. 600mm f/4. 1/750 at f/9.5. ISO 400. *Toxostoma rufum.*

Page 94: bottom What's Up? 600mm f/4. 1/650 at f/6.7. ISO 200. *Sylvilagus aquaticus.*

Page 95: top Old Oaks. 24–70mm f/2.8. 1/125 at f/11. ISO 400. *Quercus virginiana.*

Page 95: bottom Splendor in the Grass. 70–300 f/4.5–5.6. 0.7 at f/16. ISO 200. *Spartina alteriflora.*

Page 97 Future Beds. 24–70mm f/2.8. 1/500 at f/8. ISO 200.

Page 98 Seeing Double. 500mm f/4. 1/125 at f/5.6. ISO 800. *Strix varia.*

Page 99 Architects. 600mm f/4. 1/350 at f/5.6. ISO 200. *Ardea alba.*

Pages 100–101 Lush. 20mm f/2.8. 1/90 at f/9.5. ISO 400.

Page 102 Linear. 20mm f/2.8. 1/125 at f/8. ISO 200.

Page 103 The Maze. 70–200mm f/2.8. 1/60 at f/8. ISO 200.

Page 104 See Page vi: 12.

Page 105: left Anyone Home? 20mm f/2.8. 1/250 at f/13. ISO 200. *Glaucomys volans.*

Page 105: right The Thinker. 600mm f/4. 1/500 at f/11. ISO 400. *Ardea alba.*

Page 106 A World Apart. 20mm f/2.8. 1/500 at f/8. ISO 400. *Nymphea odorata.*

Page 107: top Roseate Flight. 600mm f/2.8. 1/2000 at f/4. ISO 400. *Platalea ajaja.*

Page 107: bottom left Mama! 24–70mm f/2.8. 1/250 at f/8. ISO 800. *Nyctanassa violacea.*

Page 107: bottom right Hanging On. 70–200mm f/2.8. 1/2000 at f/4. ISO 200. *Ixobrychus exilis.*

Page 108: left Peeking from Palmettos. 105mm f/2.8 macro. 1/125 at f/4.8. ISO 800. *Pseudacris crucifer.*

Page 108: top right Trampin' Through. 24–70mm f/2.8. 1/30 at f/11. ISO 800. *Sabal minor.*

Page 108: bottom right Hidden Treasures. 70–200mm f/2.8. 1/180 at f/2.8. ISO 3200. *Lynx rufus.*

Page 109 Fairy Hat. 105mm f/2.8 macro. 1/60 at f/8. ISO 400. *Clematis crispa.*

Page 111 Pied Piper. 600mm f/2.8. 1/350 at f/6.7. ISO 800. *Podilymbus podiceps.*

Pages 112–113 Lunar Landscape. 70–200mm f/2.8. 1/500 at f/11. ISO 800.

Page 114: top Tracked. 20mm f/2.8. 1/30 at f/8. ISO 800. *Odocoileus virginianus.*

Page 114: bottom Tiny. 24–70mm f/2.8. 1/60 at f/5.6. ISO 400. *Odocoileus virginianus.*

Page 115: left Turquoise. 105mm f/2.8 macro. 1/250 at f/8. ISO200. *Cnemidophorus sexlineatus.*

Page 115: right Coachwhip. 105mm f/2.8 macro. 1/180 at f/6.7. ISO 200. *Coluber flagellum.*

Page 116 Bates Mountain. 24–70mm f/2.8. 1/125 at f/8. ISO 200.

Page 117: top Golden Canopy. 85mm f/1.4. 1/4000 at f/1.4. ISO 200. *Acer floridanum.*

Page 117: bottom Frosty Oaks. 70–200mm f/2.8. 1/15 at f/8. ISO 200.

Pages 118–119 Green Waves. 70–200mm f/2.8. 1/60 at f/8. ISO 200.

Page 120: left Dogwood Bloom. 105mm f/2.8 macro. 1/60 at f/8. ISO 400. *Cornus florida.*

Page 120: right See Page vi: 8.

Page 121: top See Page vi: 6.

Page 121: bottom Liquid Lunch. 105mm f/2.8 macro. 1/350 at f/9.5. ISO 400. *Rhododendron canescens. Papilio glaucus.*

Page 122 West Feliciana Beaches. 24–70mm f/2.8. 1/250 at f/11. ISO 100.

Page 123 Stealthy. 70–200mm f/2.8. 1/60 at f/4.8. ISO 800. *Lynx rufus.*

Page 124 A Walk through the Swamp. 24–70mm f/2.8. 1/180 at f/6.7. ISO 800.

Page 125 See Page vi: 11.

Page 126 Skinky! 24–70mm f/2.8. 1/250 at f/4.8. ISO 800.

Page 127: top Hanging Vireo. 70–200mm f/2.8. 1/45 at f/6.7. ISO 200. *Vireo qriseus.*

Page 127: bottom Learn. 20mm f/2.8. 1/125 at f/6.7. ISO 800.

Page 128 Castaway. 70–200mm f/2.8. 1/45 at f/4.8. ISO 800. *Sylvilagus aquaticus.*

Page 129 The Long Journey. 20mm f/2.8. 1/40 at f/7.1. ISO 400. *Terrapene Carolina triunguis.*

Page 131 Ravine. 20mm f/2.8. 1/125 at f/8. ISO 200. *Magnolia grandiflora.*

Page 132: top Red Eye. 105mm f/2.8. 1/60 at f/5.6. ISO 400. *Magicicuda* sp.

Page 132: bottom Winter White Trail. 20mm f/2.8. 1/30 at f/8. ISO 400.

Page 133: top Feed Me! 105mm f/2.8 macro. 1/60 at f/9.5. ISO 200. *Toxostoma rufum.*

Page 133: bottom Acorn. 105mm f/2.8 macro. 1/350 at f/9.5. ISO 200. *Quercus nigra.*

Page 134: top Fall. 20mm f/2.8. 1/15 at f/11. ISO 200.

Page 134: bottom Winter. 20mm f/2.8. 1/180 at f/9.5. ISO 200.

Page 135: top Spring. 20mm f/2.8. 1/8 at f/8. ISO 200.

Page 135: bottom Summer. 20mm f/.8. 1/180 at f/9.5. ISO 200.

Page 136 Grand Champion Wet. 24–70mm f/2.8. 1/125 at f/5.6. ISO 400. *Taxodium distichum.*

Page 137 Grand Champion Dry. 24–70mm f/2.8. 1/8 at f/11. ISO 200. *Taxodium distichum.*

Page 138 Creek Crossing. 24–70mm f/2.8. 1/90 at f/4.8. ISO 800. *Elaphe obsoleta lindheimeri.*

Page 139 Black and White. 24–70mm f/2.8. 1/45 at f/6.7. ISO 200. *Andropogon elliotti.*

Page 140 Pointing to the Pines. 105mm f/2.8 macro. 1/2000 at f/2.8. ISO 400. *Liatris pycnostachya. Rudbeckia grandiflora.*

Page 141 A Prairie Littered with Flowers. 20mm f/2.8. 1/125 at f/8. ISO 400. *Marshallia graminifolia.*

Page 142 *Liatris* Lunch. 24–70mm f/2.8. 1/350 at f/6.7. ISO 200. *Liatris pycnostachya. Papilio glaucus.*

Page 143 Lake Ramsay Moon Rise. 20mm f/2.8. 0.7 at f/2.8. ISO 3200.

Pages 144–45 Shooting to the Sky. 20mm f/2.8. 1/350 at f/9.5. ISO 200. *Pinus palustris.*

Page 146 Follow Me. 24–70mm f/2.8. 1/10 at f/9.5. ISO 200. *Pinus palustris.*

Endsheet On the Flame. 105mm f/2.8 macro. 1/250 at f/8. ISO 200. *Macranthera flammea.*

Endsheet Savanna Grass. 70–300mm. 1/750 at f/5.3.

Index